INSPIRED BY FAITH

INSPIRED BY FAITH

ROBIN LANDA

Fleming H. Revell
Old Tappan, New Jersey

Scripture quotations in this volume are from the King James Version of the Bible.

Library of Congress Cataloging-in-Publication Data
Landa, Robin.
 Inspired by Faith.
 Bibliography: p
 Includes index.
 1. Painting—Technique. 2. Art and religion.
I. Title.
ND1430.L36 1988 751.45'482 88-15644
ISBN 0-8007-1612-4

Copyright © 1988 by Robin Landa
Published by the Fleming H. Revell Company
Old Tappan, New Jersey 07675
Printed in the United States of America

TO my beautiful mother
Betty Erder Landa,
with love.

Contents

Illustrations

Plates
Following Page 96

Figures

Preface

Inspired by Faith is intended as a handbook-guide for oil painters and draftsmen who want to create religious art and enjoy art's religious potential. Therefore, it includes numerous old-master painting and drawing techniques, with step-by-step instructions; religious art history and criticism; and many examples of old-master works and contemporary-master works.

This how-to book addresses the art of oil painting with many factors in mind: design, color, drawing, composition, style, technique, and content. Its proven, well-rounded approach to the art of painting religious works is particularly advantageous for an instructor who wishes to educate students in technique and history. The easy-to-follow format also makes it a fine reference for individual artists who wish to create timeless works of art.

Why create religious paintings? Artists choose to paint religious and spiritual works in order to reveal their beliefs to themselves, to others, and to God. I have included Protestant, Catholic, and Jewish artists, as well as those who would call themselves "spiritual," rather than religious, but these artists are not always flagged as such. In many cases, their beliefs are already visible through their art. By including each, I am not trying to make a statement concerning the depth or orthodoxy of his or her faith. Nor can I claim any unity of faith among them—art is the only unifying factor here.

Painting, one of the most dynamic and complex mediums we have ever invented, allows us to search out our minds and souls, revealing our inner worlds. Art makes ideas, feelings, and beliefs visible to ourselves,

as we create it, and to others, when they see the finished work. Art affects its viewers, influencing people, awakening their perceptions, stimulating their senses, and enlightening their minds and souls.

My years of college teaching experience have revealed a need among adults for a vehicle through which they can express their deepest thoughts about their life search for meaning, faith, and human existence. At the same time, my education in art and art history gave me the utmost respect for our art heritage and the potential of art in today's world. It is a vital and essential part of our lives.

In writing this book, I spoke to many professional and "Sunday" painters who felt, as I did, that painting, drawing, and the making of art were a great part of their lives. My hope is that this text will provide both practical advice about painting techniques and inspiration in the form of examples of religious and spiritual art.

I wish to thank Margaret Beaudette, S. C., the Erder family, Morris Guralnick, Mary Kennan, Ruth Landa, John Jerry Anthony Parente, Gilda Morera, Richard Nochimson, and Alan Robbins for their help and encouragement. I also wish to thank all the museums, galleries, and individuals who kindly allowed me to reproduce works of art from their collections.

Although a painter may be inspired, it is important to have friends who believe in your work. Thank you Michael Saccone, for your faith in my work.

A special thanks to my parents, Betty Erder Landa and Hyman Landa, who were always patient and understanding, and to my grandmother, Minnie Erder, who inspired me.

1 What Is Religious Painting?

From prehistoric times people have expressed themselves through the visual arts. But why do we find the need to create visual images?

Humans have always seemed to have a need to turn their feelings and thoughts into a permanent medium: visual art. Whether in idols, narratives, ritualistic works, or responses to their visual perception, the peoples of other eras created visual art. Even when religious beliefs warned against icons or idolatry people have created some kind of permanent nonrepresentational visual images. Today we still seem to need the permanence painted, sculpted, or crafted imagery can offer.

What is religious painting all about? It has the same basis as all other art. Painting allows us to express our beliefs about our faith in a communicable, concrete, visually satisfying way. Painting can relate not only to our intellects and to our sight, but it can stimulate our other senses to a heightened level of awareness of truth and beauty.

What is religious painting? What is Christian painting? What is Catholic or Protestant painting? What is Judaic painting? What subject matter and styles are Christian, Judaic, or religious?

Any painting, realistic, nonrepresentational, or abstract, that utilizes the agreed-upon structures of art to convey ideas or feeling about one's religion is religious painting. But does today's Catholic religious art have to take the form of an icon or altarpiece? No. Does Protestant or Judaic art have to avoid images? No. Perhaps these statements were not true many years ago, but the arena for artists of all beliefs is wide open today.

Can I Create a Religious Painting?

Painting is a person-made schema created as a vehicle for expression and communica-

tion. It therefore is a learnable, teachable medium that requires patience and practice on the part of the participant.

As we learn and practice, we begin to see the world through a painter's eyes, and our whole lives will be enhanced. When we express our emotions and intellect through painting, we are forced to think long and hard before we communicate. To translate anything to paper or canvas, we have to investigate how we see, think, and feel.

The Elements of a Painting

Understanding and creating religious paintings means we need to start by looking at the six components of any such painting:

1. *Time.* When was the painting created?
2. *Subject.* What is the religious subject of the painting?
3. *Meaning.* How do we communicate religious meaning through the formal elements of the painting medium?
4. *Artist.* Who created the painting?
5. *Purpose.* What is the religious painting's intended purpose?
6. *Style.* What is the style of the religious painting? What does that style signify?

Time: When was the painting created? In order to best understand the potential of a work of art and the way it reveals information about the time in which it was created, let us momentarily invent and ponder a ludicrous situation. Let's take an art object from a different country and time period, place it in a contemporary American time capsule, and speculate on its significance. If we placed *Chasse of Champleve Enamel* (figure 1), a French twelfth-century reliquary, in a time capsule marked LATE TWENTIETH CENTURY AMERICA and buried it

for posterity, what would future generations think of us, based on what they found? How would this art object change their perceptions of our period?

Since a reliquary is a repository for relics, would they think all Americans were Christians? Would they think we were all rich because of the material of which it is composed? Who would they think was our leader? What would they think of our craftsmanship and choice of materials? Clearly, this art object would create false notions about our society, culture, and system of government. Art has the potential to reflect its birthplace: the culture, priorities, economics, craftsmanship, values, and government of its creator and creator's environment.

Perhaps *Diner* (figure 2) better reflects our time and should be placed in the time capsule. Although it seems to be a simple image, we can extract a great deal of meaning from this work. This photorealist painting speaks to us about urban life, industrialization, mechanization, high-level technology, apartment life, and skilled craftsmanship. From these, we can derive even more thoughts about the way we live today—from eating in public restaurants to the social significance of choosing a subject such as this and turning it into a modern-day icon.

Why does art tell about a time period and society? We reveal and reflect our place in time, environment, culture, and heritage through our artistic creations. They reveal our search for meaning and how we see our surroundings. But according to noted historian and theoretician George Kubler, art is primarily a matter of our perception: "Artistic inventions alter the sensibility of mankind. They all emerge from and return to human perception. . . ."[1] Therefore we

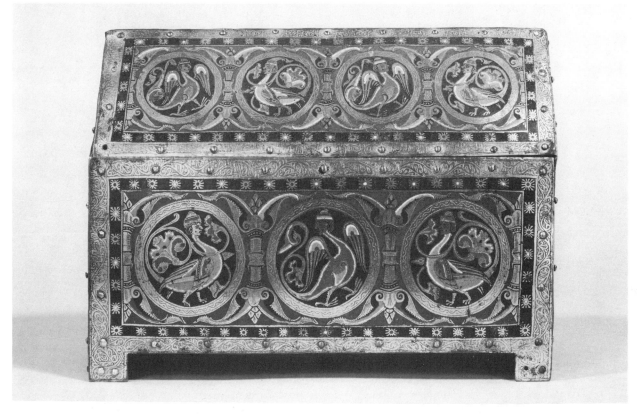

FIGURE 1: French twelfth-century Limoges, *Chasse of Champleve Enamel*, enamel, 7⅜" x 4⁹⁄₁₆" x 10⁵⁄₁₆", courtesy of the National Gallery of Art, Washington, D. C., Widener Collection.

This reliquary reflects its own time period and culture. Any art object tells us something about its creator and its creator's environment.

should be able to draw meaning from *all* works of art, regardless of the time period in which they were created.

Extracting meaning from art hinges on these points.

1. We must desire to enlarge our perception of the world through artistic creations.
2. We must understand the language, the subjects, and the history of art.

Most people do want to enlarge their perception of the world through looking at or making artistic creations. Let us say that this is a given element. But understanding the language, subjects, and history of art is a process undertaken by those people who are serious about their revelatory journey through artistic creation. Because art is not a natural phenomenon, we must study its language. The medium of painting has procedures, methods, and active theories that were devised by humans years and years ago. Modern times have stretched the "rules" of art, but it is still an artificial medium. We also can no longer assume that all people in our city, country, or hemisphere will understand all subjects. Finally, having a sense of the history of art enables us to enlarge our range of subjects, see where artistic creations fall in relation to others, enabling us to enlarge our perceptions of the world.

A View Near Volterra (figure 3), by the French nineteenth-century painter Corot, is a wonderful example of human perception

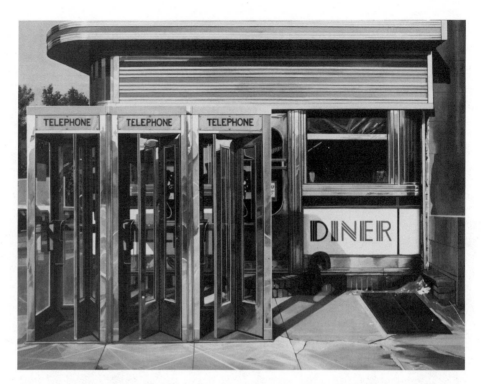

FIGURE 2: Richard Estes, *Diner*, 1971, oil on canvas, 40⅛" x 50" (101.7 x 126.8 cm),
courtesy of the Hirshhorn Museum and Sculpture Garden, Smithsonian Institution.
In this work, Richard Estes, a contemporary New York artist, has chosen to depict
the modern urban world resplendent in glass, chrome, and slate.

translated into a painting. Here we see a painting that gives us little trouble. We can easily recognize the images, understand the subject, and place the painting in modern times. We do not need to look up the subject in a book on myths or religion, if we are content with the universal message of land and sky. But can we fully understand how Corot used the painting language to convey feelings of tranquility and harmony? Where in the history of modern art does this work fall, and what are its historical, social, and political underpinnings? What will happen when we look at art that is not so close to us in time or so universal in subject?

Subject: What is the religious subject of the painting? What culture or philosophy does it reflect? The subjects of religious paintings can directly or indirectly reflect the

cultures from which they stem, as well as those cultures' philosophies and interests. Religion as well as philosophy, history, politics, literature, mythology, psychology, and human emotions have been subjects well-served by painting.

For a great part of the history of Western art the Catholic Church was a great patron of painting. Countless altarpieces, murals, frescoes, wood panels, and canvases were commissioned by the church, along with sculpture, illuminated manuscripts, Bibles, prayer books, architecture, mosaics, and stained-glass windows, which were executed for the church by artists, architects, and artisans. The religious subjects that were painted covered everything from icon images of the Madonna and Christ all the way to esoteric narratives from Apocrypha texts. Some subjects seemed to be very

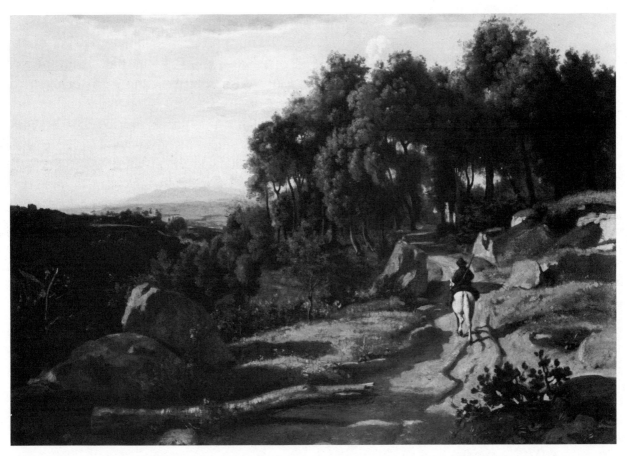

FIGURE 3: Jean Baptiste Camille Corot, *A View Near Volterra*, 1838, oil on canvas, 27⅜″ x 37½″ (0.695 x 0.951 cm), courtesy of the National Gallery of Art, Washington, D. C., Chester Dale Collection.

The subject of landscape has universal appeal; we need not go to an outside reference in order to understand it. The artist's perception of the landscape and feelings about it are permanently fixed on canvas, allowing us to compare our perceptions of similar images and responses to visual stimuli.

popular, such as the Crucifixion, the descent from the cross, the Madonna enthroned, pietà, dead Christ, and images of certain saints, such as Saint Sebastian and Saint John. These subjects had different specific messages, but in general, they were meant to arouse positive responses toward the church and the faith of the viewer. Some images made the viewers feel closer to their religion, as if they were a part of the actual images or narratives. (In fact, some patrons wished to be included in the scenes that they commissioned.) Other images were meant to educate the faithful in the stories of the Bible, and some were meant to

comfort and help people deal with their own troubles and tragedies by establishing biblical figures as prototypes of behavior.

With the rise of Protestant churches that opposed religious icon paintings, because they considered them idolatrous, many artists chose more generic subjects. Landscape, still life, and portraiture (*see* figures 4–6) became important subjects, especially in seventeenth-century Holland. Strict Calvinists felt all decorative objects were dispensable luxuries, so among them only portraits, small panel paintings, and book illustration were popular forms.[2] During the Renaissance, those artists who

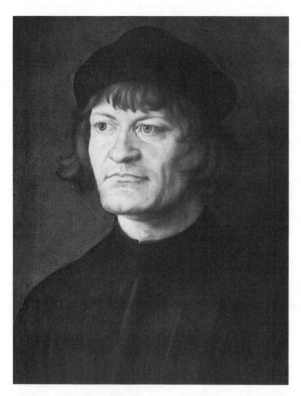

FIGURE 4: Albrecht Dürer, *Portrait of a Clergyman*, 1516, parchment on canvas, 16⅞″ x 13″ (0.429 x 0.332), courtesy of the National Gallery of Art, Washington, D. C., Samuel H. Kress Collection.

Dürer was a follower of Martin Luther as well as being a scholar and a humanist. This portrait of a clergyman may be that of the Reformer.[3]

hoped for the commission of important artworks that embodied the Protestant faith did not see that come to pass, due to the strong beliefs against imagery in art held by some Protestant religious leaders and iconoclasts. Protestant artists such as Albrecht Dürer and Matthias Grünewald even had to depend upon Catholic patronage for their survival.

(Though Dürer depended mostly upon Catholic patronage, his Protestant convictions led him to create such works as *The Four Apostles*, which embodies his Lutheran beliefs [figure 7]).

The followers of Judaism were also against idolistic imagery. "Thou shalt have no other gods before me. Thou shalt not make unto thee any graven image, or any likeness of any thing that is in heaven above, or that is in the earth beneath, or that is in the water under the earth: Thou shalt not bow down thyself to them, nor serve them . . ." (Exodus 20:3–5). Clearly this ruled out all possible interpretational or representational images of God. However, in recent discoveries of Judaic art, we find that continuous narrative seemed to be an acceptable form of painting; and many Judaic images and decorations in temples of worship and prayer books were abstract and nonrepresentational.

Many great Jewish artists were involved with some of the most important movements of the twentieth century. Artists such as Marc Chagall, Amedeo Modigliani, Jules Pascin, Chaim Soutine, Moise Kisling, and Max Weber reflect the pressing formal

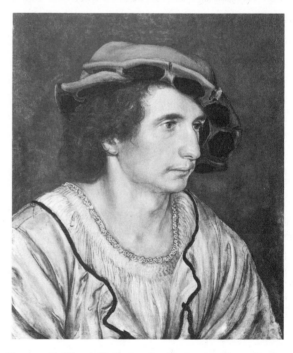

FIGURE 5: Hans Holbein the Younger, *Portrait of a Young Man*, oil on wood, 8⅝″ x 6¾″ (0.219 x 0.170), courtesy of the National Gallery of Art, Washington, D. C., Samuel H. Kress Collection.

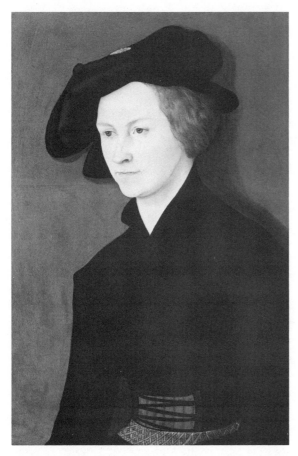

FIGURE 6: Lucas Cranach the Elder, *Portrait of a Woman*, oil on wood, 22⅜″ x 15″ (0.568 x 0.381), courtesy of the National Gallery of Art, Washington, D. C., Samuel H. Kress Collection.

issues of modern art as well as their Jewish heritage (figures 8, 9).

In modern times, people of all Western faiths have utilized both realistic and abstract images to convey their beliefs.

Religious paintings definitely make up an enormous part of the entire Western history of art. Some painters and their patrons of religious art found inspiration in arenas analogous to religion, such as philosophy. At various times in the history of art, people have turned to the ancient Greek and Roman philosophers for subjects. Although pagan, these philosophies provided latter-day patrons and artists with metaphors for situations in

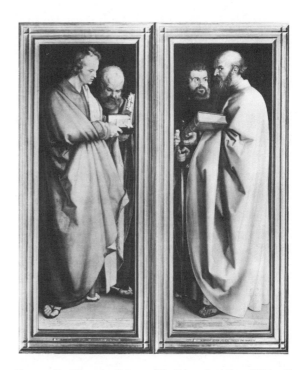

FIGURE 7: Albrecht Dürer, *The Four Apostles*, 1526, oil on wood panels, each 85″ x 30″ (215 x 76 cm), courtesy of the Alte Pinakothek, Munich.

This subject is a basic one to Protestant doctrine and was probably meant as a statement of faith by Dürer.

their own lives and countries. The metaphoric quality drawn from philosophy dramatized and ennobled the quality of the artist's life. Our lives assume a grandeur when placed in history, as against the fleeting transience of everyday existence. For example, *The Death of Socrates* (plate 1), by the nineteenth-century French painter David, was painted during a time of unrest in France, just prior to the French Revolution. David was actively engaged in the events of his day, and we can see how he might want to borrow the look of established Greek virtue. Perhaps we can even draw a relationship between the figure of Socrates and Christ. Analogies could also be drawn between the philosophical ideas and the religious ideas of the figures.

In the twentieth century, artists went a

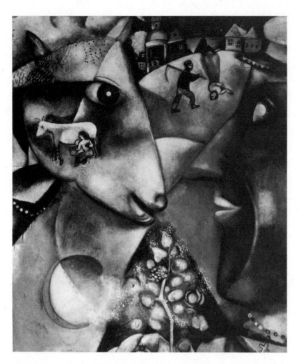

FIGURE 8: Marc Chagall, *I and the Village*, 1911, oil on canvas, 6' 3⅝" x 59⅝", courtesy of the Museum of Modern Art, New York, Mrs. Simon Guggenheim Fund.

Chagall, a Russian-born Jew who studied art in Paris, is perhaps the most famous Jewish artist. His paintings reflect Jewish folklore, God's love and presence in all things and places (perhaps derived from a Hassidic legend), and the joys and tragedies of Jewish life. In Paris, Chagall was friends with many well-respected artists, including other displaced Jewish artists Chaim Soutine (Russian), Amedeo Modigliani (Italian), and Jules Pascin (Bulgarian).

On the formal level, his work reflects various schools of thought that were being explored around 1923, when he returned to Paris. But Chagall was able to maintain a genuine identity, a definite style. This style, which utilized representational images in fantastic settings, was appropriate to the intensity of feeling Chagall wished to convey through painting.

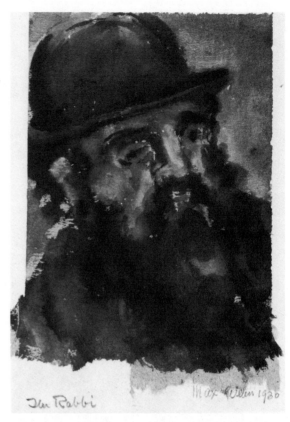

FIGURE 9: Max Weber, *The Rabbi*, 1930, gouache, 6" x 4⅛", courtesy of the Museum of Modern Art, New York, Gift of Abby Aldrich Rockefeller.

Max Weber, like Chagall, was born in Russia. He emigrated to the United States and settled in Brooklyn, studied at Pratt Institute, but soon moved to Paris to further his studies. Upon returning to New York, he joined other artists who were riding the hub of the most modern artistic movements. He is most often called an expressionist, but he did go through cubist and fauve periods in his work. The "expressionist" label may stem from his works' intensity. Not only was Weber constantly involved with formal issues, which became the only subject for most moderns, he was also interested in how the formal elements could convey feeling—and often religious feelings. His involvement was with the Jewish religion, Jewish folklore, and how it felt to be a Jewish American.

step farther, viewing the painting medium itself as a vehicle for the expression of philosophy. No longer did artists have to merely illustrate the writings of ancient philosophers or the narratives of religious stories. They did not need to relate stories by or of philosophers and prophets, but could use paint and canvas (instead of words) to make philosophical statements.

Even though religious art makes up a

large part of the Western history of art, other subjects took on importance as the Catholic Church lost power. History, including current and past events, was considered a grand and important painting subject, especially by the artists of the seventeenth, eighteenth, and nineteenth centuries (*see* figure 10). Paintings served as records of events or as reminders of important history lessons. American artists have always viewed history as an important subject. They painted American historical events to help establish a sense of place and roots for the newly established nation.

During wartime, American artists acted as illustrators. People made firsthand sketches, which were turned into engravings or woodcuts, of battles and of wartime conditions; these were then printed in newspapers. Of course the invention of photography changed twentieth-century minds about the importance of painting historical events. Journalistic illustrations were soon replaced by journalistic photographs.

Just as artists and patrons found inspiration in philosophy and history, political subjects also presented them with differ-

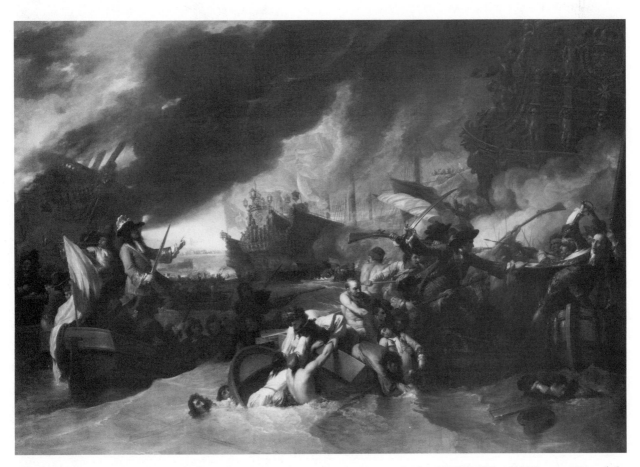

FIGURE 10: Benjamin West, *The Battle of La Hogue*, 1778, oil on canvas, 60⅛″ x 84⅜″ (1.527 x 2.143), courtesy of the National Gallery of Art, Washington, D. C., Andrew W. Mellon Fund.

History painting was considered a noble subject by artists and art academies in the seventeenth, eighteenth, and early nineteenth centuries. Paintings could report on contemporary events or commemorate past ones. The invention of the camera ended the need for or interest in history painting. Not until the 1970s did history reemerge as a viable topic for contemporary artists.

ent challenges. Artists in the past justifiably feared the reaction of their governments to their treatment of political subjects. Contemporary artists, especially those residing in free countries, feel comfortable expressing their political views on canvas. Margaret Beaudette, S. C., a contemporary New York painter and sculptor, feels free to express her views about political events in the form of watercolor paintings (*see* plate 2). For this artist, political subjects encompass her ideas about religion, ethics, history, and philosophy. There has always been controversy over the suitability of art to politics, but great artists have nonetheless successfully tackled the arena of political themes.

Literature and mythology hold a plethora of stories and images suited for painting. These subjects, like philosophy, can act as metaphors. The writings of innumerable authors, for example Dante and Lord Byron, served as subject matter for their contemporaries as well as artists of later times. The nineteenth-century French painter Delacroix depicted stories of earlier writers, like Dante and his contemporaries (*see* figure 11). Greek and Roman myths comprising classical mythology and folklore stimulated the minds of many Western artists from the Renaissance until the present. During the Italian Renaissance, some artists and philosophers felt mythology could be symbolically connected to religion. For example, Venus, the goddess of love and beauty, can be seen as a symbol of the Virgin Mary in painted imagery of certain artists. As with religious subjects, certain mythological characters and stories were more popular than others. Venus was depicted on water, on a bed, on land, alone, or with other figures, painted countless times by countless artists. Titian, an Italian

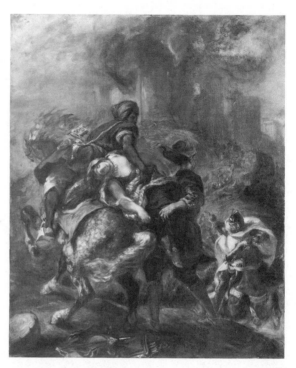

Figure 11: Eugène Delacroix, *The Abduction of Rebecca*, courtesy of the Metropolitan Museum of Art, New York. Wolfe Fund, 1903. Catherine Lorillard Wolfe Collection.

Inspired by literature, Delacroix paints a scene from Sir Walter Scott's *Ivanhoe*.

sixteenth-century artist, depicted Venus over and over again during his lifetime (*see* figure 12). The sensuality of Titian's Venus defines her as the goddess of love and beauty.

The freedoms provided by twentieth-century technology gave rise to the redefinition of the role of art. If it no longer had to serve history as a recorder of events and did not serve the church on a major level, what would art be about? We have already seen that it became a vehicle for philosophical ideas. But it also found a newly developed arena: psychology. Could art reveal the subconscious or unconscious mind? Could art reveal our true psyches? our inner spirits? Some artists believed it could. The abstract expressionist artists in New York,

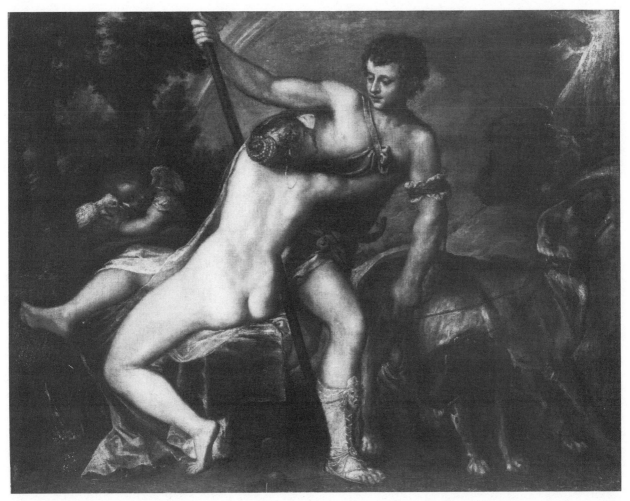

FIGURE 12: Titian, *Venus and Adonis,* oil on canvas, 42″ x 53½″ (1.068 x 1.360), courtesy of the National Gallery of Art, Washington, D. C., Widener Collection.

The subjects of Venus by herself, Venus with attendants, and Venus with Adonis have all been popular with artists since classical times. But the metaphoric link between these mythological figures and religious figures occurred during the Renaissance in Italy. In this work, we see a very sensual love between Venus and Adonis. Other depictions of Venus and Adonis include the tale of Venus lamenting over the dead body of Adonis, which might be the early prototype for the familiar pietà imagery.

during the 1940s and 1950s, found great creative energy in the psychological arena. Similarly, artists could express their personal feelings through art in a way that was never afforded to them before. They could use the painting medium to serve their own ideas, spirituality, and feelings, rather than serve outside sources.

Meaning: How do we communicate religious meaning through the formal elements of the painting medium? As we said earlier, painting must use the agreed-upon structures of art to convey religious meaning. If we want to paint a religious picture, we must take the many *formal elements* of painting, composition, color, size, scale, line, shape, texture, light, and shadow, into consideration.

These elements convey feelings and communicate messages to the viewer. For example, vertical lines and horizontal lines

can take on different meanings from diagonal lines. Bright hues can convey different feelings from dull ones. In this book, we will investigate the diverse meanings inherent in the formal elements.

Realizing that the formal elements of painting communicate meaning and feeling, it is of the utmost importance that we study them if we want to create meaningful religious paintings. It is not enough to choose a religious subject and expect that the literal message will convey the meaning. The meaning must be conveyed through the structuring, the way in which the formal elements are composed and chosen.

Artist: Who created the painting? Many people study art by studying monographs of artists, but it is not enough to simply know the personal life of the artist. We must also know who came before him or her, the culture of the country in which the artist lives, and the artist's influences, in order to gain insight into the art.

For example, if we studied the life of Raphael, we would learn that he was considered one of the greatest artists of the Italian Renaissance. Some called him a perfect artist. Further investigation would tell us that Raphael lived at a time that was ripe for artistic expression and that he lived in a society that heavily patronized the arts. Raphael's name has become a household word not only because he was extraordinarily talented, but because he lived at the right time, in the right country, and received the right kind of publicity. The artists of the next generation, some of whom were as talented as Raphael, did not receive the same fame or publicity. Why? If Raphael and his generation of artists, including Michelangelo and Leonardo da Vinci, were considered to be so great, it

must have been next to impossible for the following generation to gain the same type of fame, no matter how talented they were. With the same argument in mind, what would have happened if Raphael had been a woman? Would Raphael still have become an artist? Probably not. Women at that time did not have the same opportunities as men.

If we look at two paintings, one done by Raphael (figure 13) and one done by Pontormo (figure 14), an artist from the next generation, we can see how the artists differ in their approach to painting. Pontormo's approach reacted to the previous generation of famous artists, who were considered to be of the highest order. It is very difficult to follow in the footsteps of the best in one's field. So rather than trying to be better than the best, Pontormo and his peers reacted by being different. The forms they used were often distorted or elongated, never in the perfect proportions of Raphael's works, and were considered "mannered" or affected by the same audiences. Thus they were given the title of the "Mannerists." How unfortunate that they were so misunderstood. Interestingly, Raphael's late work was, in turn, affected by the next generation of artists, including Pontormo. Clearly we must learn a great deal about artists and their environments to get the total meaning behind a picture.

Purpose: What is the intended purpose of a religious painting? Knowing the reason *why* a religious picture was painted is as important as knowing when it was painted, being able to analyze its formal structure, or knowing who painted it. Sometimes we can discover the purpose of a painting from the painting itself, whereas at other times we must research the reasons. There are still

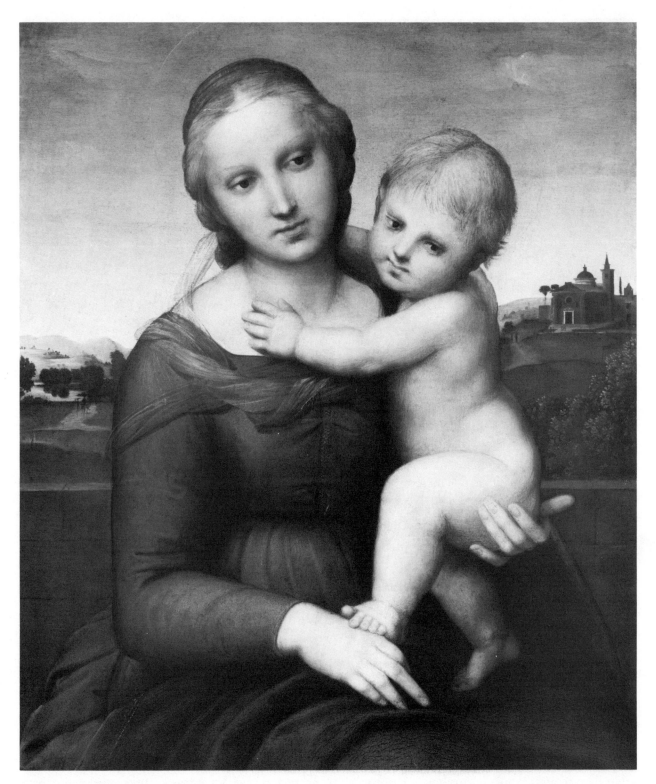

FIGURE 13: Raphael, *The Small Cowper Madonna*, c. 1505, oil on wood, 23⅜" x 17⅜" (0.595 x 0.440), courtesy of the National Gallery of Art, Washington, D. C., Widener Collection.

Raphael enjoyed a much-envied, though well-deserved rank as a great artist in his own time. He was sought after by patrons as well as being highly respected by his peers. The first biographer of the artists, Giorgio Vasari, a contemporary of Raphael's, considered him a "mortal god."[4]

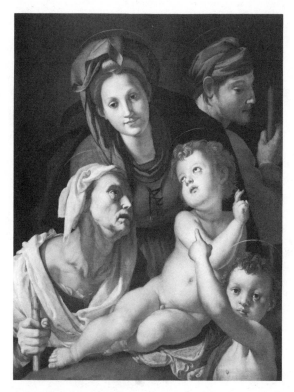

FIGURE 14: Jacopo Pontormo, *The Holy Family*, c. 1525, oil on wood, 39⅞″ x 31″ (1.01 x 0.79), courtesy of the National Gallery of Art, Washington, D. C., Samuel H. Kress Collection.

Following the artists of the High Renaissance came a group called the Mannerists. Mannerism, a label given to this group of sixteenth-century artists, is not a complimentary term. These artists seem to have reacted to the art of the Renaissance by being rebels.

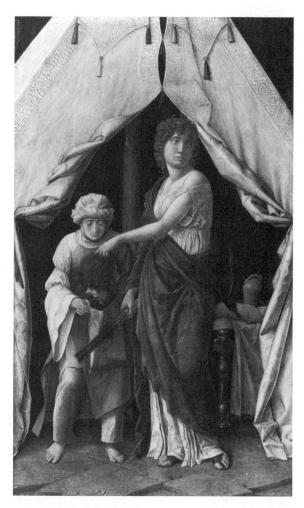

FIGURE 15: Andrea Mantegna, *Judith and Holofernes*, c. 1495, wood, 11⅞″ x 7⅛″ (0.30 x 0.18), courtesy of the National Gallery of Art, Washington, D. C., Widener Collection.

Although Mantegna painted innumerable extraordinary religious works, which are extremely well-composed, delicately rendered, and full of emotion, he was not known to be religious. We can then imagine that his convincing imagery was meant for the soul of his patron and not his own.

some unanswered art historical questions about the purposes of particular works.

In the past, art served ideas outside itself, such as religion, mythology, history, and literature. Painting served patrons, people who commissioned works of art, in the form of portraiture, religious altarpieces, icons, or narratives (*see* figure 15). For many centuries, especially in Italy, the church and the nobility were the major patrons of the arts. The royalty and churches of other countries patronized the arts as well, at times importing artists from other countries, so that the intention of the artist was mixed with the wishes and needs of the

patron. In the seventeenth century, particularly in Holland, middle-class members of society became patrons of the arts. This mixing of intentions, between artist and patron, could become inseparable and even quite specific. Contracts between the artist and the patron could call for particular amounts of different colors, specific dimen-

sions of the canvas, and designate the canvas shape. Or as in seventeenth-century Holland, paintings were created with the general buying market in mind.

Even in prehistoric times, the reasons why images were painted on cave walls are essential to understanding the images. Although we have no recorded information about cave art, its reasons for existence seem to be involved with magic or ritual. The paintings done during prehistoric times have very different purposes from paintings created in civilized cultures. During the early Christian era, paintings were created not only as religious objects, but were used as teaching tools to inform the faithful of biblical stories.

It was not until the modern era that art turned in on itself and addressed issues about art, and art as a philosophical mode (figure 16). It was felt that the formal elements of art could convey pressing questions about reality, spirituality, life, death, love, and hate, as well as express particular philosophies of life.

Style: What is the style of a religious painting? What does that style signify? Before we can discuss the style of a painting, we have to agree on a definition of the word. For our purpose as painters, the appropriate definition of *style* is, ". . . A system of forms with a quality and a meaningful expression through which the personality of the artist and the broad outlook of a group are visible. It is also a vehicle of expression within the group, communicating and fixing certain values of religious, social, and moral life through the emotional suggestiveness of form."[5]

In other words, *style* refers to the appearance of the forms within a painting, the common factors that make up that work.

The style communicates the philosophies of an artist or time period. So if we choose to paint in a style that emphasizes light and shadow or in a style that emphasizes line, we say something about our own ideologies.

Stylistic observations allow us to understand the various ways we communicate to others through the medium of painting. If we examine the formal elements that comprise a work of art, ignoring the subject matter for a moment, we can analyze the way in which the formal elements are chosen and composed to determine the work's style.

Many critics and art historians have written about stylistic analysis. In the 1920s, one art historian, Heinrich Wölfflin, systematized art analysis by setting up several pairs of comparative terms in his book *Principles of Art History*.[6] Wölfflin's terms enable us to approach painting in a didactic way so that we can establish a working vocabulary with which we can analyze paintings.

Wölfflin's Terms

Linear Versus Painterly

Linear applies to paintings that make extensive use of line to describe forms. They emphasize figures and all other important forms with clear outlines and boundaries. (All the forms, figures, or inanimate objects seem as though they could easily be cut out of the painting with scissors [*see* figure 17].) Raphael's painting *The Marriage of the Virgin* (plate 3) is linear. Each figure is separate from the other; they are clear, complete, and sculptural forms, not obscured by light, shadow, or brushstroke.

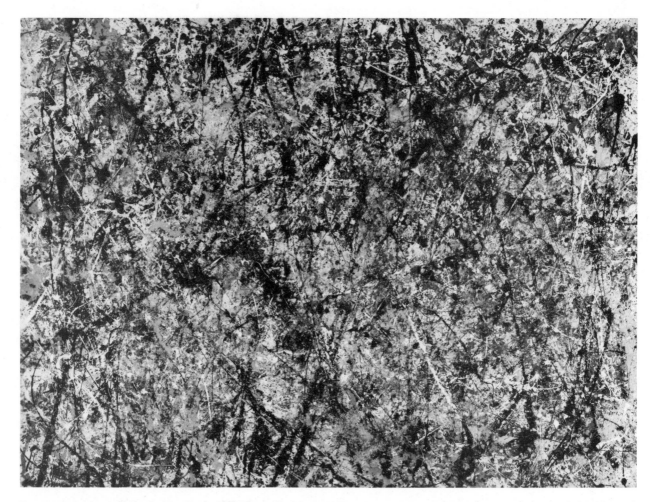

FIGURE 16: Jackson Pollock, *Number 1, 1950* (*Lavender Mist*), 1950, oil, enamel and aluminum on canvas, 87" x 118" (2.210 x 2.997), courtesy of the National Gallery of Art, Washington, D. C., Ailsa Mellon Bruce Fund.

Art turned in on itself in the twentieth century. Art could be about art and the artist. It did not have to serve patrons, churches, or anything else. Human energy, consciousness, and feelings could be expressed by the dynamics created between the formal elements of the painting medium and the actions of the artist. The limits of the painting medium were expanded. Artists could drip paint onto unprimed canvas if that action better expressed their deepest inner feelings or ideas. Is this work religious or spiritual? Could it be a modern-day icon? It is certainly not a representation of a Christian or Judaic image or narrative. Its spirituality lies in the way in which it records the search for an individual human spirit or soul.

The *painterly* style opposes the *linear* in that the forms seem to be fused together, joined. Clear outlines are lost in light, shadow, and apparent brushstrokes. In Ruben's painting *Prometheus Bound* (plate 4), the bird seems to merge with the tree, and we generally have trouble finding the beginnings and ends of forms (the limits of forms). (Due the limitations of any printing process, reproductions of linear works of art lose some of their clarity and outlines, and painterly works become more clear. We really should utilize these terms in front of original works in museums and churches.)

Planar Versus Recessional

The term *planar* comes from the word *plane* and suggests that the main elements of a painting are arranged in planes that are

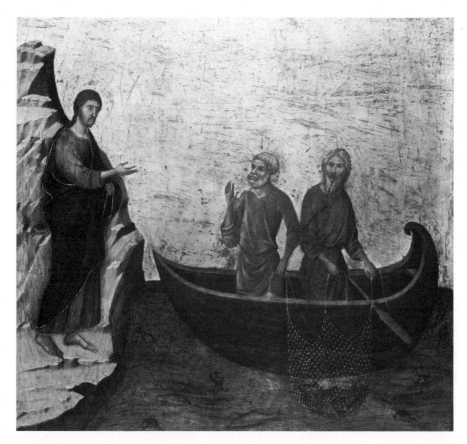

FIGURE 17: Duccio di Buoninsegna, *The Calling of the Apostles Peter and Andrew*, wood, 17⅛″ x 18⅛″ (0.435 x 0.460), courtesy of the National Gallery of Art, Washington, D. C., Samuel H. Kress Collection.

Notice how clearly and distinctly each figure and object is rendered in this linear work. The emphasis on the edges of forms defines a work as linear. (Note: Although some modern artists did literally outline and separate forms with lines, earlier paintings, such as this one, make use of clear and distinct edges rather than outlines.)

parallel to the picture plane. A plane is a flat surface and the picture plane is the front surface of the canvas. None of the major elements penetrate the picture plane, move in front of it at an angle. If we look at Raphael's *The Marriage of the Virgin* (plate 3), we can see that the picture plane, which is the plane closest to us, acts as an unbroken front plane. The figures, forming a horizontal frieze, are parallel to the picture plane. Even though some of the figures in the front of the group seem to be turned inward, their individual body gestures are diminished by their linkage with the frieze grouping. The building in the background is also parallel to the picture plane. In fact, in this painting the picture plane is almost like a windowpane; we look through it at a stable arrangement of forms.

In contrast, Rubens's *Prometheus Bound* (plate 4) establishes diagonal movements within the forms, which move against the picture plane. The figure of Prometheus and the bird are at angles to the picture plane, creating recessional movement and depth.

Although both paintings have depth, it is the different ways in which they establish

the depth that we are distinguishing. The fact that one plane can exist and stand behind another implies depth. In Raphael's painting, the use of perspective and the turning inward of several of the front figures invites our eyes into the work. The use of diagonals by Rubens is different from the use of diagonals in Raphael's perspectival schema. The diagonals that comprise the perspectival lines of the floor plane in the Raphael are stopped by the parallel plane of the building, whereas the diagonal movement of the forms in the Rubens joins together to establish the depth.

Closed Versus Open

The terms *closed* and *open* refer to the way in which the elements of a painting relate to the edges of the container (the edges of the canvas). If the internal elements in a painting echo the vertical and horizontal edges of the canvas, then the painting is called closed. If the elements of a painting deny the boundaries of the canvas (container) then the painting is open.

Notice that the figures in the Raphael (plate 3) are generally vertical movements, and the general form and the details of the building are vertical movements that echo the vertical edges of the container. This particular painting has a semicircular top, which is echoed by the dome shape of the building in the painting. The verticals, horizontals, and curves in this work, which repeat this shaped hybrid container (rectangle plus semicircle), create a static, balanced, harmonious feeling.

In comparison, the major movement of the Rubens (plate 4) is a diagonal thrust that moves against the edges of the container. Although the tree in the painting is a vertical and the land is a horizontal, they are overpowered by the diagonal thrust of the figure and bird. The diagonal movements, set against the container's edges, create a dynamic, imbalanced, propulsive feeling.

Multiplicity Versus Unity

Wölfflin explains that in both these styles unity is paramount, for all great works of art are unified. It is the way in which they are unified that concerns us. The painting that employs *multiplicity* allows its individual forms to maintain a certain independence from one another. In other words, we do not lose any forms; each one is a distinct part of the composition. On the other hand, paintings that utilize *unity* are perceived holistically, in a single gestalt vision. We see the whole before we see the parts. This set of terms refers to the way in which individual forms are conceived by the artist and perceived by the viewer.

A viewer looking at *The Marriage of the Virgin* (plate 3) would progressively look from one form to another. A viewer looking at *Prometheus Bound* (plate 4) would first perceive the painting as a whole. Please note that the elements of line, light and shadow, and color are the contributors to this set of stylistic differences. So we can see all Wölfflin's terms seem to interrelate. The Renaissance painting, by Raphael, is linear, planar, closed, and utilizes multiplicity. The baroque painting, by Rubens, is painterly, recessional, open, and utilizes unity. It would seem certain elements of style go hand in hand. The Renaissance painting makes use of diffused light, clear outlines, static composition, and distinct forms. The baroque painting uses strong directional light, obscured forms, dynamic diagonals receding into depth, and an overall gestalt reading.

Choosing Your Own Style

Style signifies the personality of the artist or the outlook of a group; it reflects religious, social, or moral values. How can you choose a style that is right for you and reflects your beliefs?

José Ortega y Gasset, in his brilliant essay entitled "On Point of View in the Arts," explains ways of examining works of art in terms of the painter's point of view.[7] He says the point of view of the artist in relation to the thing seen by the artist has changed through different time periods; this change reflects artists' views about themselves in relation to the world. The different points of view are manifested as styles. Ortega y Gasset's essay reveals the many possibilities of expressing meaning through art.

The artists of the Quattrocento and Renaissance, whose paintings are described by Ortega y Gasset as using "proximate vision," obviously felt a need for the tangibility of forms. Paintings that use "proximate vision" have all images rendered in focus and in detail, no matter where they are located in space. It allows us to see everything up close and clearly, no matter how close or how far it is in relation to us.

Iconography, or symbolism, was an important part of these religious paintings, and in order to "read" the symbolic objects and figures in their paintings, we need clarity and detail. *Madonna and Child With Saints in the Enclosed Garden* (plate 5) by the Master of Flemalle, has an enormous amount of symbolism. The flowers, book, sword, colors, and figures all relate to the lives of the Virgin Mary and Christ. The proximate vision allows us to "read" their meaning, recognize, and scrutinize the iconography.

Not only does proximate vision allow us to read symbols, it gives the forms in the painting a solidity and mass associated with reality. This is not what art historians label *realism* or *naturalism* in the nineteenth century, but it certainly is another kind of realism. It entreats our sense of touch and knowledge of the mass and solidity of forms. Viewing audiences of those time periods were probably awed by the realism of the period's paintings.

What does the style of proximate vision signify? Very generally, it was used by artists who wanted to render the world in the most clear, distinct, and tangible way possible. The solidity of each painted form lends believability to the existence of the objects, so we feel we could touch them, trace them with our fingers, feel their bulk or mass. If we, as the audience, could perceive their paintings as corporeally as they were rendered, the religious narratives would be that much more real for us, a real part of our world and not out of our reach.

Late sixteenth- and early seventeenth-century artists were involved with the investigation of vision, their own vision and the visual world. The study of optics, the grinding of lenses, and the making of instruments with lenses, which allowed people to see beyond their normal vision, were all being investigated in their lifetimes. Because no artist creates in a vacuum, they were part of this investigation. As a result, this style emphasized light, and the artists' point of view moved away from proximate vision. Instead their style, called "chiaroscuro," uses extremes of light and dark relationships to create volume. The chiaroscurists, such as Caravaggio (plate 6) and Georges de La Tour (figure 54), utilized an extreme unidirectional flow of light. Use of light in paintings to act as a compositional unifier appeals to our sense of sight.

The middle of the seventeenth century brought a new point of view. The artist no longer focused on the thing seen, but on the space between the thing seen and his or her own eye. This point of view manifests itself in a style Ortega y Gasset calls "distant vision," which yields a great deal of atmosphere, one point of focus, with all surrounding elements obscured. Wölfflin would describe this style as painterly (*see* figure 18).

The nineteenth and twentieth centuries brought new points of view and new styles. The impressionists (plate 7) and the cubists (figure 19) moved further away from the thing seen, internalizing the act of seeing. They imposed ideas about perception and reality on what they saw. The nineteenth century and early twentieth century, the times of impressionism and cubism, were

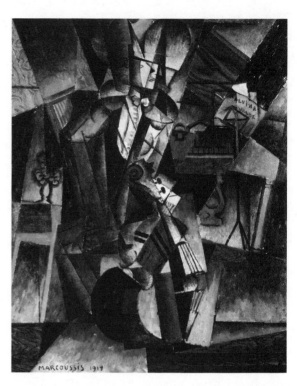

FIGURE 19: Louis Marcoussis, *The Musician*, 1914, oil on canvas, 57½″ x 45″, courtesy of the National Gallery of Art, Washington, D. C., Chester Dale Collection.

Cubism is not merely a decorative style or look. As a style, it embodies a philosophical attitude toward reality and perception that was shared by painters, sculptors, writers, philosophers, and poets of this time period.

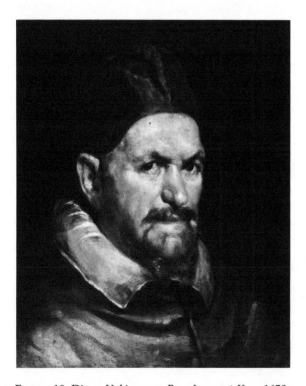

FIGURE 18: Diego Velázquez. *Pope Innocent X*, c. 1650, oil on canvas, 19½″ x 16¼″ (0.49 x 0.42), courtesy of the National Gallery of Art, Washington, D. C., Andrew W. Mellon Collection.

also times of investigation. Visual theories about color were being published and read. Science, technology, and art came closer together than ever before. The church and royalty were no longer major patrons of the arts. Established academies of art were challenged by avant-garde artists. Artists recognized the freedom of artistic expression and went with it—art could be about art and the artist. The retraction from the thing seen to the self (the artist's thoughts and feelings) became paramount in the 1940s and 1950s in New York, during the era of abstract expressionism. Artists no longer looked at the outside world for

perceptual information; they turned inward for their subject matter.

> First things are painted; then sensations; finally, ideas. This means that in the beginning the artist's attention was fixed on external reality; then, on the subjective; finally, on the intrasubjective. These three stages are three points on a straight line.[8]

What is the style of art today, in the late twentieth century? Anything goes! It seems that respectable artists are tackling a multitude of styles and media. Well-known artists have changed styles once (or more) in their public careers. If we were to take a trip through Manhattan's galleries, uptown and downtown, we would find artists creating superrealist images, painterly narratives, abstract art, conceptual art, idea art, earthworks, performance art, crossover art (music and art), video art, religious art, neoexpressionist art, in short, art of every style, old and new. The late twentieth century has seen the expansion of art past painting and sculpture; art has a new expanded definition to include all the above and more.

How do you choose your own personal style? Some might tell you it comes naturally, through practice, and others might say it should be a deliberate choice. The answer lies in both; we all have affinities toward certain styles, whether linear or painterly, proximate vision or distant vision. Some good painters never study art criticism or history and are intuitive artists; they develop on their own. It seems sad, though, that they might never know where they stand in the history of time or really understand how their works communicate to others. Making the most of your art requires a mastery of technique and style. Personal style results from intuition and research, practice and knowledge.

2 How an Artist Sees the World

PART I: A NEW WAY OF SEEING

If we assume art's and religion's concerns are separate, we miss out on an incredibly intense spiritual experience. The separation of studies at all levels of schooling has left us with knowledge in and of many distinct disciplines, but few academic courses and few teachers demonstrate the interrelatedness of different disciplines. In specific terms, if art is a medium with learnable theories and skills, and that is all, then it is limited to addressing issues about itself. But if we see art as a tool that can be utilized to address religious values, concerns, issues, symbols, and ideas, then we have a medium with ethical, moral, and symbolic implications.

One central concern in the study of art is the study of seeing, learning how to see the world as form, color, shape, texture, and light and shadow. If we can learn that the reexamination of the physical world on an artist's terms is not disconnected from learning to see the world through one's religion, we can learn to see so much more intensely. For example, if we analyze the shape of a tree and then compare it in scale to the shape of a plant, are we not studying God's architecture? God's creations in the plant kingdom each have distinct designs that can be analyzed with an artist's formal language. This artistic analysis not only allows us to see the physical world more actively, but brings us closer to God's architectural plans for this kingdom and for the universe. Not always will direct connections be made in this text between active seeing and religion; the artist's language is presented to you so that you may make your individual connections.

How Do We Begin to See Actively?

Like all artists, the religious painter must learn to see the world as form, that is,

shape, color, volume, light, and shadow. As children, most of us were trained to see the world through the use of language. For example, our mothers and fathers would point to a tree and say, "That is a *tree*, can you say *tree*?" They wouldn't say, "That is a vertical, brown tubular shape with a varied green semicircular top that is bathed in light and shadow." Although this is an accurate description, we would have never learned the language if they had not labeled objects for us. At the same time, that labeling process disconnected our vision from actively seeing the world. As artists we must learn to see beyond labels; we must actively look at the particular shape, color, and volume of things in the world. Not only will this attitude toward seeing enable us to draw and paint with greater accuracy, it will enhance our sensitivity, not only visually and perceptually but also in our religious experience.

There are several elements involved in the process of active seeing: calculating dimensions (size, scale), measuring distances and positive or negative shapes, understanding proportions, understanding point of view and foreshortening, and reading light, shadow, and color. Without this understanding, our religious paintings will lose their meaning as expressions of religious experience.

To calculate dimensions, we have to make comparisons between the forms of objects. If we are drawing a vase and an apple, then we have to make several visual decisions:

1. Which one is bigger? Which one is smaller?
2. How much smaller is one than the other?
3. How tall are they in relation to each other? In other words, where does the top of the apple fall in relation to the vase?
4. How wide is one in relation to the other?
5. Which one is in front of the other? Or are they next to each other?
6. Where are they in relation to the front of the table they are sitting on? to the back of the table?
7. Do they make positive and negative shapes with each other? Are there drawable negative shapes between them?
8. What is your point of view? Are you looking straight at them? Are you above them? below?
9. Are you seeing them in their true, full form? or in foreshortened form?
10. Are they both receiving light? shadow? Is one casting a shadow on the other?
11. Are they both casting shadows on the tabletop?
12. What is the difference in color between the two objects, specifically, hue, value, and chromatic differences?

This all might seem obvious. You might think, *Oh, I know what an apple looks like. . . . I know how big it is and what shape it is.* But the main point is all apples are not alike. This exercise teaches you to draw what you see and not what you know to be! Really look at what you are drawing.

PART II: THE TRANSLATION OF SPACE

The page you draw on and the canvas you paint on are flat. If you choose to use things in the real world as models for your religious work, you must learn how to translate real space and three dimensions

into the illusion of space on the two-dimensional surface.

A plane is a flat surface, and the flat surface of the page we draw on or the canvas we paint on is called the "picture plane." If we draw vertical lines or horizontal lines on these surfaces, we maintain the flat surface, because we are simply repeating the edges of the rectangle. If we draw diagonal lines and connect them with horizontal and vertical lines, we create tilted planes on the surface; and we begin to create the illusion of space (figure 20).

In traditional linear perspective, which was very popular with religious painters of the Renaissance, we can indicate spatial depth by the convergence of parallel lines toward a vanishing point (the point at which parallel lines seem to converge and then disappear from the viewer's sight). We understand that diagonal lines represent the convergence of lines in space. Perspective, which is a schematic way of translating three-dimensional space onto the two-dimensional surface, is based on the idea that diagonals moving toward a vanishing point or vanishing points will imitate the recession of space into the distance and create depth. Early Renaissance artists used perspectival schemas to represent rational interior and exterior spaces and environments. These artists understood simple and elaborate perspectives; they used these schemas to control the relationships of figures and objects in space. Perspective afforded them a way of creating logical, rational, balanced, controlled, and ideal representations of the real world. Why? All things and people had a place in the rational perspectival world. Linear perspective could convey to the viewer the position of the artist in relation to the painted work, that is, how close the artist was in relation to

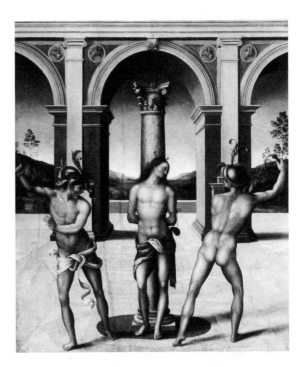

FIGURE 20: Bacchiacca, *The Flagellation of Christ*, wood, 22" x 18⅞", courtesy of the National Gallery of Art, Washington, D. C., Samuel H. Kress Collection.

If we create the illusion of tilted planes on the two-dimensional surface, we also create the illusion of space. Renaissance artists, particularly in the early fifteenth century, were concerned with depicting logical, rational, and believable spaces. Although ancient Roman artists also created illusionary spaces in paintings, it was not until the fifteenth century in Italy that a true system for single-point perspective was worked out and written down.

Bacchiacca's setting for the flagellation utilizes a tilted plane (the ground plane), which is at an angle to the picture plane, to create depth. All lines of perspective move toward one vanishing point. If we look at the lines on the floor and the tops of the columns that support the arches, we can see how they act to create space. The front of the columns and the figures are parallel to the picture plane, whereas the ground plane is tilted in relation to the picture plane.

the things seen, as well as the eye level of the artist. Could perspective have been a tool that allowed Renaissance artists to reconcile religion and the natural sciences? Most later artists abandoned rigid systems

of perspective for looser methods of translating spatial depth, based on perception and the visual reading of recession and space. We can call this *perceptual* perspective (figure 21). (It is sometimes called "eyeballing.")

The later artists used what they had learned from looking at paintings that utilized perspectival schemas and realized that the illusion of space could be created

without the strict ratios of *linear* and *atmospheric* perspective, yet still imitating its basic principles.

The Basic Principles of the Creation of Depth

Size and Scale. Forms that are close to us appear to be larger than forms that are further away from us. As forms move into

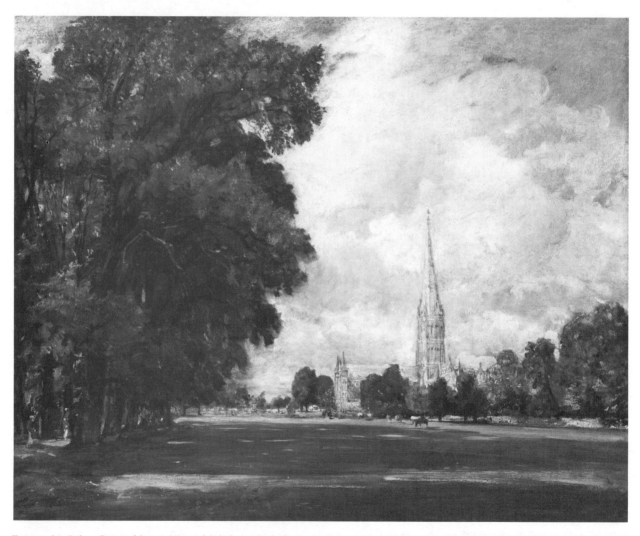

FIGURE 21: John Constable, *A View of Salisbury Cathedral*, oil on canvas, 28¾" x 36", courtesy of the National Gallery of Art, Washington, D. C., Andrew Mellon Collection.

Most modern artists, such as the nineteenth-century British artist Constable, abandoned rigid perspectival schemas in favor of perceptual perspective. They were able to establish a convincing ground plane and recession into space without utilizing a formal perspectival geometric grid or a perspectival formula. The "eyeballing" of the space went hand in hand with the natural depiction of the hues, values, and chromas of the imagery seen in the real world.

the distance they become smaller and smaller. In Raphael's *The Marriage of the Virgin* (plate 3), we can see how figures in the distance are smaller than the figures closest to us in the picture's space.

Point of View. Our point of view is determined by our position and the angle of our vision in relation to the thing seen. For example, we know that a television has a top, bottom, and four sides. Our position in relation to the television would determine how many of its sides we would be able to see from any one given point. If we were above it, we would see its top. If we were far away from it, we might see two or three sides. The schema of perspective allows us to represent forms as they appear to the eye from different points of view as well as in terms of distance and depth. In plate 3, we face the facade of the domed building. We· cannot see its sides in full or its back, because of our point of view.

Eye Level. Eye level determines whether we can see the tops, bottoms, or centers of forms. We must determine whether our eye level is above, below, or centered in relation to what we see or the space we are creating. In the *Conversion of Saint Paul* (plate 10), by Caravaggio, we know our eye level is above Saint Paul, since we can see across the top plane of his reclining body.

Convergence. If we drew a box, we would represent the front as being wider than its back. In reality the front plane of a cube is parallel and equal to its back, but visually on the surface of the canvas we depict the back plane of the cube as smaller, narrower. The cube follows the visual laws of perspective; the parallel lines that comprise its planes move toward a vanishing point and appear to converge (rather than remaining parallel).

A good visual analogy is that of railroad tracks. We know they run continuously parallel in reality. However as we look at the tracks in the distance, they seem to converge along the horizon (the imaginary line where the sky meets the land or water). Visual perspective imitates this illusion and creates convincing spaces.

Foreshortening. When we cannot see the total length of a form because of our point of view, that form is foreshortened. We draw the form, reducing its length or parts in order to create the illusion of depth and distance. For example, if we wanted to draw an arm that is perpendicular to us, we would reduce the true length of the arm to the perceived length.

In plate 10, Saint Paul's torso is foreshortened. We do not see the true full length of his body, because of our point of view.

Atmospheric Perspective and Clarity. Forms that are closer to us are in sharper focus than those that are farther away from us. Objects and figures lose detail and clarity as they move away from us into the distance. We call this visual law atmospheric or aerial perspective.

Atmospheric Perspective and Color. Hues are brighter and values have more contrast when they are close to us; they become grayer and grayer as they move away from us into the distance.

Drawing What You See Versus Drawing What You Know to Be

When painting perceptually, from life, we must draw or paint what we see, and not

what we know to be there. For example: If two small children sitting across a table from each other are asked to draw each other, they will probably draw legs as well as upper bodies. This occurs because they are drawing from what they *know to be* there, to exist, and not what they really *see*. They can't see the child's legs, but they know they are there. The children draw from their minds' eyes rather than from vision.

All beginning students tend to draw what they know rather than what they see. They tend to tilt up the top planes of tables, because they know tables have tops. We would only see the entire top planes of tables if we're standing directly over them, seeing them from a bird's-eye view. From a sitting position, we would see the top plane moving back into space. Remember to draw or paint what appears to the eye rather than what you know it to be, in order to create a convincing illusion (figure 22).

Before you can paint religious works, you need to become proficient at some basic elements of art. Once you have learned them, we will move on to putting symbolism in paintings. Begin with some exercises on perspective.

Exercise 1: Drawing a Tabletop

1. Draw the front horizontal of a tabletop.
2. Estimate the distance between the front horizontal and the horizontal line depicting the back of the table. Draw the back of the table as a horizontal, estimating the visual distance between it and the front horizontal.
3. You can best estimate the visual distance by comparing it to other information around it. All objects in space

should be seen in relation to all surrounding things. Compare the distance between two points to a distance that is easy for you to estimate. For example, it might be easy for you to estimate the height of a vase in your setup. Compare other distances or heights to the height of the vase. It is easier to determine or "read" the distance of an object by comparing the distances between the two horizontals of a plane.

4. Now estimate the length of each of the horizontal lines.
5. Connect the two horizontals with diagonal lines.
6. You've created a diagonal plane that recedes in space.

You can also use vertical and horizontal lines as devices to help you see where things fall in space (*see* figures 23, 24).

Exercise 2: Drawing a Room Space

1. Divide your page into four quadrants, using a vertical and a horizontal line.
2. The horizontal line that divides the page in half will represent the place where the floor meets the wall.
3. Anything above that line will be drawn in the quadrants above the drawn horizontal and the bottom of any object on the floor will be drawn below the horizontal line. If the objects on the floor rise above the line where the wall meets the floor, they will move into the upper quadrants.
4. Place a broomstick or any vertical object in the middle of the room space. This will represent the vertical line that divides the page in half.
5. Anything in the room that is to the right

FIGURE 22: William M. Harnett, *My Gems*, oil on wood, 18" x 14" (0.457 x 0.355), courtesy of the National Gallery of Art, Washington, D. C., Gift of the Avalon Foundation.

The side of the table that is parallel to us is established as the picture plane. Therefore, the sheet music that hangs over the table's edge is in front of the picture plane and in our space. This illusionary space is called *trompe l'oeil*, a French term meaning "to fool the eye."

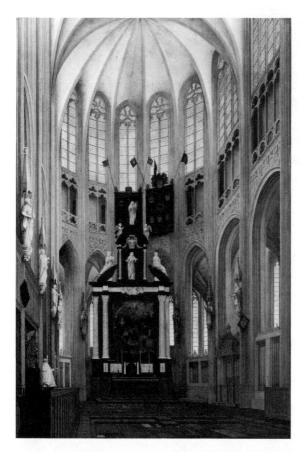

FIGURE 23: Pieter Jansz Saenredam, *Cathedral of Saint John at 's-Hertogenbosch*, oil on wood, 50⅝″ x 34¼″ (1.288 x 0.870), courtesy of the National Gallery of Art, Washington, D. C., Samuel H. Kress Collection.

The wonderful illusion of a three-dimensional interior space is created by Saenredam, using detailed line drawings that were usually drawn on sight and scaled up to wooden panels, utilizing many plans and ratios. Saenredam painted many churches; but he seemed to prefer the clean, simple look of Protestant churches.

 of the stick will be drawn to the right of the vertical line (or in the right quadrant).

6. Anything in the room that is to the left of the stick will be drawn to the left of the vertical line (or in the left quadrant).

Exercise 3: Drawing a Still-Life Space

You may want to use graph paper to try this drawing experiment. It will give you an extra way of measuring space; you can count boxes to form distances.

1. Divide your page into four quadrants, using a vertical and a horizontal line.
2. Set up a still life on a table against a wall.
3. The line created by the back of the table, where it meets the wall, will be repre-

FIGURE 24: Hans Memling, *Madonna and Child With Angels*, c. 1480–1494, oil on wood, 23⅛″ x 18⅞″ (0.588 x 0.48), courtesy of the National Gallery of Art, Washington, D. C., Andrew W. Mellon Collection.

Memling provides us with two strong vertical lines that comprise either side of the Virgin's throne. We could use these lines to divide the space. We can also see the floor line, which divides the space in half. The combination of vertical lines and the floor line allows us to see where the figures, objects, and architecture fall in the space.

sented by the horizontal line that divides the page in half.

4. The bottoms of objects that sit on the table will be drawn in the quadrant below the horizontal line.

5. When the objects go above the horizontal line, they will be drawn in the quadrants above the horizontal line.

6. Place a vertical object in the middle of the setup. This will represent the vertical line that divides the space in half.

7. Any object to the right of the vertical object will be drawn in the right quadrant.

8. Any object to the left of the vertical object will be drawn in the left quadrant.

This device allows you to see where objects are in relation to one another in space and how they can be translated onto the page. After a while this device becomes unnecessary, because you learn to divide up the space simply by looking at it. Such analytical looking allows you to create believable illusions on the canvas.

Now that you can place objects in their proper places on the canvas, you're ready to deal with some more complex elements of composition.

3 Composition

We've already considered how art, as a tool or language, can embody religious ideas, concerns, and issues. But how do religious beliefs and the formal language of the medium of art relate to each other?

Not all religious people are intellectuals or academics, so the structure of religion may not be an important concern to them. Structures, whether in English composition or chemistry, are studied in depth by those with academic or intellectual inclinations. Not all religious people need a degree in theology in order to practice their faith, but they must be aware of the inherent structures within their religion.

In the realm of art, if one is to be a painter, one must want to be a painter (have the spirit) and believe in the credibility of the painting medium. But to be a good or great painter, one must study the given structures, theories, and history of painting (have the intellectual knowledge). This study can be done in a school or on one's

own; it doesn't matter which. What *does* matter is that an interrelationship be seen between the painter's spirit and the painter's language. This does not mean you must master the structures of painting (which we will call composition) in order to paint; you must simply be aware of them.

When we can give homage to all aspects of a discipline, to its spirit, intellect, and creativity, we can begin to see that the study of one discipline has connections to the study of others and that the language of one discipline, such as painting, can embody or integrate the experience of another discipline, such as religion (*see* figures 25, 26).

THE BASICS OF COMPOSITION

Composition can be defined as the organization of elements on the two-dimensional surface. We organize these component parts: color, line, shape, light, shadow,

FIGURE 25: William Blake, *Job and His Daughters*, c. 1823, oil on canvas, 10¾″ x 15⅛″ (0.273 x 0.384), courtesy of the National Gallery of Art, Washington, D. C., Rosenwald Collection.

Blake certainly had the painter's spirit and the painter's knowledge. Together with his spiritual zeal he created some of the most moving, unusual images of the nineteenth century.

texture, and brushstrokes. Our elements should communicate religious and spiritual subjects and beliefs, affect the viewer, aesthetically please the viewer and ourselves, and explore the potential of the painting medium to its fullest as a vehicle for self-expression and communication.

Understanding and executing successful compositions require a knowledge of design. The basic theories we should know are those of:

1. The container (the shape of the canvas or page)
2. Balance
3. Unity
4. Positive and negative space
5. Scale

The Container

We call the page or canvas the container. It contains the meaning and forms we create. Most often, we use a rectangular container, so that we begin with a form that is made up of two vertical lines and two horizontal lines. As artists, we have a responsibility to work with and respond to the given edges of the container, whatever shape that may be. When we paint a line on a rectangular canvas we actually create a fifth line, since the four edges are a given, active element.

In modern times, artists who paint reli-

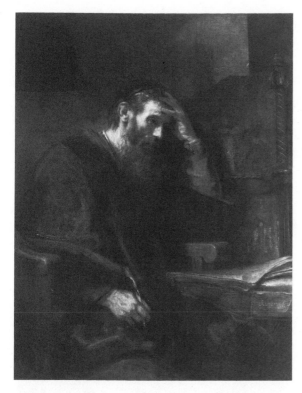

FIGURE 26: Rembrandt van Rijn, *The Apostle Paul*, probably 1657, oil on canvas, 50¾" x 40⅛" (1.29 x 1.02), courtesy of the National Gallery of Art, Washington, D. C., Widener Collection.

Rembrandt combined his faith with the imagery of the Dutch seventeenth-century school, to form a unique, essential, thoughtful Protestant art. He studied his national heritage of art, his Protestant faith, and the art of other countries and religions.

gious or spiritual works use all sorts of shaped canvases. Most religious painting prior to the modern era was done on rectangular or round canvases. The rectangular canvases varied in proportion, so it is worth distinguishing the different types. *Regular rectangles* (figure 27) are not extremely prolonged in any direction. They can be held either horizontally or vertically. Squares would fall into this category. *Vertical extensions* are rectangles extremely prolonged in a vertical direction (figure 28). The vertical extension can be used to communicate an extended field of vision. It can symbolically express a move

from bottom to top or top to bottom, as well as giving a sense of continuity of extended space.[1] *Horizontal extensions* are rectangular canvases prolonged in a horizontal direction (figure 29). They have traditionally been used for religious narrative painting.

Round canvases are called tondos (plate 8). The tondo is particularly appropriate to gentle themes such as the Madonna and Child. It acts as a loving embrace of the imagery. The obvious quality of the tondo is its undeniable power of expressing not just the gentle embrace, but the all-encompassing omnipotence of God himself. Like a square, a tondo is a perfect unit. *Shaped canvases* can be hybrid formats; for example, they may have round tops and rectangular bottoms. They may have geometric edges or free-form curved edges (figures 30, 31).

The marks we make with a brush or pencil respond differently to different types of containers. Lines are generally static when they repeat an edge. For example, if we draw a curved line in a tondo, it will be more static than a straight line. Antithetically, if we draw a horizontal line in a regular rectangle, it will be more static than a curved line drawn in the same container.

Static and dynamic elements are relative to the original container shape. It is possible to force static elements to become dynamic by manipulating other formal elements. For example, we said that vertical and horizontal lines are static elements within a regular rectangle. If we arrange them so they constantly meet at right angles and fill the entire space, they might become more dynamic. *All elements in art are relative.* Rules and theories are meant to be studied and ingested, but remember that they are not rigid restrictions. Allow these guidelines to

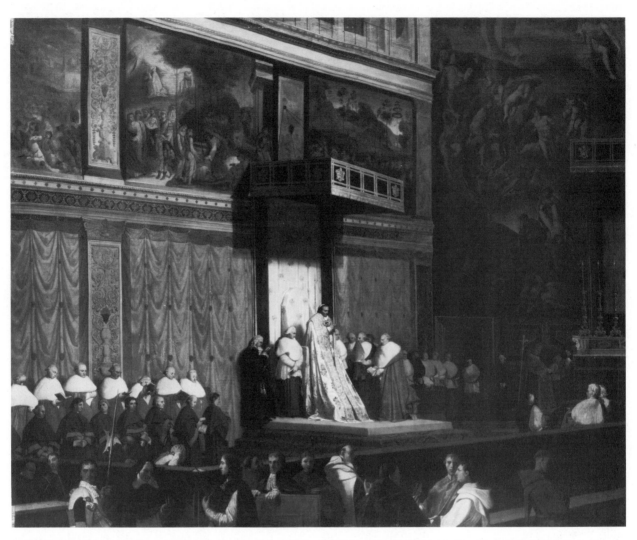

FIGURE 27: Jean Auguste Dominique Ingres, *Pope Pius VII in the Sistine Chapel*, 1810, 29¼″ x 36½″ (0.745 x 0.927), courtesy of the National Gallery of Art, Washington, D. C., Samuel H. Kress Collection.

When we are about to create a painting, we decide upon the shape of the canvas (or container). Our choice of container shape should relate to our subject matter and the feeling we want to communicate. Formal elements of painting react differently in different shaped containers.

This work by the nineteenth-century French painter Ingres is what we call a regular rectangle. Vertical and horizontal lines repeat the edges of this container and are therefore static or calm elements. Diagonal lines and curves do not repeat the edges and are therefore dynamic elements.

act for you as a *general* guide, not as unbendable laws.

Exercise 4: Responding to the Container's Edges

 1. Design four similar shapes within each of the different types of containers, so that you take into account the interac-

tion of particular lines with particular containers.

Balance

Human beings have an inherent understanding of balance. We are able to balance ourselves when we walk, run, dance, skate,

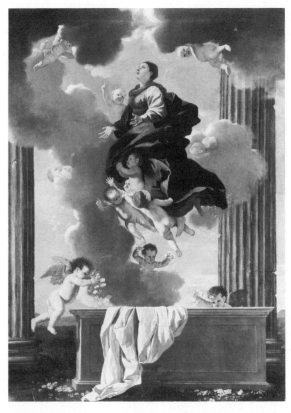

FIGURE 28: Nicolas Poussin, *The Assumption of the Virgin*, c. 1626, oil on canvas, 52⅞″ x 38⅝″ (1.344 x 0.981), courtesy of the National Gallery of Art, Washington, D. C., Ailsa Mellon Bruce Fund.

This container, a *vertical extension*, symbolically can express an upward or downward movement, depending upon the subject. Poussin selected it in order to structure upward motion, which underlies the theme of the Assumption. Vertical extensions have also been used for such religious themes as the descent from the cross, the Resurrection, the Crucifixion, the death of the Virgin, and the Last Judgment. At times, artists create clear divisions within these containers, denoting heaven, earth, and hell, or sky, land, and water.

Since this container is exaggerated in the vertical direction, vertical lines that repeat the given edges of the container are stronger than their horizontal counterparts. Diagonal lines and curves do not repeat the edges and are therefore dynamic.

and exercise. Most people prefer balance to imbalance. If we utilize the state of imbalance in visual arrangements, we should re-

alize we are doing so and it is for a particular desired effect.

The rectangular page or canvas, which we will call the container, is a balanced shape at the outset. We can either maintain or destroy its inherent stability. The container has its own energies, which many art theoreticians have investigated in depth.

Can the right side of a container hold more weight than the left side or vice versa? Can the bottom of a page hold more visual weight than the top? Our answers to these questions will, of course, affect the way in which we balance shapes.

Most people find their eyes the best and final critics in determining whether or not a composition is balanced and whether or not one side can hold more weight than another. Novices judge distribution of visual weight with great success, once the idea of balance is introduced into their design vocabulary. Why? A great part of judging balance relies on instinct. As always, the choice of maintaining or destroying balance should reflect the particular meaning of the religious subject that is chosen. Balance is more appropriate to a depiction of the Visitation than it is to the kiss of Judas. Balance gives a harmonious feeling.

Exercise 5: Understanding Balance

1. Cut seven shapes out of black construction paper (or color in seven shapes on white paper) that are different sizes, ranging from one inch in any direction to five inches in any direction. The shapes may be free form or geometric.
2. Arrange the shapes on an eleven- by fourteen-inch white page, so that:
 • The page appears to have too much weight at the top. The top-heavy

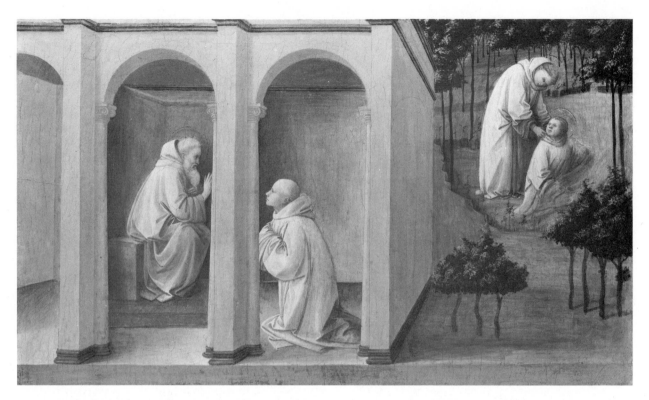

FIGURE 29: Fra Filippo Lippi, *Saint Benedict Orders Saint Maurus to the Rescue of Saint Placidus*, 16⅜″ x 28″, courtesy of the National Gallery of Art, Washington, D. C., Samuel H. Kress Collection.

This container is called a horizontal extension. Western artists have always equated the unfolding of time in pictorial language as moving horizontally. For this reason, horizontal extensions have been used over and over again for narratives and storytelling. Most artists unfolded their narratives paralleling the way we read, from left to right. For example, the first part or event of the narrative would occur at the left corner, the next event in the middle, and the last event at the right. Some artists chose to follow a more arbitrary time sequence as established by position in space. It was common to see the same figures depicted a few times within the same container. Audiences accepted this formula as we accept split-screen images on television.

Since this container is prolonged in a horizontal direction, horizontal lines drawn on the container are more powerful than their vertical counterparts. (Vertical lines can act as dividers of scenes or time shifts.) Diagonal lines and curves are dynamic in this container, since they do not repeat the edges of the container.

composition will be in opposition to your sense of gravity.

- The page appears to have too much weight on the left-hand side. You can achieve this in an obvious manner by simply placing all the forms to the left, but try to be subtle.

 Do the same for the right side.

- The page has all the weight in the middle. Does the page seem to be balanced? Does the center of the page seem to have a lot of carrying power?

- The page has all the weight at the bottom. Does the page seem to be balanced?

- Now that you have seen the weights distributed in an unequal manner, arrange the shapes in the container to achieve balance.

- Please note that you should stand back from your design so that you can see it from a fresh point of view.

- If you think you have achieved balance, glue your shapes to the page.

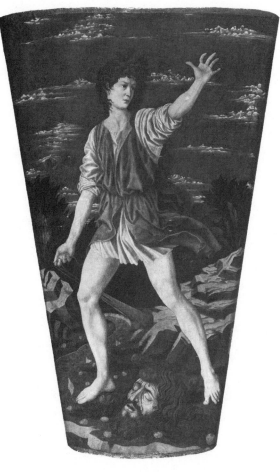

FIGURE 30: Andrea del Castagno, *The Youthful David*, c. 1450, courtesy of the National Gallery of Art, Washington, D. C., Widener Collection.

Shaped canvases can have geometric edges or be free flowing and curved. The reaction of the formal elements within a shaped canvas depends upon the particular shape of the canvas. In this work, although the edges that define the length are diagonals, David's gestures do not repeat the diagonal edges of the container. They are at counterpoints to them, so they create a dynamic feeling.

> Now turn the page upside down. Is it still balanced? Turn it on its side. Is it balanced? Look at it through a mirror. Is it still balanced? Turning the container in different directions allows us to judge our designs or paintings from fresh points of view.
> • Look at old-master paintings and ask yourself if they are balanced (*see*

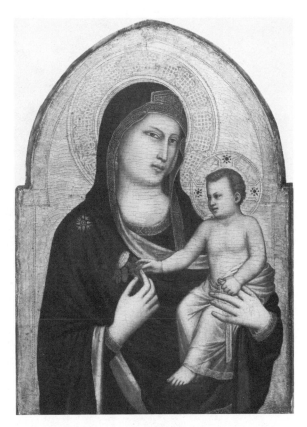

FIGURE 31: Giotto, *Madonna and Child*, probably c. 1320/1330, wood, 33⅝″ x 24⅜″ (0.855 x 0.620), courtesy of the National Gallery of Art, Washington, D. C., Samuel H. Kress Collection.

Late Gothic or early Renaissance altarpieces, for churches or private devotion, were usually shaped similarly to this painting by Giotto. This shaped container could symbolize the arch of a Gothic cathedral or church as well as Mary's relationship to the church.

> figures 32–34). If you believe they are, determine the balancing factors.

Symmetry and Asymmetry

Symmetry is always balanced. It is the equal distribution of mirror-image weights on either side of a vertical axis. If we place a shape on one side of the vertical axis (which divides the page in half), we have to place its mirror image on the opposite side of the vertical axis. Symmetry is an easy

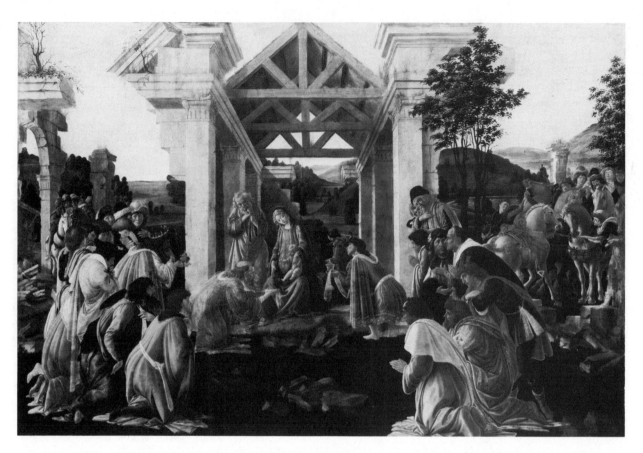

FIGURE 32: Sandro Botticelli, *The Adoration of the Magi*, early 1480s, wood, 27⅝″ x 41″ (0.702 x 1.042), courtesy of the National Gallery of Art, Washington, D. C., Andrew W. Mellon Collection.

way to achieve balance, but it does not always serve our needs, because it tends to be predictable in its appearance. Symmetry can be a symbolic religious statement; it could symbolize people and God or people and the Bible.

We can achieve balance in an asymmetrical composition, that is, without the use of corresponding arrangements on either side of a vertical axis. This is more difficult than using symmetry as a compositional device; we are relying on our eyes to determine balance rather than on a given formula. Elements need not be identical mirror images to balance each other. Can we use this other notion of balance to symbolize the relationship between people and God? between Mary and Christ? between Jonah and God?

Exercise 6: Symmetry and Asymmetry

Materials: black construction paper, two sheets of white paper, pencil, ruler, rubber cement or glue, scissors or a blade.

1. Cut out three different black shapes, and make a pair of each.
2. Divide your paper in half by drawing a vertical axis with a pencil and ruler.
3. Arrange your shapes on either side of the vertical axis to form a symmetrical composition.
4. Glue the shapes down.
5. Cut across the page horizontally, yielding ten even pieces.
6. On a different page, utilizing a vertical axis, arrange the pieces to form an asymmetrical, balanced composition.

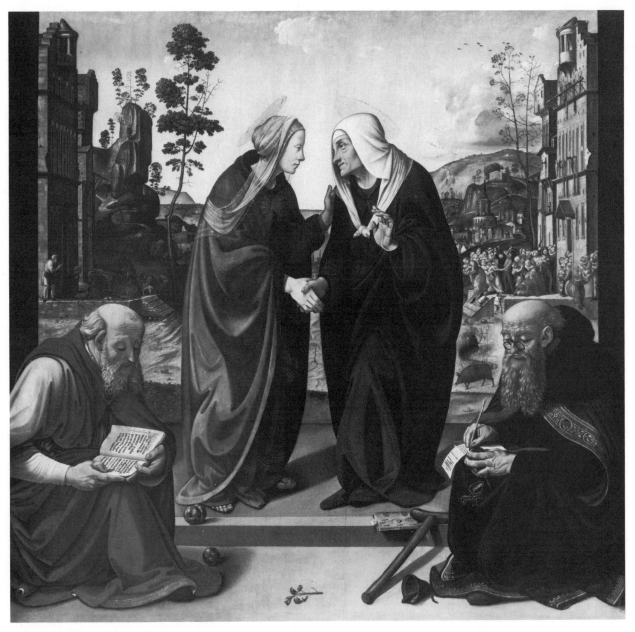

FIGURE 33: Piero di Cosimo, *The Visitation With Saint Nicholas and Saint Anthony Abbot*, c. 1490, wood, 72½" x 74¼" (1.84 x 1.89), courtesy of the National Gallery of Art, Washington, D. C., Samuel H. Kress Collection.

Figures 32 and 33 are clearly balanced. They are not symmetrical, but come very close to being so. Both works have a central vertical unit. The center of *The Adoration* is an architectural setting that embraces the Madonna and Child. Saint Anne and Mary are the center of *The Visitation*. On each side of the central vertical axis, figures balance the opposite side. The desire for balance in the paintings of Renaissance artists goes hand in hand with their interest in rationality, logical space, and man's control over his world. These humanistic interests gave religious subjects a new realism.

Unity

If we ignore the religious subject of a painting, we are left with the formal elements: line, shape, color, light, shadow, size, scale, brushstroke, and texture. These formal elements must be arranged so that they act together to affect the viewer and convey the appropriate feelings or message.

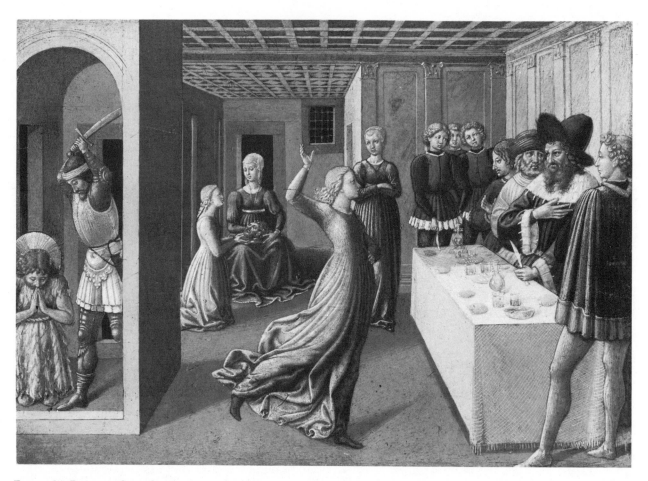

FIGURE 34: Benozzo Gozzoli, *The Dance of Salome*, wood, 9⅜″ x 13½″ (0.238 x 0.343), courtesy of the National Gallery of Art, Washington, D. C., Samuel H. Kress Collection.

How do we organize multiple figures, architectural settings, and assorted objects into a balanced composition, without staying close to symmetry? This artist used a central vertical axis, the central female figure (Salome) as the pivotal center. The table and figures on the viewer's right are balanced by the arch and figures on the left side. Hue, value, chroma, shape, and space all contribute to the maintenance of balance. In organizing elements, we must weigh one color or shape against another. How much visual weight does a color or shape appear to have?

The composition must have some sense of unity.

Unity can be defined as "the establishment of organic connections among the formal elements." Establishing unity among the elements on a canvas is one of the primary considerations of painting. A painting is given a structural life or support when organic connections are made among all the elements, when they seem to be acting toward a common goal or purpose. Unity can be achieved through the use of:

1. Line
2. Light and shadow
3. Color
4. Gesture
5. Parallels and counterpoints
6. Overlaps
7. Brushstrokes
8. Textures or patterns

Line. Line is perhaps the most basic means of creating organic compositional connections. A line, the mark we make with a brush or pencil, is the physical, visible

evidence of our investigation into some-
thing seen or conceived. Whether it is a line
drawn by Michelangelo or one that traces a
child's hand, it is a symbolic proof of human
existence.

Line can relate one form in a painting to
another by virtue of edge, hatching, out-
line, or arabesque.

> *Edge:* Lines can be used to cast strong
> edges behind forms, pushing forms
> forward and back in space.
> *Hatching:* Line can be used as a veil of light,
> in the form of lines that move in a
> similar direction.
> *Outline:* Lines can separate forms to en-
> hance clarity, yet still tie them together.
> *Arabesque:* Lines can act like dancers on a
> stage, creating sweeping, graceful curv-
> ing connections among forms.

Lines are artificial; we do not see them
around forms. We see by virtue of light. So
when we use line as a compositional device,
we employ a method that relates to our
sense of touch, not our sense of sight. Line
touches a form and traces it as though we
were following that form with a finger. Line
can create clear boundaries, yet tie all the
forms in a composition together, simply
because they are all touched in a similar way
(figure 35). Gothic painting, which is at
times thought of as the most intensely
religious period of art, used line as the
major compositional unifier because the
tangibility of the line brings religion closer
to our "touch."

In the Renaissance period, artists such as
Mantegna and Botticelli used line as a
unifying element. Their works have a tactile
appeal and seem to flow, hold together, as
if all forms were conceived together (figure
36). Their use of line was not as severe as

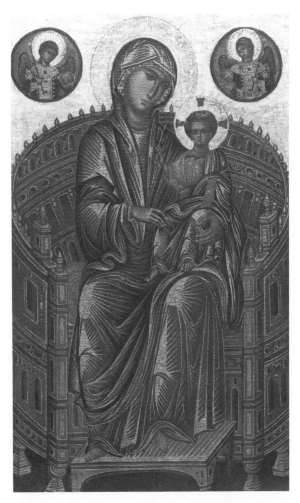

FIGURE 35: Byzantine school, thirteenth century,
Madonna and Child on a Curved Throne, wood, 32⅛" x
19⅜" (0.815 x 0.490), courtesy of the National Gallery
of Art, Washington, D. C., Andrew W. Mellon
Collection.

Artists of the Gothic period used line to establish
forms, volumes, and connections among forms.
Notice that the folds in the Madonna's and Child's
garments are expressed by lines. A light line flows
around the figures, to separate them from the throne.
Continuously moving, winding lines describe folds,
ornamentation, forms, and furniture.

Gothic art's, but it intensely communicates
religious subjects.

Light and Shadow. If an artist establishes
a logical flow of light that touches all the
forms in its path, the light acts as a unifier of

FIGURE 36: Andrea Mantegna, *The Death of the Virgin*, courtesy of the Prado Museum, Madrid.

Mantegna, one of the greatest early Renaissance artists, always used line as an organic unifier in his compositions. Dürer, Rembrandt, and Degas all looked to Mantegna's works for inspiration and information about the painting medium. Each and every line, whether it describes a small fold or a column's edge, has a part in the entire composition. No line is painted for its own sake, but relates to the rhythm of the entire work.

Our eyes move along the tiles on the tilted ground plane, and the feet of the figures in the foreground, the folds in their garments pointing inward, toward the center of the container. The folds on the bed cover act as pointers or arrows, directing our eyes upward or carrying the Virgin's body upward. At the same time we notice the swing of the incense burner and the gesture of the figure holding it, moving us into the space. The candles, palm, halos, columns, three figures behind the Virgin, and candleholders all move our eyes up the space. The open scene allows us to cross over (the bridge) from one space to another, symbolizing a move from one state of being to another.

the composition. The source of the light need not be included in the painting in order to be understood. The viewer assumes that there is a window or artificial light source outside of the painting's perimeters. Painters who utilize a clear continuous light flow usually throw the light from the left or right side. Lighting a subject from the top or bottom is unusual and would create an atypical effect. Edgar Degas, a nineteenth-century French painter, enjoyed using a bottom light source in his paintings of ballet dancers on the stage; this would, of course, remind us of stage lighting.

Light and shadow as compositional unifiers appeal to our sense of vision. Light enables us to see form, mass, and color. This compositional device became very popular in the seventeenth century and has remained as one of the major methods of natural or representational painting. Artists such as Caravaggio, a seventeenth-century Italian painter, Vermeer, a seventeenth-century Dutch painter, and Velázquez, a seventeenth-century Spanish painter, all utilized a strong flow of light to unify their compositions and represent their type of vision (figures 37, 38). This natural technique gives corporeality to religious subjects. Some viewers want to relate to religious subjects by understanding them through the use of a natural-looking language of form.

Color. There are innumerable theories of color, and we should be sensitive to the power of color as a compositional unifier. We can orchestrate color to lead our eyes around the canvas or create a color harmony that produces a unified appearance or visual effect.

Color orchestration. If we think of the way different instruments in a symphony or-

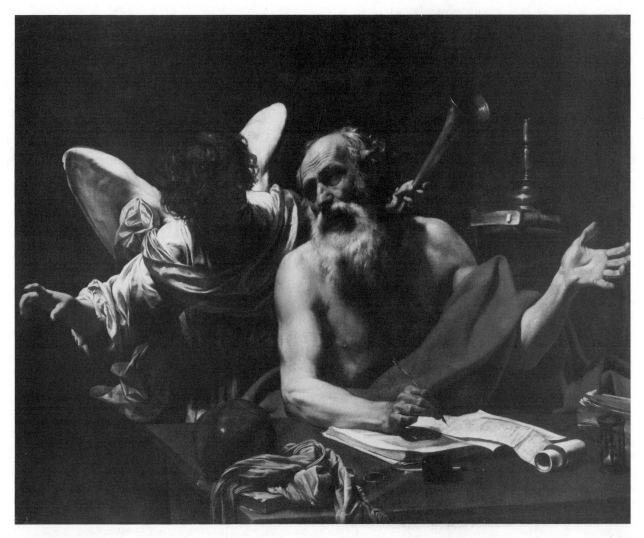

FIGURE 37: Simon Vouet, *Saint Jerome and the Angel*, c. 1625, oil on canvas, 57" x 70¾" (1.448 x 1.798), courtesy of the National Gallery of Art, Washington, D. C., Samuel H. Kress Collection.

Vouet, a French follower of Caravaggio, uses extreme contrasts of light and shadow to unify the figures and forms in his composition. The light touches and illuminates all forms in its path. Those forms in darkness marry the background. Not only does Vouet use light and shadow to tie forms together, he sets up a psychological relationship between the figures of Saint Jerome and the angel, through their gazes and parallel gestures.

chestra work together to create harmonious and coordinated sounds, we can begin to appreciate the power of color orchestration. If we focus on a symphonic piece of music and try to just listen for the violins, and then just listen for the flutes, and so on, we can notice how all the different instruments work into the musical fabric. In painting hues, such as red or blue, can move our eyes, choreograph our eyes' movement, over the entire surface of the canvas. The various hues should ultimately be synchronized to work as a total unit.

Color harmony. Color harmonies are used to create coherent visual images. Since the nineteenth century many color theoreticians have concerned themselves with the effects of color on the viewer and how we perceive and discern its inherent qualities. Artists such as Georges Seurat,

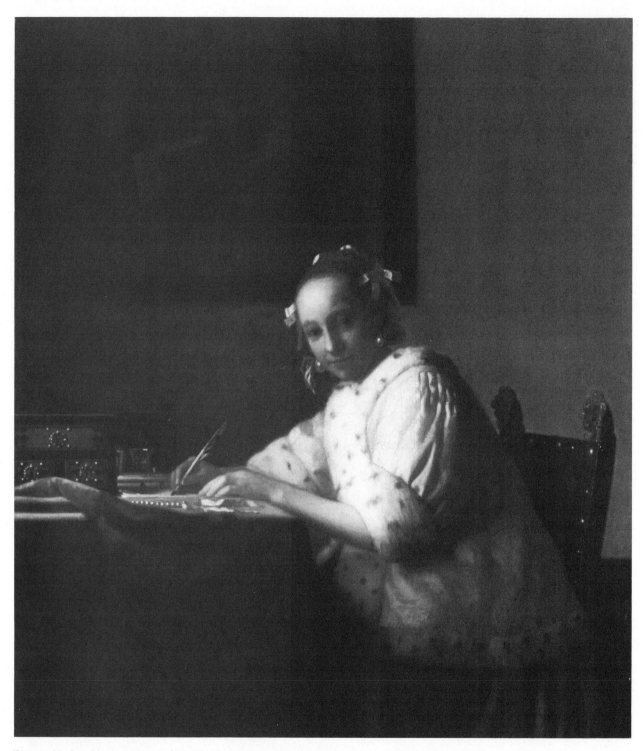

FIGURE 38: Jan Vermeer, *A Lady Writing*, c. 1665, oil on canvas, 17¾″ x 15¾″ (0.450 x 0.399), courtesy of the National Gallery of Art, Washington, D. C., Gift of Harry Waldron Havemeyer and Horace Havemeyer, Jr., in memory of their father, Horace Havemeyer.

Natural light coming from a window outside the reference of the painting gently touches the figure and her surroundings. The naturalness of the light and the organization of the other formal elements unite the forms.

a nineteenth-century French painter, and Vincent van Gogh, a nineteenth-century Dutch painter, believed in and utilized specific color theories. Throughout modern history, artists have struggled with various notions about color. Some believe they should base their color decisions solely on visual aesthetics; others believe they must use proven theories and explore new ones.

Can the use of color in painting be based on personal taste? Can we trust our sensibilities and eyes and ignore theoretical studies? These answers come to each one of us in a different way. Some people have a wonderful intuitive sense of color and do not need to rely on rigid formulas for color usage; others develop a color sense after utilizing theories. It would be foolish to limit ourselves to only the colors we "like" or not to investigate all avenues of color theory at the beginning of our study of the medium of painting. Once we comprehend the theories, we can make decisions regarding the use of standard color harmonies. As a religious painter, each of us also needs to ask, *Do I want to focus on the symbolism of color and use it according to traditional rules? (See* chapter 5.)

Gesture. The dictionary defines *gesture* as "an expressive motion or action . . . used for emphasis or to express some idea or emotion."[2] This refers to an individual gesture, but if we use gestures collectively, we can orchestrate them into a compositional motif (*see* figures 39, 40).

In recent times *body language* has been used to explain the meaning behind our poses, postures, and gestures. At one time or another we have all understood that someone was depressed or unapproachable because of the way he stood, sat, or folded his arms. We can also understand the way

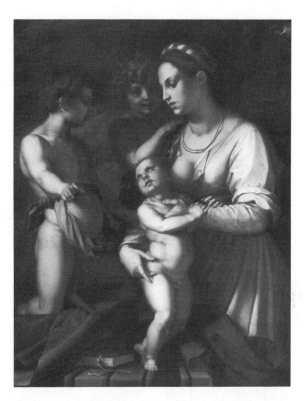

FIGURE 39: Andrea del Sarto, *Charity*, oil on wood, 47¼" x 36½" (1.200 x 0.927), courtesy of the National Gallery of Art, Washington, D. C., Samuel H. Kress Collection.

Gestures can be orchestrated to unify a composition. Forming a semicircular unit in space, these figures are linked together. All four are turned, posed at angles to the picture plane, forming a circular unit that scoops out the central space.

in which people are relating to one another because of the body language they use as they carry on a conversation. Public body language of people who like each other is quite different from the language of those who dislike or disagree with each other. We can use this known everyday information and translate it for use in the painting medium. The way in which people's gestures interact can be used in a compositional schema. For example, look at paintings of the Madonna and Child, and you can see how gestures evoke feelings. The embracing rhythms of the Madonna's posture suggest the relatedness of gesture and

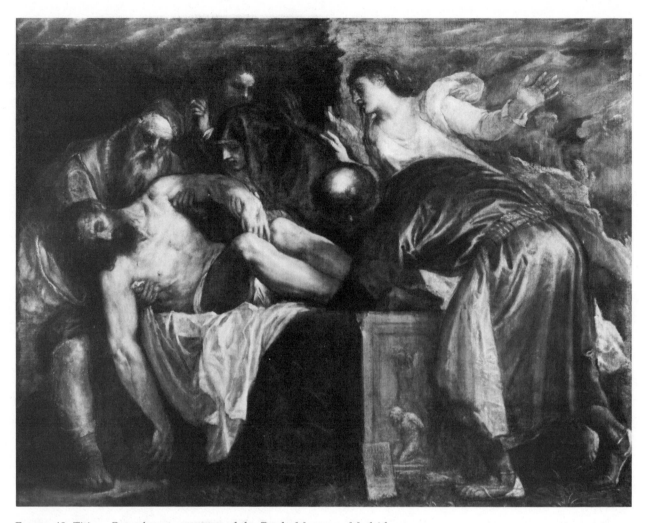

FIGURE 40: Titian, *Entombment*, courtesy of the Prado Museum, Madrid.

When figures take gestural poses, they are actually acting to create compositional connections. Besides the literal reading we get from a pose (such as grief or happiness), we can read its structural underpinning as it relates to the composition as a whole. The figures surrounding the body of Christ seem full of care and grief, yet their individual gestures are subordinate to their participation in the larger structure they form as a semicircular unit embracing Christ.

composition (*see* plates 5, 8 and figures 13, 24, 31, 35).

When people gesture they are actually designing themselves, their arms, legs, and torsos, to form shapes with the space, objects, and figures around them. If we can "see" the shapes they create, we can compose them into compositional motifs.

The figures or objects in a painting should react to one another either directly or indirectly. When we draw a line on a page, we should be conscious of the way in which it reacts with other lines and the borders of the page. In the same vein, we must remain aware of how the gesture of one figure we draw or paint is reacting to the gesture of all the others in the container.

Parallels and Counterpoints. Whether we paint representationally, using figures or recognizable objects, or abstractly, the forms we paint should relate to one another in order to establish unity. The particular way in which they parallel (echo) or counter

(oppose) one another will depend upon the subject or theme of the painting. Continuous parallels are more harmonious than sharp counterpoints. Therefore if the subject is loving or tender, we would want to structure the composition to evoke such feelings, utilizing parallel elements. Parallel forms are harmonious and consonant (figure 41). Forms that are at counterpoints, for example, two opposing diagonals, are dissonant and violent, and should be used

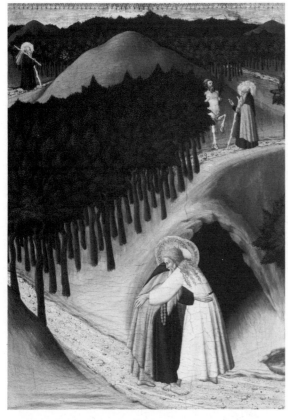

FIGURE 41: Sassetta and Assistant, *The Meeting of Saint Anthony and Saint Paul*, wood, 18¾″ x 13⅝″ (0.475 x 0.345), courtesy of the National Gallery of Art, Washington, D. C., Samuel H. Kress Collection.

If a subject is loving and tender, as this one is, we would want to structure the composition to evoke such feelings by utilizing parallel elements. The hugging gesture formed by the figures of Saint Anthony and Saint Paul is paralleled by the arch in the landscape and by the hill above; they strengthen the emotive power of the gesture.

for severe subject matter (plate 9). For example, a subject such as the finding of Moses might use parallel elements, whereas a subject such as the flagellation might use counterpointing elements.

Whether the forms seem to agree in shape and contour or oppose each other in form, they must seem to respond to each other and be conceived in juxtaposition.

Overlaps. A simple way to establish connections in a composition is to actually have the objects overlap one another, so that they are physically closer. If they are disconnected or isolated, it is difficult to establish unity, so we must use other means. If we set up a still life and all the objects in the arrangement are separated, we must unify them by virtue of color, light, line, or texture.

The overlapping of objects, abstract forms, or figures also increases depth, pushing forms in front of and in back of one another. We understand overlaps to mean that forms are either in front of one another or in back of one another (figure 42). Overlaps can also demonstrate relatedness, as in a family unit. Painters who overlap the members of the holy family might be suggesting their interrelatedness as an integral family unit.

But what if we want to evoke a sense of isolation, disunity, or disparity in a painting? Can we express this feeling by not establishing connections? by not establishing unity? No. If we are confronted by too many disparate elements in a painting, our perception of it as a unit will fall apart. The painting, as a statement, will fall apart. If we wanted to express this feeling in writing, we wouldn't abandon the principles of English composition. We would, instead, express our feelings in terms of the types of

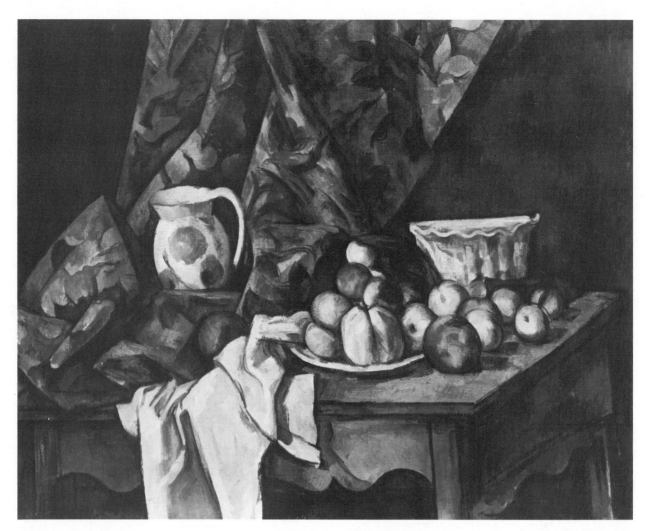

FIGURE 42: Paul Cézanne, *Still Life With Apples and Peaches*, c. 1905, oil on canvas, 32″ x 39⅝″ (0.812 x 1.006), courtesy of the National Gallery of Art, Washington, D. C., Gift of Eugene and Agnes Meyer.

A simple way to establish connections and unity in a composition is to have the forms overlap one another. When the forms overlap, our eyes tend to move in a continuous fashion from one to the other. Movement is very important to Cézanne's compositions. His use of overlapping forms, outlines, and perceptual space keeps our eyes interested.

verbs, adjectives, sentences, and paragraphs we used, rather than abandoning the given formulas for construction. In painting, the composition must work together in order to express any emotion or idea, whether it is one of connection or disconnection. The type of composition, choice of color, the decision to use line or light and shadow, be painterly or linear, open or closed will communicate our philosophy.

Brushstroke. The direction of brushstrokes can increase volume, guide the eye, and establish connections among forms. Modern artists have allowed their brushstrokes to remain visible, making them an active participant in the composition (figure 43). The idea of allowing brushstrokes to remain visible is a relatively modern concept that began in the seventeenth century. This method of painting has remained popular, and many artists today still main-

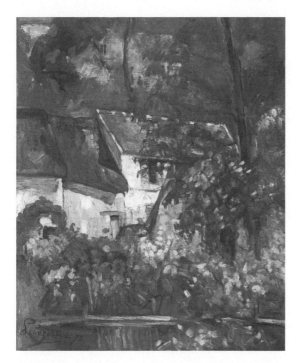

FIGURE 43: Paul Cézanne, *House of Père Lacroix*, oil on canvas, 24⅛" x 20" (0.613 x 0.506), courtesy of the National Gallery of Art, Washington, D. C., Chester Dale Collection.

Through a method of setting down broken color in patches and allowing patches of canvas to go uncovered, Cézanne formed his still life, landscape, and figure paintings. Though different in technique from the impressionists and other postimpressionists, Cézanne's visible brushstrokes and concern with visual perception defined him as a modern.

tain that the visible brushstroke does not interfere with believable illusion. For some artists, the visible brushstroke makes a statement about the inherent flatness of the surface of the canvas. For example, in a representational painting, the brushstrokes make us continually conscious of the surface, of the fact that the painting is an illusion of reality and not real. In an abstract painting, the visible brushstroke makes us conscious of the flat surface as a real fact. The brushstroke can add volume and texture to the space and forms, as well as establishing definite visible movements.

Vincent van Gogh's brushstrokes are the major compositional device in his paintings. They lead the viewer's eye around the work. Visible brushstrokes are an interesting way of seeing the artist's movement; they are evidence of how and where he or she placed and moved the brush.

Textures or Patterns. If we divided a page into equal-size boxes and drew the same form in each box, we would create a pattern. We create patterns and textures by establishing a *repetition* of like or unlike units that are adjacent to one another. By virtue of their proximity, they will be perceived by the viewer's eye as a single unit.

The establishment of different patterns within the same painting can be organized to give a unified feeling. But we must realize that their color, position in space, and size will participate in the compositional unification (figure 44).

Positive and Negative Space

If we paint a star on a blank canvas, then the star is called the positive space (or figure) and the remainder of the space on the canvas is called the negative space (or ground). We want to constantly be aware of the interaction between the positive space that we draw or paint and the negative space. The negative space is as important to the dynamics of the composition as are the positive elements.

Whether we paint many forms or a single form on a canvas, the negative space can and should be as important as the positive forms. The positive forms we paint create shapes with the negative space, and this should be taken into account when composing.

The following short exercises will increase our awareness of the importance of

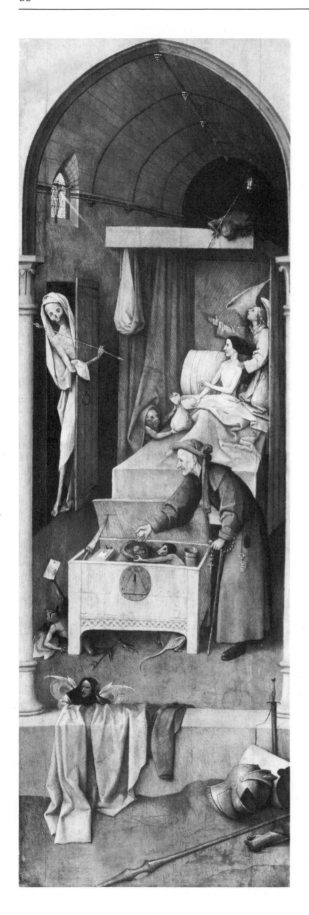

the interaction between the figure and the ground.

Exercise 7: Activating the Entire Ground

Materials: pencil, eraser, and two sheets of blank paper.

1. Draw a small tree on a blank page.
2. Now draw the same tree form on a second blank page, utilizing the entire ground space.

Exercise 8:
Organizing Figures to Activate the Ground

Materials: pencil, eraser, scissors, and two sheets of blank paper.

1. On a piece of scrap paper draw five different shapes. Cut them out.
2. On a blank page, organize all five shapes to create shapes with the ground space.

If we analyze old-master and modern-master paintings, we can see how conscious they are of the dynamic relationship between the positive and the negative space. Whether or not artists utilize other compositional ideas, such as light, line, or gesture,

FIGURE 44: Hieronymus Bosch, *Death and the Miser*, probably c. 1490, oil on wood, 36⅝″ x 12⅛″ (0.93 x 0.31), courtesy of the National Gallery of Art, Washington, D. C., Samuel H. Kress Collection.

When early Renaissance artists used proximate vision to make forms appear corporeal, texture provided an added element of tactility. Scanning this vertical extension, we can see a wooden ceiling, a stream of light, cloth, flesh, a skeleton's bones, hair, metal armor, chains, metal key, beads, reptilian creatures, and stone. This tour de force of textural painting lends solidity and tactility to the forms, which in turn become the fabric of a larger, woven tapestrylike composition.

the positive-negative concept can underpin their compositional thinking.

How does the impact of positive-negative shape relationships relate to faith? Can it reflect a belief in good and evil, in darkness and light?

Scale

When we speak of *scale,* we are talking about size relationships, that is, the size of one form compared to another.

There are two types of scale:

External scale: We can paint on a large scale using a large canvas, or a small scale, if we use a tinier canvas. In order to learn proper techniques, beginners should use an average-sized canvas.

Internal scale: (1) There are scale relationships among the many forms in a single work. Some forms are large, compared to others. (2) The size of the forms in a painting can also be compared to size of the canvas on which they are painted (*see* figure 14). For example, if we are painting on a five-foot canvas and all the forms on the canvas are no bigger than five inches, they are small in relation to the canvas size.

Scale can be used to create space and depth. In the average situation, we place large forms in the front of the space (or foreground), and small forms in back of the space (or background), to give a greater sense of depth. This rational formula coin-cides with the way we most often perceive actual forms in nature, so viewers interpret what they see as a composition with depth.

Naturally, such rules are not hard and fast. If a seven-foot-tall person were standing in the back of a room and a three-foot-tall person was in the front of the room, then the scale relationships would not seem to be rational or "correct." But this is an unusual case.

When composing our paintings, we should be aware of whether we are making use of rational or irrational scale. Irrational scale opposes the way we actually perceive the real world, and can be utilized to convey dream states or fantasy. In the same vein, we can create irrational scale by exchanging the expected scale of forms. If an apple is as large as a human being, we communicate something irrational or unexpected. In a religious painting, we might choose to ignore rational scale and depict all figures the same size, no matter where they stand, to convey the idea of the equality of their souls.

To create a successful work of art we need to harmonize all the design elements, including scale, balance, color, and the creation of depth. A good way to learn more about them is by studying the old masters' paintings and identifying their use of these composition elements.

In the next chapter we will begin to put some of the lessons we've learned so far into practice: We'll start to draw.

4 Drawing

Is drawing just an objective action, or does it have an element of interpretation? Can it be a religious experience? Why do we draw at all? First, we need to look at a few of these questions and see how drawing relates to art and life as a whole.

Mimicry or Spiritual Experience?

Some would have artists believe drawing from life is objective; that when we draw, we merely mimic what we see. Though we *do* draw what we see, I believe art is not and cannot be purely mimetic. It requires some subjective interpretation of the real or imagined world—especially from artists who choose to reveal or explore their religious beliefs through their creations.

Drawing is a discipline that demonstrates interrelatedness; it synthesizes what we see and what we *know* (and our religious beliefs are a part of what we know). Drawing is one way of revealing our faith and our knowl-

edge of God and their relation to the visual world.

The art of drawing has a meditative basis we cannot ignore. Because artists do it over and over again, drawing sets up an encounter between them and what they see and know—ultimately it reflects their spirits.

Why Draw?

Although drawing can be a preliminary step to painting, in reality it requires the same amount of time and discipline as painting. But representational painting can hardly be tackled without a knowledge of drawing, and rest assured, the study of drawing feeds the study of painting.

To become good painters, we need to be polished draftsmen, and that requires constant practice. It's good to carry a drawing notebook or pad with you and draw anything and everything you see. Draw as you ride the train, wait in the bus station,

snack at the coffee shop, or watch television in your living room. Draw all the time, from imagination or life. Carrying a drawing pad is not only good for developing skill, but it is a good way of collecting ideas and thoughts.

Just as in the art of painting, formal elements must be considered in the art of drawing: the container, line, value, composition, texture, light and shadow. Some drawings are also executed with a brush or in color. More frequently, they are done in pencil or charcoal and in values of gray rather than a full color range.

MATERIALS FOR DRAWING

Paper

The most common ground or support for drawing, whether with pencil, charcoal, or crayon, is paper. Certain papers are more appropriate for particular drawing tools and media.

Paper comes in various textures and finishes. Hot-pressed paper has a smooth texture. Cold-pressed and unpressed paper have rough textures or finishes. We refer to a paper's texture, characterized by different finishes, as a "tooth."

Smooth finishes are suited to pointed instruments, such as pencils. Best suited to blunt instruments, such as charcoal, chalk, and crayon, or brushes, are usually cold-pressed, rough-finished papers, which can be bought in a variety of colors. Rough papers with a lot of tooth allow for special effects of light and shadow. White chalk, colored chalk, and conté crayon can be used in connection with charcoal on the same papers. Individual sheets of domestic or imported papers with high rag content are also good for charcoal and crayon.

The choice of paper and drawing medium should also reflect your subject. For example, you can draw a Nativity scene in which a symbolic light focuses on the Christ Child. Conté crayon or charcoal and a rough paper are better suited to this purpose than pencil and smooth paper. Or you may wish to stress the realism of the event by using line, pencil, and appealing to the viewer's sense of touch.

Of course artists can try any combination of papers and drawing instruments. For the beginner, a paper with a moderate amount of tooth is recommended, for use with pencil.

The quality of a paper is determined by the *rag content*, which refers to the amount of cotton or linen fibers in a paper. Papers of 100 percent rag content are of the highest quality and are therefore most expensive. Papers with a combination of ingredients, such as wood pulp, rag, and chemicals, are less expensive and of a lower quality (meaning they will yellow because of the chemicals, and they cannot hold up to a lot of erasing). For the beginning artist, inexpensive papers are fine. They may be bought by the pad, roll, or individual sheet. There are many brands of paper pads, and they are a convenient and economical way of buying paper. Touch the surface of the paper in the pad before purchasing it, though, because written descriptions on the pad cover can be deceiving. A pad of moderately priced white paper with some tooth, for use with pencil, is a good choice. Choosing an extremely smooth pad for pencil might present difficulties for the novice. A good workable-size pad is about fourteen inches by seventeen inches. Working too small, at first, might create bad habits, such as holding the pencil too tightly or not utilizing your arm movements.

Pencils

The most popular drawing tools, pencils are available in a wide range of cores that yield different types of marks. There are synthetic graphite pencils, charcoal pencils, chalk pencils, colored pencils, metallic pencils, and plastic pencils.

Synthetic graphite pencils, the modern equivalent to lead, come in varying degrees of hardness and softness. The pencils are stamped H for hard and B for soft. As the numbers increase so does the degree of softness or hardness. For example, a 6H pencil is harder than a 2H; and a 6B pencil is softer than a 2B. Soft pencils make darker marks than hard ones; for example, a 6H makes a very light line, and a 6B makes a very dark line. This range is very much like a range of musical instruments. Some instruments make high sounds, some make low ones, and some make sounds in between. You would use a flute to make high sounds and a tuba to make low sounds. Forcing a flute to sound like a tuba wouldn't make sense. Likewise, why force an H pencil to make a dark line, when you could use a 2B? The available range of pencils allows us to use different hardnesses for varied values and effects. If we desire different ranges, we can either change pencils or build up areas of darkness with repeated strokes. An assortment of pencils may be used on a single drawing.

Why choose a particular graphite pencil? Some artists prefer dark lines and tones, while others prefer to work in a light range. A heavy-handed artist may prefer to work with a harder pencil to compensate for that touch. Another artist has a very light touch and prefers to work with a soft pencil. Some religious subjects require a darker tone, and others a lighter one. Pencils are inexpen-sive, and it is definitely worth your while to buy a range of synthetic graphite pencils, to try your hand with all of them and test their capabilities or voices. Most people feel comfortable holding a pencil in the writing position.

Charcoal pencils are generally darker, blacker, than synthetic graphite pencils. They are used by artists who desire the look of charcoal, but prefer to work with a pencil-shaped tool.

Colored pencils can be used to try out color ideas for paintings, but mastering them requires practice and experimentation. You might try them on black or gray paper.

Mechanical pencils are available with interchangeable leads that come in various hardnesses and thicknesses.

Most pencils can be sharpened with inexpensive ready-made metal sharpeners, electric sharpeners, single-edge razor blades or X-acto® knives. When sharpening with a razor or knife, always cut away from yourself, keeping your fingers clear of the blade. Once the point is cut with a blade, it should be smoothed on a sandpaper block made especially for this purpose.

Pencils are pointed instruments and should be used as such. They can make lines, broken or unbroken, and create areas of tone through hatching. Hatching is done by repeatedly drawing lines in the same direction. If you want to create a solid area of tone, don't turn the pencil on its side—use a different tool with an appropriate shape. Tools such as crayons, chalk, or charcoal have exposed sides and blunt ends to create solid tones and are thus more appropriate for such tasks. Avoid rubbing pencil marks with your finger to create areas of tone. This "dirty finger" technique is not professional. Avoiding the "dirty finger" method is a rather orthodox or purist

approach to the use of tools, and we should learn the appropriate uses of instruments before we break with traditions.

Charcoal and Chalk

Charcoals

There are two basic varieties of charcoal that come in stick form: vine charcoal and compressed charcoal. Both are available in hard, medium, or soft grades and various sizes. Vine charcoal is basically soft and produces a moderate range of grays; it also breaks easily. Compressed charcoal, which is very dense, produces a strong range of grays and blacks.

Pencils are available with black or white charcoal centers, in various hardnesses. Charcoal pencils cannot offer the same pliability as sticks and are best used in conjunction with the sticks.

Finished charcoal drawings should be sprayed with fixative in a well-ventilated room.

Chalks

Crayons are sticks of pigment held together with wax, which make permanent marks that cannot be erased. We can purchase an enormous variety of crayons in an extraordinary number of colors. Ready-made sharpeners are available. Crayons can be used on almost any paper surface.

Conté crayons, made in France, fall somewhere between the quality of charcoal and crayons. They come in a limited variety of colors, black, gray, earth tones (red to brown), and white, and a range of hardnesses, #1 (hard), #2 (medium), and #3

(soft). When used with a heavy-toothed paper, a wonderful range of subtle tones can be achieved. Conté crayon can be used on its side to create large areas of tone or on its point to draw lines. The pressure of your hand, when used on a heavy-toothed paper, can create a range of tones. Conté crayons can be sharpened with a sandpaper block. A finished drawing should be sprayed with fixative.

Pastels and *colored chalk* come in a large variety of colors and should be used on heavy paper. They can be used to try a variety of color schemes for your painting. Hard pastels are very much like conté crayon, and soft pastels are more like chalk in terms of texture and fragility. A fixative should be used on finished drawings. Some artists like to use a workable fixative as they are drawing to prevent smudges; experiment with it before you use it on a serious drawing.

Oil pastels have an oil base and should be used on a heavy paper, because they have a tendency to bleed through paper. Oil pastels do not require a fixative.

Erasers

The most widely used eraser for pencil and charcoal is the *kneaded eraser,* which to a large extent cleans itself when you knead it with your fingers. They come in different sizes and can easily erase large areas. Kneaded erasers will not damage the surface of your paper and can become an active tool in the drawing process, when used in areas covered with charcoal or pencil, to create lights, whites, or highlights. Don't hesitate to erase; drawing is a process of decision making and going back and forth between tool and eraser is perfectly valid and necessary.

Gum erasers are soft and nonabrasive, but not as versatile as kneaded erasers. *Pink erasers* are more abrasive, and some artists prefer them for use with pencil. Certain erasers are made specifically for use with felt-tip pens and ink, and they tend to be abrasive. Marks made with felt-tip pens and ink should really be considered permanent.

Crayon, compressed charcoal, and chalk are virtually impossible to erase. We should therefore treat them as definitive mediums.

Fixative

The marks made with pencil, charcoal, conté crayon, chalk, and pastel tend to wear off in time and need to be fixed permanently to the paper's surface. Fixative is a diluted resin solution sprayed on a finished drawing to bind the above-mentioned mediums to the paper's surface. Workable fixative, which can be drawn over after spraying the paper's surface, can be used during the drawing process to prevent smudges.

Use fixative in a very well ventilated room or, even better, out-of-doors. Do not remain in the same room in which you have sprayed your drawing. It will have a strong odor for a few hours.

Drawing Techniques

Line Versus Tone

We can break drawing into two basic categories: those that predominantly utilize line and those that predominantly utilize tone. Interestingly, any of the above-mentioned tools can achieve either the effect of line or tone; the way in which they achieve it makes the difference.

A pencil is a pointed tool, and it can create the most delicate light line or a wonderfully dark broad line. The pressure of the hand can vary the width of the line; the variation in the line's width produces the illusion of volume. The creation of a line is natural to a pencil.

In order for a pencil to create shadow or volume, we have to draw hatched lines. Hatched lines are drawn close together and move in the same direction (figure 45). They can consistently move in the same direction, no matter what form they touch, throughout an entire drawing, or they can change direction describing the turn of different forms (figure 46). These tech-

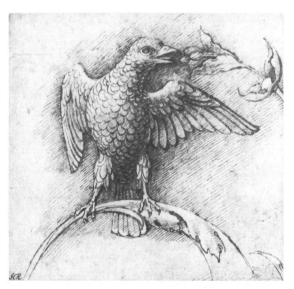

FIGURE 45: Andrea Mantegna, *Bird Perched on a Branch With Fruit*, pen and brown ink, 4⅛" x 4½" (10.4 x 11.5 cm.), courtesy of the National Gallery of Art, Washington, D. C., Andrew W. Mellon Fund.

Any pointed drawing instrument, such as a pen, pencil, or stick of charcoal, can produce line. Mantegna uses hatched lines in this drawing to create shadow areas, texture, volume, and mass. The hatched lines move in the same direction and grow darker behind the bird, in order to create a cast shadow that pushes the bird forward of the picture plane.

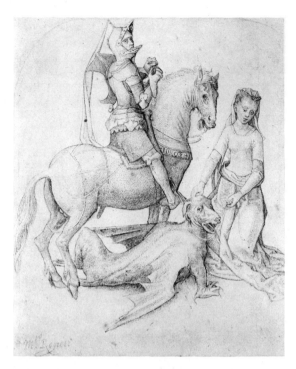

FIGURE 46: Attributed to Hugo van der Goes, *Saint George and the Dragon*, pen and sepia ink, 7⅞" x 6½" (20 x 16.6 cm.), courtesy of the National Gallery of Art, Washington, D. C., Rosenwald Collection.

Line can be used as outline, to describe the forms' outer edges and visually connect all the shapes and images in the drawing. Some outlines receive more emphasis than others.

niques represent two different schools of thought (figure 47).

Line can be used for geodesic drawings. In art the term *geodesic* refers to lines that are used internally, building up circular rhythms, to describe the volume of forms. Pens can be used the same way as pencils.

Charcoal or chalk sticks can create lines, outlining or filling in forms, or constructing patterns (figure 48). Tone is easily achieved with charcoal, by turning it on its side and drawing a large area in one sweep or blending separate lines together. Lines can be made by sharpening the charcoal or chalk with a sand block in order to make it a pointed instrument. Line and tone can be combined in drawings or used separately.

A paper's tooth can also be employed to create tone. When charcoal or conté crayon is used on a very rough paper, the pressure of the hand and the tooth of the paper act together to create areas of light and dark. Erasers can be used over drawn tones to create areas of light, white, or highlight. (In chapter 7 preliminary drawing for the chiaroscuro painting method will utilize an eraser in this manner.)

Sketching Versus Prolonged Drawings

Sometimes you want to draw just to give yourself a simple idea of the way a composition will look, or the way a gesture will look. At other times you may want to quickly record fleeting gestures, sudden ideas, or interesting perceptual information. These uses of drawings are called sketches (figures 49, 50). A sketch implies rapidity. Many artists prefer to use soft pencils, felt-tip markers, or technical pens for sketching on inexpensive paper, because these tools are conducive to rapid drawing.

A prolonged drawing implies that an extended period of time is being spent on a particular piece. You may want to take a long time to work out ideas for a painting on one drawing. Use a good, heavy paper for an extended drawing, along with any drawing tool. The heavy paper will stand up to a lot of corrections and handling.

Preliminary Drawings

It takes as many years to master all the subtleties of drawing as it does of painting. In modern times drawing is viewed as a separate discipline. If you do not already know how to draw well, read a text on the

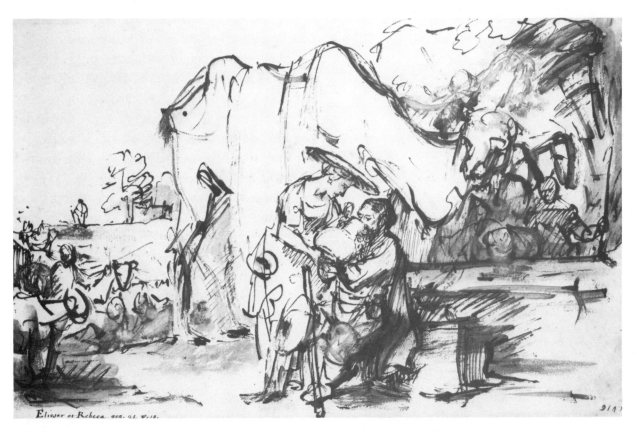

FIGURE 47: Rembrandt van Rijn, *Eliezer and Rebekah at the Well,* c. 1640–50, pen and brown ink and brown wash with white body color, 8″ x 12⅞″ (20.4 x 32.6 cm.), courtesy of the National Gallery of Art, Washington, D. C., Widener Collection.

These broad, sketchy lines allow the artist to understand the rhythmic potential of a composition. They are no more or less emotive than delicate lines; they are simply different.

subject, take a class, or just practice, practice, practice!

Drawing from life involves the translation of three-dimensional space onto the two-dimensional surface (figure 51). If you intend to draw abstractly, whether you create designs or engage in doodling, it is important to study two-dimensional design. Once again, I recommend that you read a reputable text on this subject or take a class in design and color.[1]

Beyond the translation of three-dimensional space onto the two-dimensional page or canvas are the following issues:

Eyeballing
Scaling up or down

Viewfinder composing
Shades versus paint
Achieving likenesses
Theory versus practice

Eyeballing

The strange-sounding term *eyeballing* refers to the process of recording perceptual information without the use of a perspectival system. When we draw from life, whether we draw a model who is ten feet away from us or a still life that is two feet away, we look from one place to another. We look at the setup and then at our drawing pad or canvas. We move our eyes, head, and hands in the process. Some kind

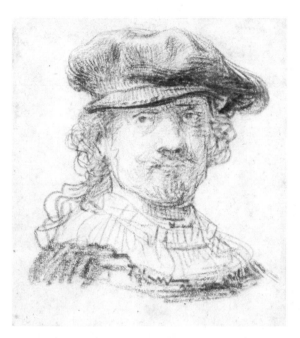

FIGURE 48: Rembrandt van Rijn, *Self-portrait*, c. 1636–1637, red chalk, 5⅛" x 4¾" (12.9 x 11.9 cm.), courtesy of the National Gallery of Art, Washington, D. C., Rosenwald Collection.

The tooth of a paper can be incorporated into the creation of tone. When we use charcoal, crayon, or chalk on a paper with a heavy tooth, we can allow the texture of the paper to come through.

of shift between our visual perception and visual recording of what we see has to occur because of the movement. Most novice artists become frustrated by this experience, but we are not cameras with one eye and a fixed position. We move and shift our two eyes and have to realize that this is natural to the way we see and to the perceptual drawing process.

If we use a schematic system such as one-point or two-point perspective in our drawing, we eliminate the natural shifts that occur when we draw from life. All forms follow the rational guidelines of the perspectival order. The natural shifts that occur when we draw from life can be eliminated without the use of a perspectival schema, as well. If we are conscious of this phenome-

non, we can "correct" it. When we eliminate the natural shifts in our vision, we idealize our visual perception, making it more "perfect" than it really is. For centuries, artists idealized drawings, denying the perceptual process. This reflects a particular attitude toward themselves and reality. As thinking human beings, we can impose ideas on reality and the way we see. We can choose either to eliminate the natural shifts in our vision or to reflect the movement and shifts in the drawing. Some religious ideals may require the corrections of natural vision; for example, an ideal art style may symbolize God's perfection. Many modern artists, beginning with Paul Cézanne in the nineteenth century, allowed the perceptual shifts to remain in the drawing, revealing the visual search for the truth of visual perception. It may also symbolize the search for religious meaning for some of us today. Cubist artists took this notion of the shifting in our perceptual vision to its extreme. The early cubists related the shifts in our perceptual vision to the philosophy that forms are never complete and are always in motion; all things are in the process of becoming. Today, our thoughts about philosophy and faith can be revealed through many avenues of art.

Scaling Up or Down

Scaling is defined as "'the increasing or reducing of forms and dimensions of a given subject, while maintaining its correct proportions."

We use scaling when we draw from life or when we want to transfer a drawing to a canvas.

Drawing from life. If we are drawing an adult figure, and we are close to it, in order to draw what we see on an average-size

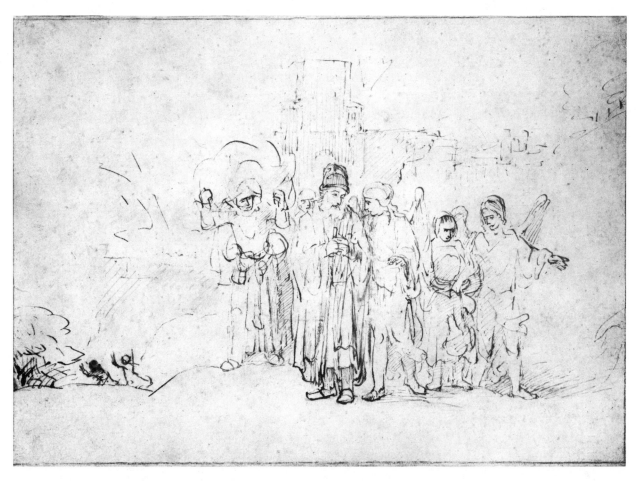

FIGURE 49: Rembrandt van Rijn, *Lot and His Family Leaving Sodom,* c. 1655, pen and bistre, 7¼″ x 11″ (19.7 x 27.9 cm.), courtesy of the National Gallery of Art, Washington, D. C., Widener Collection.

Painters and draftsmen create preliminary sketches in order to visualize their ideas. Be willing to do many preliminary sketches for ideation.

drawing pad (fourteen inches by seventeen inches or twenty inches by twenty-four inches), we must reduce the size of the forms. In most cases, the life forms that we choose to draw, figures, buildings, furniture, or landscape, are larger than our drawing pads. Therefore, we must scale down what we see. This entails maintaining the correct proportions when transferring the perceptual information to the page. If we draw a still life in which a lamp is next to a vase, and the lamp is twice the size of the vase in reality, that proportion should be maintained in the drawing.

Conversely, if we draw a still life made up of small objects, and we want to enlarge them on our drawing pad, we must scale up what we see. Many artists choose to blow up or enlarge forms to create a dynamic image. Once again, when enlarging forms, we should maintain the correct proportions of the forms in relation to one another. If we draw an apple and a cherry, and we want to enlarge the forms to fill a large page, we must make sure that the cherry stays proportionately smaller than the apple.

Of course, this theory assumes we want our drawings to accurately reflect the proportions that exist in reality. We may want to purposely distort or exaggerate what we

FIGURE 50: Luca Cambiaso, *Martyrdom of Saint Lawrence,* before 1581, pen and brown ink and wash, 15¼″ x 9⅝″ (38.8 x 24.4 cm.), courtesy of the National Gallery of Art, Washington, D. C., Ailsa Mellon Bruce Fund.

Drawing internal lines that describe volume reminds us of the illusionary three-dimensional quality we want forms to have.

FIGURE 51: James Ensor, *Mystic Death of a Theologian*, 1880, pencil, charcoal, paper/canvas, 970 x 830 mm, courtesy of the Koninklijk Museum Schone Kunsten.

Focal points can be created by emphasizing a part or parts of a drawing with darker tones and/or more lines. The mystical feeling in this drawing by Ensor is partially communicated by the buildup of atmosphere through tone and light and dark relationships.

see in reality to convey a particular feeling or message to the viewer.

Transferring a drawing to the canvas. If you have a drawing that is eight inches by ten inches, and you want to accurately transfer it to a canvas that is sixteen inches by twenty inches, you must scale up the drawing. To do this, you have several alternatives:

1. Using an opaque projector, project the image onto the canvas. The distance between the projector lens and the canvas will determine the size of the image. The projector will do the scaling up.

2. Draw the image by eye, without the use of any system or grid. This method is challenging and can teach you a lot about the way the same forms look and feel on different size containers.

3. Using a grid system of equal-sized boxes, draw the same grid on both the canvas and drawing. Then transfer the drawing, box by box, from the drawing to the canvas.

To transfer an eight-by-ten-inch drawing to the same size canvas, you can use the following methods:

1. Use an opaque projector.
2. Use the grid system.
3. Draw it by eye.
4. Trace the drawing onto the canvas, copying only lines, since tones will only make the surface muddy.
 - Trace the drawing on tracing paper with a soft pencil.
 - Turn the tracing over.
 - Trace the reversed image with soft vine charcoal.
 - Turn the tracing back in its correct position and place it on top of the canvas.
 - Now trace it again with pencil. Touch the page lightly so as to prevent the canvas from being damaged.
 - The charcoal that was applied to the back of the tracing will be transferred to the canvas as you trace the lines.
5. Transfer paper is made especially for the transfer of images and works very much like carbon paper. It comes in a variety of colors.

Viewfinder Composing

When you look out a window, there is a border to what you are seeing. But when

you go outdoors to draw or paint or when you draw an interior still life, there is no frame (except for the limits of your eyes). A device called a viewfinder can be used to frame a composition. You can do this when you look at life or choose a portion of your drawing as a composition. Some people use their hands. You've seen photographers and film directors in cartoons or movies using their hands in this manner. You can also make a simple viewfinder out of cardboard or heavy paper.

> Simply cut two L-shaped pieces about two to three inches wide.
> Overlap them the shape of a frame.
> Open and close the view created by the L-shaped cardboards to the size you like.

Values in Drawing Versus Values in Painting

The scale of gradations between white and black is called a value scale. The values (tones and shades) in between black and white are infinite. We achieve value in drawing by either hatching with pencil or covering an area of the page with charcoal or chalk. These values of gray fall somewhere on the value scale. In order to understand value we usually refer to a ten-step scale of values, from white to black.

If we have created a charcoal drawing using large areas of different values that we intend to use as a guide for a painting, we must translate the grays that are made from the white of the page and charcoal into grays of colored paint. Probably, we would not want to limit our painting to black and white. How do you go about translating the values in gray to values in color?

Let's look at the three qualities of color: hue, value, and chroma. We see that value is an integral part of the color makeup. This enables us to realize that whatever we have learned to see in black and white through the art of drawing will help us in judging colors during the painting process. It is the hue and chroma of a color that create difficulty in reading the value. The chroma tends to jar our retinas, but we can attempt to read the value by squinting at the color to diminish the intensity. Some hues are easier to read than others. For example, the cooler hues, such as phthalo green and phthalo blue, ultramarine blue, and alizarin crimson, are easier to read than the warm colors, such as cadmium red and cadmium yellow. Warm colors tend to be more intense in their chroma, and the greater the intensity, the more difficulty we have reading the value. Please remember that the most important aspect of reading the value of a color, or any quality of a color, depends upon comparison. We must compare one hue to another. We cannot accurately read a color in isolation. The same is true of values.

Achieving Likenesses

We all want to make our drawings and paintings look like what we see. It is very frustrating when we draw, especially when we draw people, if the drawing doesn't look like the thing seen.

How can we best achieve likenesses? by thinking abstractly. If we draw a portrait and as we draw, we think, *I've got to get this nose right,* or, *I've got to get her eyes,* then we've got it all wrong.

The proper way to think is, *How much distance is there between her nose and her upper lip?* or *What type of curve makes up her upper eyelid?* If we look at objects, people,

the features of faces, and landscapes as abstract forms, we have fought half the battle. Once we think of recognizable objects as pure form, we are free of the object-oriented attitude that makes us into literal artists.

Look for the way recognizable forms break into figure or ground designs, the type of curves or angles they have, the amount of volume, the distance between internal forms, the distance between forms in a setup, the shape of forms, the texture of forms, and so on.

If we are object oriented and view forms as separate things, we won't achieve likenesses. Thinking abstractly, analytically, is the key to achieving likenesses.

Theory Versus Practice

It is all well and good to discuss theories of drawing, but the best teacher is practice. True, good instruction is very important. In fact, most people with normal eye-hand coordination and a reasonable amount of intelligence can learn to draw well from a very good instructor, regardless of the lack of "talent." If you have the above prerequisites, drawing is an acquirable skill. But you have to practice on your own, too.

We are all anxious to "get on with it," to paint pictures; but quality pictures come after learning the existing body of knowledge and experimenting with it. Practice, practice, practice!

5 Color

Once we have a command of the use of lines and tone, we are ready to make use of color. However, people have different ways of looking at this element of art. Some claim that color has universal appeal and meaning, while others say colors hold different meanings to people from different religions and cultures.

Another group maintains an artist paints for the largest of audiences: the entire world. Painting is a universal language that should be aimed at every living soul. Or does one paint for a very small audience, an elite who understands the language of art and art's many messages?

In order to deal with these issues, we must decide whether we are answering them in respect to our point in time or in respect to all of history. Did the Italian Renaissance painters commissioned by the Catholic Church have the entire world in mind when they used color and the painting language? Does a religious Protestant artist painting today have everyone in mind?

In part, color and the painting language are universal. We all react to painted images, compositions, and color; images, compositional structures, and color evoke emotional, spiritual, and intellectual responses in us all. Although our spirits and minds are stimulated, are we all receiving a universal message? No, because people of different faiths and cultures have arrived at separate ways of creating compositional structures and spatial illusions and have chosen to endow specific colors and forms with particular meanings. But we have access to the use of the painting language and the meaning of color to various faiths and cultures, which would enable us to bridge gaps related to the universality of color and the language of painting.

In our study we must:

1. Learn how to use, control, and allow color to become a tool for us.

2. Understand color symbolism. (This chapter gives you the meaning of a good number of colors in Christianity and Judaism.)

3. Each answer the questions of the universality of form and color in our own painting experience.

Before we begin to paint religious pictures, it would be beneficial to experiment with color relationships and color mixing. Just as composition creates a skeletal structure for our pictures' meaning, so does color. Color evokes feelings in the viewer, creates mood, enhances meaning, and symbolizes religious ideas.

Composition is perhaps the most learnable of all the painting skills, because it relies on the practitioner's ability to think and analyze. By comparison, color is the most elusive element. It depends on your perception and how well you train your eye to see subtleties.

We can learn theories of color and work from that basis. Artists such as Eugène Delacroix (French, nineteenth century), Georges Seurat (French, nineteenth century), and Vincent van Gogh (Dutch, nineteenth century) were interested in how we perceive and react to colors. Ever since Delacroix jotted his observations about color perception in his journal, artists have been concerned with color theory and with mastering the elusive nature of color application.

Some artists and critics believe good colorists are intuitive and do not utilize theories: You are either born with a good eye and sense for color, or you are not. This romantic view would certainly have eliminated quite a few renowned artists. It is preferable to believe that a good color sense

is something that can be cultivated, just like a taste for fine foods.

Rather than loading ourselves down with heavy rhetoric and theory, we will take the empirical route and practice color mixing and perception. Understanding the qualities of color and its potential, a workable palette, and mixing experience will give us a good foundation to begin painting (*see* figure 52).

Color = Hue, Value, and Chroma

We can break down the word *color* into three categories so that we can better understand its inherent qualities and learn to control all its aspects.

Hue is the name of a color. It is the quality that distinguishes a red from a blue or a red from a red orange.

Value is the quality that defines the lightness or darkness of a color. Synonyms for value are *shade* and *tone*.

Chroma is the quality that defines the brightness or dullness of a color. A synonym for chroma is *intensity*.

When we look at a still-life setup or figure, we "read" its colors. Reading a color means that we can discern its hue, value, and chroma; for example, we may see a blue green vase that is light and bright. Blue green is the hue of the colored vase, light is the relative value, and bright is the chroma of the vase. This is a general reading of the vase's color, which means that at first glance the vase is as we described it. But as we really look at the vase we can begin to see the variations within the hue, value, and chroma. Perhaps we can even see other colors reflecting on the vase. Variations of hue, value, and chroma create the illusion

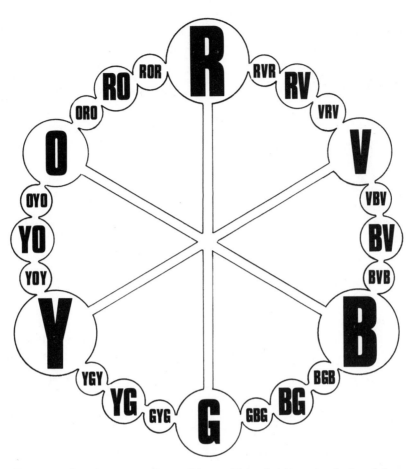

FIGURE 52: THE GEOMETRIC COLOR WHEEL. This wheel is a circular band that stems from the continuous band of hues that Sir Isaac Newton saw when he passed white light through a prism. They include the three primary hues: red, yellow, and blue; and the secondary hues: orange, green, and violet; and mixtures of the primaries and secondaries: red orange, blue green blue, and so on. This wheel not only names the hues, but yields color relationships, harmonies, and theories. The different color relationships are a result of the particular positions the hues occupy on the wheel.

Hues that are opposite each other are called "complements." Complements have different effects upon one another, depending upon their value and size. When complements of equal values and equal amounts are mixed together, they form gray. When small dots of equal value complements are placed next to each other, they mix optically in our eyes to form a visual gray color. When large areas of complements are placed next to each other, they enhance each other's appearance. For example, red and green are complements; yellow orange and blue violet are complements.

Hues that are next to each other on the wheel are considered analogous. For example: red, red orange red, red orange, and orange red orange are analogous. They are not the same, but are related. Analogous hues are consonant and harmonious. Their effect is generally a calming one.

of volume and mass when we render or translate the real three-dimensional vase to our two-dimensional canvas surface. The accuracy and subtlety of our reading of the color qualities will determine how convincing the two-dimensional illusion will be. This ability does not come overnight or even after a month or two. We develop the ability to read color and translate it onto the canvas surface over a long period of time. We must be patient with ourselves and enjoy learning to "see" and "read" color as we practice and paint. Don't forget that old masters spent most of their working time painting. They were painters by profession and only after years spent as apprentices in master painters' workshops.

Using the Limited Palette

To begin, we will not use the entire range of colors in our paintings. Instead we'll use a select few, to discover how they interact with one another, then add another group, until we have built up to a complete palette.

There are three basic color groups:

Basic group 1. White, burnt umber, ultramarine blue, alizarin crimson, naples yellow.

Basic group 2. Cadmium red scarlet, cadmium red pale, cadmium yellow medium, phthalo (phthalocyanine) green.

Basic group 3. Phthalo (phthalocyanine) blue, chrome oxide green, rose red, cadmium orange, violet.

Basic group 1 of the limited palette yields innumerable grays, which can be manipulated to be made warm or cool, blue or

green, violet or brown. This group will teach you to mix colors and see subtle differences between "color" grays rather than relying on buying dozens of tubes of gray colors or simply mixing black and white.

Exercise 9: Mixing Grays

> Using basic group 1, mix twenty different grays.
> Sample combinations:
> *Black* can be made from burnt umber, alizarin crimson, and ultramarine blue.
> *Green* can be made from ultramarine blue and naples yellow.
> *Violet* can be made from ultramarine blue and alizarin crimson.
> All the above mixtures can be shifted to gray by adding other hues.

Warm Versus Cool

Mixtures can be either warm or cool as well. Warm colors seem to have qualities that we associate with warm things in nature, such as the yellow of the sun or the red orange of flames. Cool colors are those we associate with water and green plants. Warm and cool are relative terms, because reds and yellows can be cool, while greens and blues can be warm. But we can define these terms and learn to distinguish them by examining colors as they appear when they come out of the tube, that is, their inherent qualities.

Intrinsically warm colors. Burnt umber, naples yellow, cadmium red scarlet, cadmium red pale, cadmium yellow medium, chrome oxide green. Intrinsically warm colors might communicate love, life,

warmth, birth, abundance, and resurrection. However, discretion is advised when using color symbolism. It can be quite varied from century to century, old master to old master, and country to country. For example, Italian artists often use cadmium red on Mary Magdalen, but northern European artists have used the same hue on the Virgin Mary.

Intrinsically cool colors. Ultramarine blue, alizarin crimson, phthalo green, phthalo blue, rose red, lemon yellow. Intrinsically cool colors might communicate death, desolation, despair, betrayal, or doom. On the other hand, a color like ultramarine blue can be associated with goodness and purity, as in the hue of the Virgin Mary's dress in many Italian Renaissance works.

In addition, the white or black you use may have an influence on the allover tone.

White. Zinc white tends to have a yellowing factor, resulting in a warm tone. Titanium white tends to have a bluing factor, resulting in a cool tone. Permalba is a mixture of both titanium and zinc, so it is a good choice.

Black. Mars black tends to have a yellowing factor, resulting in a warm tone. Lamp black tends to have a bluing factor, resulting in a cool tone. Black can also be made from colors in our limited palette and need not be purchased.

Transparent Versus Opaque Colors

Colors have different degrees of opacity; they are either inherently transparent or completely opaque, right out of the tube. *Transparent colors* are see-through; they do not completely cover or block out the color or canvas underneath them, unless they are layered many times or mixed with an opaque color.

Transparent colors need a little white added to them to bring them to their highest intensity and to make them opaque. Any opaque color added to a transparent color will make it less transparent.

Some transparent colors are: Ultramarine blue, alizarin crimson, phthalo green, phthalo blue, rose red, and violet.

Opaque colors are not see-through; they have good coverage and can easily block out other colors.

Some opaque colors are: burnt umber, white, naples yellow, the cadmium reds, cadmium orange, cadmium yellow, and chrome oxide green.

Basic group 2 will give us our bright colors, to create special relationships with the grays we learned to create from group 1.

Basic group 3 will yield hues we cannot create from our limited palette.

General philosophy of color mixing: If you can mix it, don't buy it straight from the tube. Why? First, it saves money. Second, it is much more challenging and fun to create your own color mixtures. Third, there is a realistic limit to the number of colors that you can keep on your palette at one time without going crazy.

Color Experiments

The following projects are exercises that will yield a great learning experience and should be done prior to attempting to paint from life or invented imagery. Try to view these as meditative experiences and enjoy and savor the placement of one color against another.

Exercise 10: Bright Colors

1. Using basic group 2, place a few bright colors at different points of the canvas.
2. Then using basic group 1, surround the bright colors with many different grays (at least thirty) derived from your limited palette.
3. Notice how different colors react to one another, for example, a cool hue against a warm hue, or a light blue against a dark violet.

Exercise 11: Analogous and Complementary Colors

1. Using analogous hues, which tend to be consonant and harmonious, create a painting with a joyous religious or spiritual theme. For example, choose the following hues: blue, blue blue green, blue green, green, green green yellow.
2. Using complementary colors, which tend to be dissonant and aggressive, create a dramatic or grave religious or spiritual painting.

Color as Symbolism

Not only can color theories, like analogous harmony and complementary colors, have meaning, but specific colors also have accepted symbolic meanings.

Black symbolizes death, mourning, and penance.

Blue symbolizes truth, purity, and fidelity. Mary is depicted in blue in most Italian Renaissance and baroque paintings.

Brown signifies mourning, humility, and lifelessness.

Gold symbolizes mystical light, the light of God.

Gray represents mourning and lifelessness.

Green signifies life, hope, fertility, and resurrection.

Red symbolizes love, hate, passion, sin, or power. It is associated with blood and fire. Most often Mary Magdalen is depicted in a red gown.

Violet is associated with sorrow and penitence. It can sometimes represent love and truth. Mary is sometimes depicted wearing a violet robe after the crucifixion.

White represents innocence, virginity, purity, and faith. Christ is often depicted in a white cloth or robe. Mary, at times, is depicted in white during the Assumption.

Yellow, like gold, is associated with the light of God and the sun. In a positive setting, it can be representative of divine intelligence and truth. In a negative sense, it can be associated with cowardice, jealousy, or treason. Judas often is depicted in yellow.[1]

By using hue, value, and chroma, warm and cool colors, and transparent and opaque colors in their proper relationships and combining them with symbolism, we can create a unified religious painting.

Now we are ready to take a look at the materials we need to use to create our paintings.

6 Materials

In order to begin painting we must know about the materials we use: painting media, supports and grounds, and tools. In other words, we need paints (painting media), something to paint on (supports and grounds), and brushes (tools).

Painting Media

Originally oil paint was only used for biblical manuscript painting in the eleventh and twelfth centuries. Its popularity for use in religious panel painting began to grow in northern Europe in the fifteenth century and on canvas in Venice, Italy, in the sixteenth century. Oil paint was the most popular medium from the seventeenth century until the 1940s, when acrylics became available to artists.

In the past, before artists could begin a religious narrative or icon, they had to go through a time-consuming process of manufacturing their own paints. Great care was taken to make sure that the proper amounts of ingredients were used. They would start by grinding pigment, which is the component of paint that gives it its color. The pigment was then mixed with a drying oil to hold and suspend the pigment. Finally, a binder was added to hold all the ingredients together and help the paint adhere to the painting surface. Luckily, we can purchase oil paints in tubes that are ready to use, allowing us more time to pay attention to form and religious content. There are several brands of paint, and they usually come in two grades: student and professional. The student grades tend to have less pigment and are therefore less expensive. They are fine for the beginner. Some brands are creamier; some are drier. You will probably develop your own preferences. For now, it will be easier to work with paints that are not too dry.

You can add additional drying oil to paint in order to manipulate and mix it. Most

painters use a combination of drying oil and a solvent to form what we call a *medium*, which they mix with paint from the tube as they paint. Unlike solvents, which evaporate, drying oils gel and then harden to form a permanent surface.

Popular Drying Oils

Some popular drying oils are linseed oil, made from the seed of flax plants, the best types of which are cold pressed or refined; sun-thickened linseed oil, which dries faster than common linseed oil; stand oil, which is a heated linseed oil and dries more slowly than common linseed oil. Stand oil is best, because it yellows least and blends easily. Other oils are walnut, poppyseed, and safflower, though these are not widely used.

Solvents and Thinners

Solvents and thinners are colorless liquids used to dilute oil paints and other oil-based materials. They evaporate while the paint is drying and add no binding quality to the paints. In fact, they are used to clean brushes, which tells us that they can break down the binder, when used straight. The two most popular solvents are *pure spirits of gum turpentine*, which are distilled from the gum of pine trees, and *rectified turpentine*, which is pure spirits of gum turpentine strained through cheesecloth. (Please note that you should avoid wood turpentine, which is not as refined as gum turpentine.) *Mineral spirits*, which are distilled from crude petroleum oil, are also popular. Paint thinners are a petroleum product that can replace solvents, but are usually of poor quality. The best replacement for pure spirits of gum turpentine is

rectified petroleum, which is completely odorless and has a good texture. Many people use rectified petroleum because they are allergic to the smell of turpentine and common paint thinners. Various manufacturers have produced products with brand names that are comparable to rectified petroleum.

If a rash develops on your hands from the use of any solvent or thinner, wear surgical gloves when painting or switch from oils to a water-based paint. Oil paints that can be thinned with water have also recently become available.

Keep a jar of solvent or thinner next to your palette, so you can clean your brushes as you paint. Wipe your brush of any excess paint before dipping it into the jar of solvent. This will keep your solvent cleaner longer and your brushes in better shape. If you wish to save your solvent or thinner, put a lid on the jar and allow the paint particles to settle to the bottom. Then transfer the clear liquid to another jar, making sure not to pour the settled material with it.

Varnish and Mixing Media

Varnish is a clear solution of a resin in a solvent and is basically used as a pigment-binding material or to protect the paint surface. Three basic types of varnish are used by artists: picture varnish, retouch varnish, and mixing varnish.

Picture varnish is used as a final coating to a painting for the sake of protection and a uniform surface. Usually an artist waits from six months to a year to varnish an entire picture surface. This waiting period allows for the different drying times of various pigments. Some artists prefer to varnish a painting several weeks after its

completion, when the paint appears completely dry to the touch, in order to prevent dirt from settling into the surface. Picture varnish can be applied with a large, dry brush, or it can be used in spray-can form. To avoid dripping and running, be careful to apply the varnish in a uniform manner, while the painting lies flat on the floor. If you use a spray varnish, hold the can at least ten inches from the picture surface, following the directions on the can. Leave the painting flat on the floor to dry; when it become tacky (about fifteen minutes), you can prop it up. Varnish gives paintings a definite glow; an artist who wishes to create religious works that emphasize warmth and mystical light might want to choose a gloss varnish.

Damar varnish, which is damar resin dissolved in turpentine, is the most popular liquid picture varnish, available in a bottled liquid or a spray can. Synthetic varnishes or mixtures of damar and synthetics are also available in spray-can form.

Retouch varnish is used during painting or when retouching a dry painting. Damar retouch varnish in a spray can or bottle is most popular. Regular damar varnish can be used, combined with two or three parts of turpentine, in place of damar retouch varnish.

It is important to varnish your work in a well-ventilated room.

Your choice of varnish should go hand in hand with your particular religious subject. Spend some time examining the surfaces of various old masters' works. For example, a glossy varnish might suit a joyous subject, whereas a matte varnish would suit a severe one.

Mixing medium is combined with oil paints during the painting process to create a workable-texture paint. Some artists use damar varnish in their mixing medium to protect against dampness. The general mixing medium contains one third drying oil, one third turpentine, one third mixing varnish. Because it creates glare, making the colors applied to the canvas hard to read, and it tends to yellow the paint, some artists prefer not to include mixing varnish in their mixing medium.

Recipes for mixing media:

1. Thin mixing medium: ¼ stand oil, ¾ solvent
2. Thick mixing medium: ⅓ stand oil, ⅔ solvent
3. General mixing medium: ⅓ stand oil, ⅓ solvent, ⅓ varnish
4. Glossy mixing medium: ½ turpentine, ½ mixing varnish

Pour the measured materials into a clean glass, Pyrex, or ceramic jar or small bowl and shake or mix until they are fully blended. Your container should be a relatively light color so that you can see when the medium is dirty. It is not necessary to keep a lid on the jar or bowl, although some artists do in order to preserve it. Avoid touching the bottom of the jar when you dip your brush into it; this will keep your mixing medium cleaner. Of course, you should use a medium that best suits your needs. Some artists find that there is enough oil in paint and that they do not need a mixing medium, while others add a great deal of oil to their paints. Experimentation will undoubtedly aid you in making a decision.[1]

Oil Paints

Any of the brand-name paints on the market today will provide you with ade-

quate oil colors, for example, Shiva®, Grumbacher®, or Winsor & Newton®. As with any other product, some people prefer certain brands. You must decide for yourself, after experimenting for a while. All these brands can be used together, as long as they are all oils. As a rule, oils and acrylics don't mix. Higher-priced, higher-quality paint is also available in tubes (but the price difference warrants a special purpose for such colors).

If you are interested in making your own oil colors from scratch, methods are available in texts on artist's materials.

A basic limited palette might include the following colors:

> White: Titanium, zinc, or permalba
> Blue: Ultramarine blue and phthalo (phthalocyanine) blue or Prussian blue
> Brown: Burnt umber
> Yellow: Naples yellow and cadmium yellow medium
> Red: Cadmium red scarlet or cadmium red pale
> Red violet: Alizarin crimson
> Green: Chrome oxide green or viridian
> Green blue: Phthalo (phthalocyanine) green

For more information on each color, see chapter 5.

Supports and Grounds

Canvas

Canvas, which refers to any stretched fabric, is usually made of cotton or linen, then primed with a ground. The sizing (glue) and ground (which can be either oil based or water based) form a layer between the paint and the fabric. Stretched canvas has been the most widely used support for painting since the seventeenth century. It is durable, flexible, and wonderful to work on, unlike canvas boards and wood panels, which have no give or flexibility. Painterly religious paintings, like those by Rembrandt, utilize canvas to provide elasticity and texture thereby endowing their subjects with a natural quality. (Canvas boards are not at all recommended to anyone!) Wood panels are generally used for a specific type of religious painting, for example, very detailed, linear painting done with a very small brush.

We can purchase prestretched canvases that have a ground on them. These products are rather expensive (considering their relative quality) and rarely come in any material but cotton duck with a water-based ground. Constructing stretched canvases can be much more economical in the long run, as well as offering a greater variety of materials. At first, the investment may seem large, because we usually purchase canvas by the roll or yard when stretching our own. But in the long run, each canvas costs less than buying an equivalent number of prestretched canvases.

Constructing your own canvases:

> *Advantages:* Choice of cotton duck or linen
> Choice of primed or unprimed
> Choice of water-based, oil-based, lead-based, or glue-based priming that you can buy or prime yourself
> Choice of odd-sized stretchers and shapes
> Cheaper in the long run
> *Disadvantages:* Time consuming
> Initially difficult to construct your own
> Difficult making sure they are squared up and even

Lead priming and glue priming are toxic and should be done in a very well ventilated room

In order to stretch your own canvases, you will need the following materials:

Stretcher strips
Hammer (a special rubber-headed hammer is preferable)
Staple gun and staples or tacks
Stretching pliers (or you can use your fingers, if you're strong)
T square

Steps to stretching a canvas:

1. Fit the corners of the stretcher bars together. You will notice that the stretchers have a front and a back. The front side has a protruding ledge, which will face the canvas. Assemble the stretcher bars tightly, making sure the corners are at right angles. Use a hammer to gently tap them into place.
2. Check the assembled stretcher frame with a T square or the corner of a door frame.
3. Cut a piece of canvas. When cutting, leave enough canvas at each side (about a 2-inch margin) so that you will be able to grasp the material with the pliers.
4. Place the canvas facedown. Lay the stretcher frame on top of the canvas, with its front side facing the canvas. Make sure the weave of the canvas is parallel to the stretcher frame.
5. Place a staple or tack in the middle of any one bar; then pulling the opposite side of canvas taut, place a staple in that side's bar.
6. Do the same for the other sides. You

should now see a diamond-shaped pull in the canvas.
7. Stand the canvas on one side and remove the first staple or tack. Replace it with another staple or tack after you have pulled the canvas tighter. Do this on all sides. (This step is only necessary for large canvases.)
8. Place evenly spaced staples on all sides, always pulling the canvas.
9. The canvas should be stretched very tightly.

Panels as Supports

Wood panels were used as supports for religious oil painting and tempera painting long before canvas. Wood panels, which are usually mahogany, poplar or oak, must be treated before we can paint on them. First a few layers of sizing should be applied. Use animal-skin glue, bone-glue size, or casein glue (milk glue). Then apply a ground, which is the layer between the sizing and the paint. The ground yields a satisfactory painting surface, and can be oil based, gesso (water based), or an emulsion. Oil grounds are generally made from a mixture of turpentine, linseed oil, and flake white. Gesso grounds are made from glue sizing and whiting. An emulsion ground is a mixture of white pigment suspended in oil and glue sizing. Sizing is not necessary when using a gesso ground.

To avoid warping, wood panels may also need to be braced on the back with wood battens.

Chipboard, hardboard, laminated boards, and cardboard are other materials used for panel painting. All require sizing/priming on both sides in order to prevent warping or buckling. Materials such as muslin or paper can be attached to these supports.

Metal plates, made of copper, aluminum, or zinc, can be used for panel painting. No sizing or ground is necessary, but the surface must be roughened in order to hold the paint.

Tools

Brushes. Oil-painting brushes are usually either made of expensive red sable or inexpensive man-made bristles. Have a variety of sizes and shapes with which to experiment. Pointed brushes are used for details, outlines, and drawing. Flats and brights are used for covering large areas of canvas and special effects. Large rounds are used for special effects, such as scumbling.

Palette knives. They can be used for mixing large quantities of paint or for applying paint.

Palettes. A palette is a flat surface that holds the paints and is also a mixing surface. Some artists have one palette for their paints and one for mixing.

Palettes are made of wood, Plexiglas, glass, plastic, or disposable wax paper. Disposable palettes come as a pad, like paper, and are very convenient. You use them once and throw them away, no cleaning, no mess. All other palettes must be cleaned after mixing on them. Most people scrape them with a single-edge razor blade, then wipe them clean with a rag wet with thinner or solvent. Palettes come in various sizes. A small palette will obviously leave little room for mixing. It is preferable to have a large-sized one, with a good deal of space for mixing.

Mahlstick. A mahlstick, which is a stick that is used to support your arm, is particularly good for painting in great detail. You can buy ready-made aluminum mahlsticks in different lengths (from about twelve to thirty inches long) with rubber tips, or can make your own, using a shortened broom handle, cotton stuffing, a chamois cloth, and a wide rubber band. Place the cotton stuffing at one end of the stick, cover it with the chamois cloth, and fasten it to the broom handle with the rubber band. This cushioned end will rest against the canvas and be held by one hand, and you will rest your painting arm on the stick for support.

Oil Painting Techniques

Oil paint can be used in many ways to achieve many different effects. Once you become familiar with the medium, you can begin to experiment with different styles and techniques. Choose the technique appropriate to the subject of your painting (*see* chapter 7).

Wet into wet. When the first layer of paint is still wet, the artist paints or scumbles into it with other colors and brushstrokes. The colors are allowed to merge, run into one another, and the brushstrokes may remain totally visible. Artists such as Rubens, Velázquez, Rembrandt, Manet, and Monet all painted wet into wet. The slow drying time of oils allows us to utilize this technique.

Painterly. This technique utilizes visible brushstrokes; loosely applied, generous amounts of paints; unclear edges; the buildup of textures; and forms that can merge with one another. Paint is applied thickly, with a greater amount of oil, and color is generally broken. Artists such as Rembrandt, Rubens, Titian, Velázquez,

Daumier, and Manet used the painterly technique (which is akin to painting wet into wet). A flat, bright, or round brush is used.

Scumbling. Using a relatively dry brush, one layer of opaque paint is applied in an uneven manner over a former layer of (darker) opaque paint, so that the first layer is still somewhat visible through the second layer. The motion of the wrist should be quick, and the touch should be light. A bright or round brush is used.

Premier-coupe ("one-shot") painting. Some artists set out to finish a painting in one sitting, so their original brushstrokes are meant to stay. The rapid application of paint fosters wet-into-wet painting and the use of opaque colors. Artists who created one-shot paintings maintaining opaque full-bodied colors are Manet and Monet. Some artists, such as Pierre Bonnard and Henri Matisse, looked at this procedure differently. They thinned down their paints in order to paint rapidly.

Underpainting. Especially during the early Renaissance, artists first painted their tones in grays (*grisailles*) or muted colors before applying glazes of color. Underpainting establishes a light-and-shadow schema, upon which they then built up layers of color. After the grays dry, the artist builds up smooth layers of color, maintaining the underlying tonal (value) relationships.

Glazing. Glazes are transparent colors or thinned opaque colors mixed with a great deal of medium, either oil or beeswax. Since they are transparent or thinned colors, light reflects the color beneath them. Glazes can be built up over a period of time and can be used over underpainting, scumbled areas, opaque paint, and impasto (*see* below). Early users of oil paints, such as Jan van Eyck and Rogier van der Weyden, used glazes to create luminous colors. Later artists such as Andrea del Sarto and Jean Auguste Dominique Ingres also used glazes to build color and skin tones. The luminosity of color can be symbolic of spiritual light or a holy presence (*see* plate 14).

Layered painting. Included in this category are glazing and underpainting. Besides these two techniques, there is the method of building one opaque layer on top of another over time to increase the density, atmosphere, and quality of the painted illusion. There is a major difference between the amount of built-up atmosphere in a layered painting as opposed to the atmosphere created in an opaque one-shot painting. The creation of a natural atmosphere in a painted illusion can make the viewer feel closer to a religious subject; the viewer can associate with naturally depicted images and air that they see in their visual world.

Impasto. When thick paint is applied to the surface and allowed to remain to create a textural or three-dimensional appearance, it is called impasto. Glazes can be used over impasto. Sand or marble dust can be added to oil paint to create textured surfaces. Many religious subjects emphasize the sense of touch, whether they refer to nature, as in depictions of Saint Francis, or to the human use of this sense, as in the subject of Doubting Thomas.

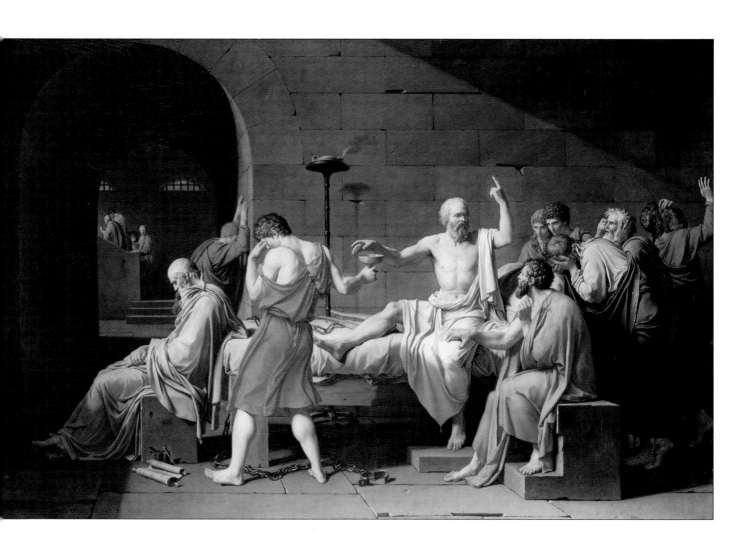

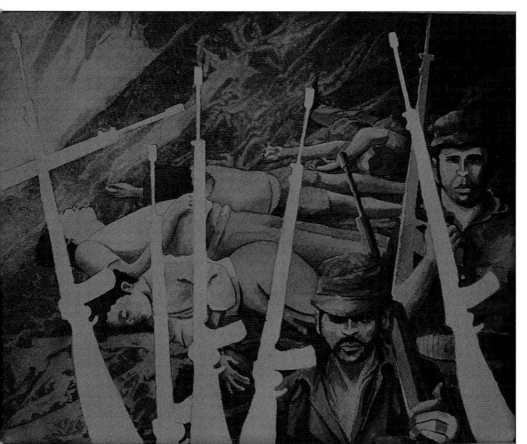

PLATE 1: *(above)* Jacques L. David, *The Death of Socrates*. The Metropolitan Museum of Art, Wolfe Fund, 1931. Catherine Lorillard Wolfe Collection.

By choosing this classical theme, David established an alliance with history. *The Death of Socrates* is therefore much more than a reportorial rendering. It symbolizes David's convictions, ethics, and the spirit of the time.

PLATE 2: *(left)* Margaret Beaudette, S. C., *Four Martyrs: Death in El Salvador,* 1983, watercolor on paper, 17" x 20", used by permission of the author.

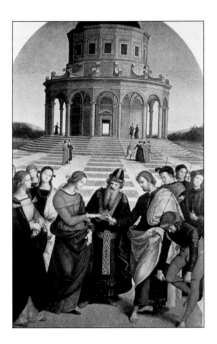

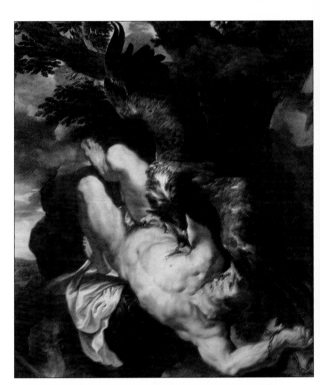

PLATE 3: *(left)* Raphael, *The Marriage of the Virgin*, c. 1504, courtesy of the Pinacoteca di Brera, Milan, Italy.

This early work by Raphael is, in Wolflinn's terms, linear, planar, closed, and utilizes multiplicity. In Ortega y Gasset's terms it utilizes proximate vision.

PLATE 4: *(right)* Peter Paul Rubens, *Prometheus Bound*, oil on canvas, 95⅞" x 82½", courtesy of the Philadelphia Museum of Art, the W.P. Wilstach Collection.

Wolflinn would categorize this painting as painterly, recessional, open, and utilizing the principle of unity. Ortega y Gasset would call this style distant vision.

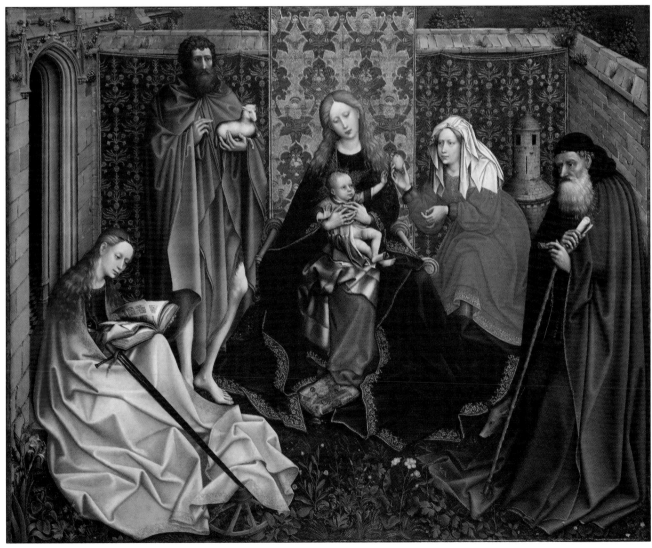

PLATE 5: Master of Flemalle (Robert Campin), *Madonna and Child With Saints in the Enclosed Garden*, courtesy of the National Gallery of Art, Washington, D.C., Samuel H. Kress Collection.

Iconography and symbolism are very important parts of this painting and almost all other paintings of the same period. The style of proximate vision allows us to see each and every object as though we were looking at them up close. Each form is rendered with solidity and in detail, which allows us to see it clearly and recognize its potential symbolism.

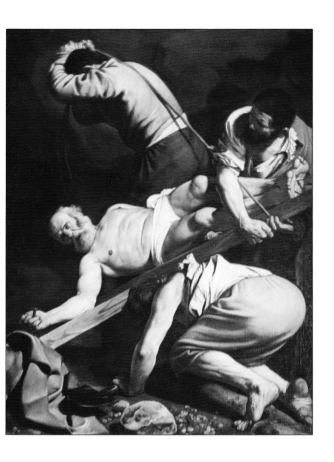

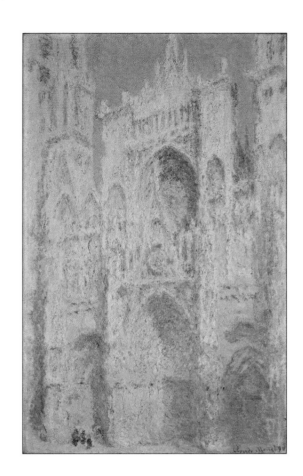

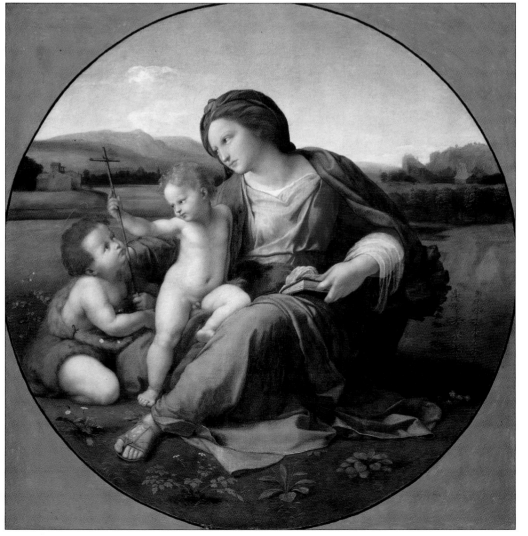

PLATE 6: *(above left)* Caravaggio, *Crucifixion of St. Peter,* Cerasi Chapel, courtesy of Santa Maria del Popolo, Rome.

PLATE 7: *(above right)* Claude Monet, *Rouen Cathedral, West Facade, Sunlight,* 1894, oil on canvas, 39½" x 26" (1.002 x 0.660), courtesy of the National Gallery of Art, Washington, D.C., Chester Dale Collection.

Artists in the nineteenth century became obsessed with perceptual painting, painting from life, and the investigation into the way they truly perceived reality. Monet attempted to visually record his perception of space, color, and form. His idea of recording visual perception acted to further remove him from the thing seen and move him closer to his own inner vision.

PLATE 8: *(left)* Raphael, *The Alba Madonna,* c. 1510, transferred from wood to canvas, diameter: 37¼", (0.945), courtesy of the National Gallery of Art, Washington, D.C., Andrew W. Mellon Collection.

A round canvas is called a *tondo.* Vertical, horizontal, and diagonal lines are dynamic within tondos, since they do not repeat the edge of the canvas; curves are static or calm elements, since they do repeat the container edge. We associate curves and tondos with human gestures of warmth; the embrace is a curving gesture. Placing the Madonna and Child in a tondo reiterates the mother-and-child bond and communicates a loving religious embrace.

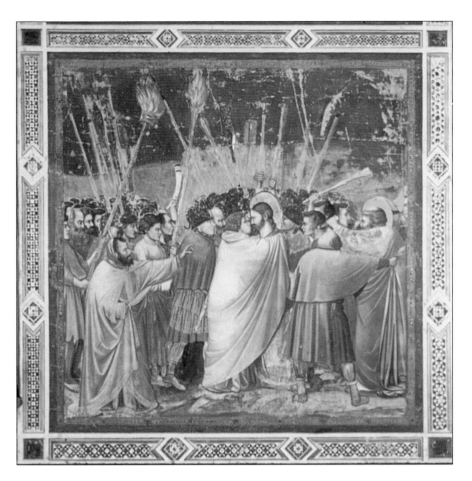

PLATE 9: Giotto, *The Kiss of Judas the Betrayal,* courtesy of the Arena Chapel, Padua.

Forms that are at counterpoints, as the figures and staves are in this work, are dissonant and violent. Opposing diagonals react with great energy against one another and the container's edge.

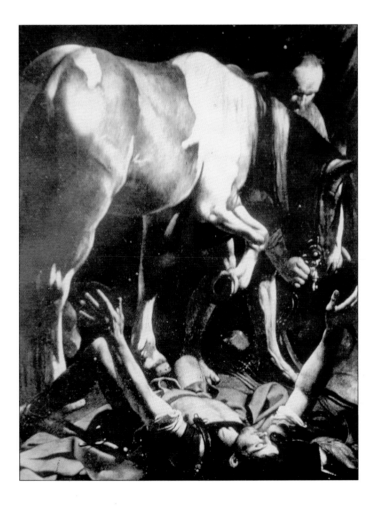

PLATE 10: Caravaggio, *Conversion of Saint Paul,* beginning of the seventeenth century, courtesy of Santa Maria del Popolo, Rome.

The intensification of forms through the use of extreme light and dark, the large-scale figures and horse, and the angles of the forms in relation to the picture plane yield an enormously powerful interpretation of the conversion of Saint Paul. Use of the formal elements of light and shadow, scale, and composition arouse the drama beyond the literal level.

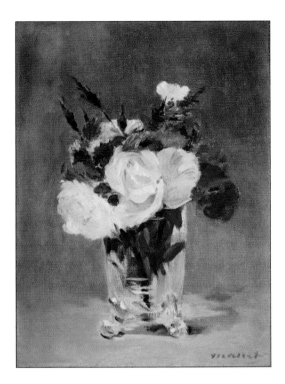

PLATE 11: *(left)* Edouard Manet, *Flowers in a Crystal Vase*, 12⅞" x 9⅝", courtesy of the National Gallery of Art, Washington, D.C., Ailsa Mellon Bruce Collection.

PLATE 12: *(below)* Paul Cezanne, *Still Life*, c. 1900, oil on canvas, 18" x 21⅝" (0.458 x 0.549), courtesy of the National Gallery of Art, Washington, D.C., Gift of the W. Averell Harriman Foundation in memory of Marie N. Harriman.

Cezanne's patches of color are planes that move with and describe forms. This method is excellent for invented figure compositions. It will allow you to work all over the canvas and orchestrate the composition with broken color.

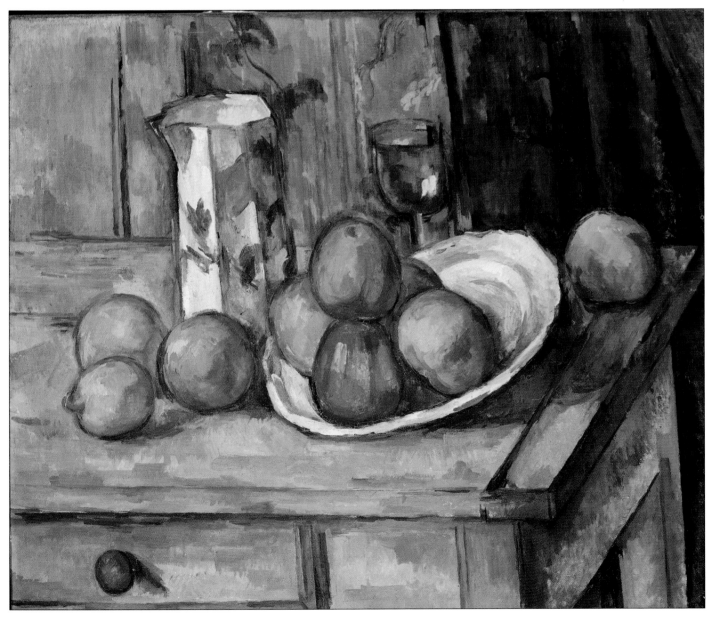

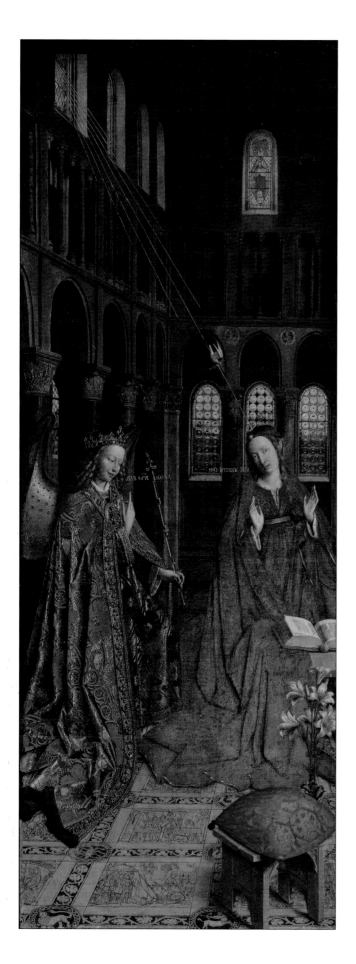

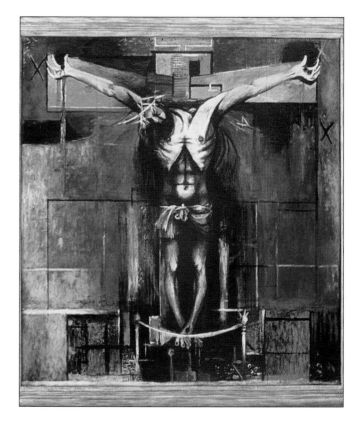

PLATE 13: *(opposite page, top)* Edward Hopper, *Ryder's House*, 1954, oil on canvas, 91.6 cm, x 127.0 cm, courtesy of the National Museum of American Art, Smithsonian Institution, bequest of Henry Ward Ranger through the National Academy of Design.

PLATE 14: *(left)* Jan van Eyck, *The Annunciation*, c. 1425/1430, transferred from wood to canvas, 36½" x 14⅜" (0.930 x 0.365), courtesy of the National Gallery of Art, Washington, D.C., Andrew W. Mellon Collection.
 Jan van Eyck's use of a linear style and proximate vision lends great solidity and tactile qualities to his paintings. Even in this work, where we see the presence of God depicted in the form of symbolic light rays during the Annunciation, the linear style allows for a mix of real and mystical qualities. The facts that all forms are treated equally and all forms have distinct edges aid in the unification of the picture space.

PLATE 15: *(opposite page, bottom)* Audrey Flack, *Baba*, 1983, oil and acrylic on canvas, 90" x 156", courtesy of the Louis Meisel Gallery, New York City.
 Eastern icons are part of a spiritual process rather than an end in themselves. Perhaps painting icons is a way of experiencing the spiritual joys of a religion.

PLATE 16: *(above right)* Graham Sutherland, *Crucifixion*, 1946, courtesy of St. Matthew's Church, Northampton, England.

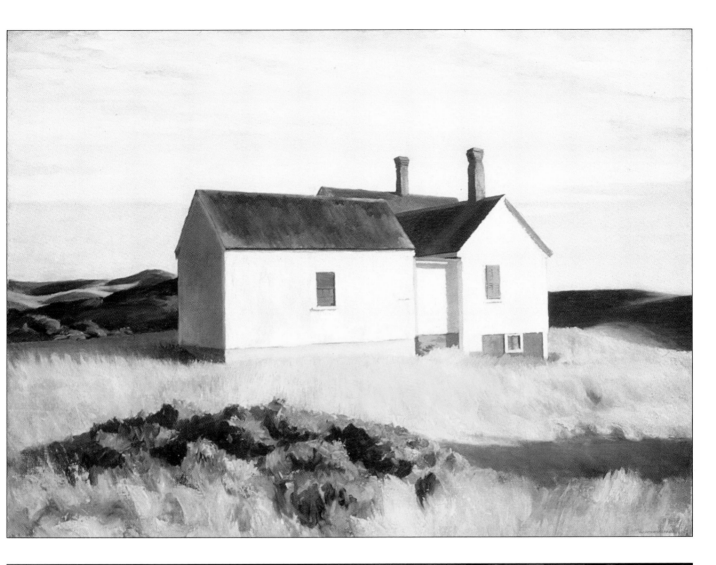

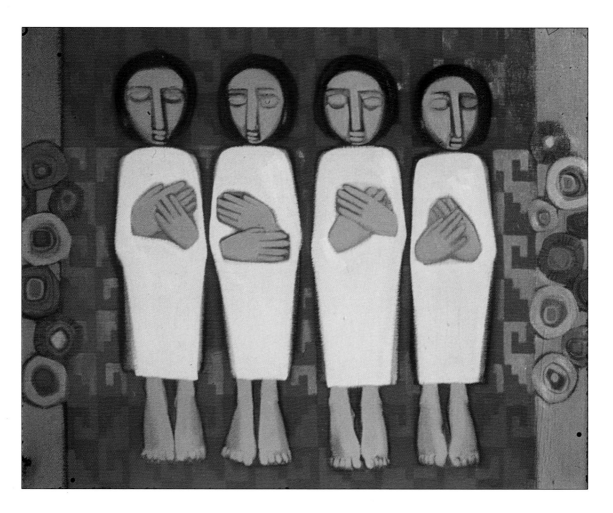

PLATE 17: *(above)* Marion C. Honors, C.S.J., *Four Women Martyrs,* 1981, oil, 22" x 28", courtesy of the artist, Latham, N.Y.

PLATE 18: *(right)* Audrey Flack, *WWII,* 1976– 77, oil and acrylic on canvas, 96" x 96", courtesy of the Louis Meisel Gallery, New York City.

7 Oil Painting Methods

PART I
CHIAROSCURO: PAINTING WITH LIGHT AND DARK

Perhaps one of the most dynamic, exciting, and far-reaching styles in the history of painting is that of chiaroscuro. Literally, *chiaroscuro* is an Italian word that means "clear and dim"; figuratively, it is defined as a style that utilizes only light and shadow to create illusions in painting. Artists of the seventeenth century gave life and fame to chiaroscuro painting.

In the late sixteenth and early seventeenth centuries, an Italian artist named Caravaggio was probably the most important and leading exponent of this painting method. After Caravaggio's chiaroscuro works were seen, the style spread all over Europe. Artists such as Georges de La Tour, in France; Rembrandt van Rijn, in Holland; and Orazio and Artemesia Gentileschi (father and daughter), in Italy, were all

followers of Caravaggio's chiaroscuro style. This new compositional use of light and dark held such dramatic potential in the creation of a highly realistic illusion that the viewing public must have certainly been shocked by the images created through the use of chiaroscuro.

No wonder this style of extreme chiaroscuro painting spread quickly throughout Europe. The heightened realism that comes with this style allows the viewer to feel closer to the subject. When an image is more "real," the average viewer tends to feel the subject is more approachable. Caravaggio's unusual interpretation of *The Crucifixion of Saint Peter* (*see* plate 6), a close-up scene with only four figures and Saint Peter (who is close to us by virtue of his size and position) allows us to sympathize with the event and the faith. Most versions of this scene illustrate Saint Peter upside down on the cross; Caravaggio makes Saint Peter accessible by showing his

struggles on the cross, and we can sympathize with his martyrdom and struggle for his faith.

Caravaggio's *Conversion of Saint Paul* (plate 10) is innovative and powerful. We see Saint Paul from an atypical point of view, at an extremely foreshortened angle. He is lying on the ground, under the massive form of the horse, and we enter the picture's space across his body—a very powerful confrontation. Notice the compositional oval created by Saint Paul's outstretched arms and the horse's body and legs.

Orazio Gentileschi painted *Saint Cecilia and an Angel* (figure 53) several years after Caravaggio had popularized the style. The light and dark, which bathe the figures, give this tender spiritual moment an earthly quality and give the figure of Saint Cecilia great volume and solidity. Notice that the background is a simple dark plane that focuses our attention on the relationship between the figures. Saint Cecilia is large in relation to the size of the canvas, a typical use of scale in the seventeenth century or baroque period. In the Renaissance, figures

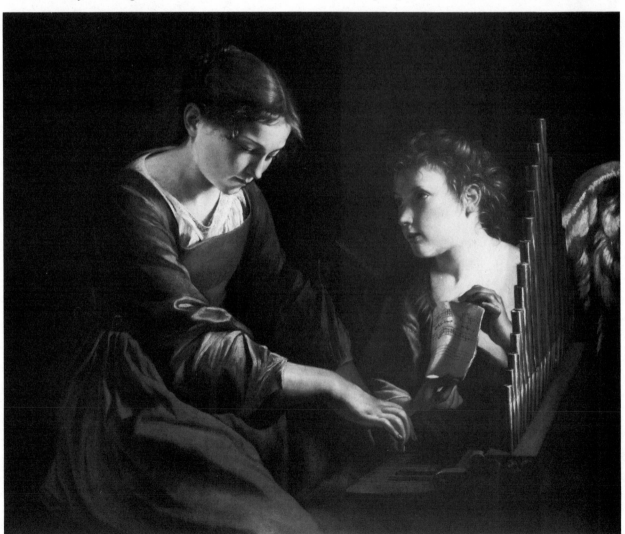

FIGURE 53: Orazio Gentileschi, *Saint Cecilia and an Angel*, c. 1610, oil on canvas, 34⅝" x 42½" (0.878 x 1.081), courtesy of the National Gallery of Art, Washington, D. C., Samuel H. Kress Collection.

The light and dark relationships give the figures a great deal of solidity and a very "human" feeling.

were considerably smaller in scale in relation to the canvas (*see* plate 3).

Georges de La Tour's painting *The Repentant Magdalen* (figure 54) gives a different twist to the chiaroscuro style. This work, as well as most of his others, illustrates the source of light in the painting, in contrast to the Italian artists, who used either a side window or did not show the source of the light within the painted image. The light from the candle gives the painting a poetic and spiritual glow. The candle seems not only to illuminate Mary Magdalen's figure, but also her thoughts. Her left hand, which touches the skull, is extremely dark in contrast to her shirt sleeve, which it overlaps; this creates spatial depth, pushing her hand in front of her sleeve. The full, seated figure of Mary Magdalen fills the entire height of the container; we feel physically close to her. The back wall is barren, although an interesting negative shape, and we focus our attention on the figure and objects in the foreground. Mary Magdalen's attitude of repentance is magnified by her contemplation of the skull (a symbol of death) and its reflection in the mirror into which she gazes.

Is it hard to imagine that one of the greatest and most famous painters that ever lived was a follower of a painting style? only if we put the importance on the innovation of the style rather than the way in which the painting medium was used to communicate meaning. Unlike many of his Dutch Protestant countrymen in the seventeenth century, Rembrandt painted many biblical scenes and themes from both the New and Old Testaments in a chiaroscuro style. Dark browns or burnt-umber hues dominate *The Circumcision* (figure 55) and allow the lights to glow miraculously from within. Rembrandt's lights do not seem to have a "real"

source. They seem to come from inside the figures caressing and caring for the forms that they touch.

The Descent From the Cross (figure 56), by Rembrandt, is beautifully composed in terms of interrelating gestures and light and shadow. The light illuminating Christ also illuminates Mary, illustrating their shared pain. Christ and Mary are also linked by the curving gestures of arms and drapery that lead our eyes from one to the other.

The chiaroscuro style spread so rapidly and with such great fury that painting was never the same again. Artists ever since cannot ignore the power of this style. Let us experiment with this highly dramatic technique.

Exercise 12: Chiaroscuro Painting

The key to this method is that all colors in the shadows will remain the color of the primed canvas: burnt umber. We will only paint the colors that we see in the lit areas and the areas of transition between light and dark.

Setup. Arrange a still life on a tabletop. Light it from one side *only*. A desk-top lamp, extended wall light, or window light will be fine. The light must come directly from one side, and the other side of the still life must be dark. Pieces in the still life should be colorful, including reds, oranges, greens, or blues. The wall or cloth behind the still life and on the tabletop should be dark and will remain the color of the primed canvas. We can add additional drapery on top of the table, if we like, as part of the still-life arrangement. Try to overlap objects and drapery so that there is some compositional connection. If objects do not overlap,

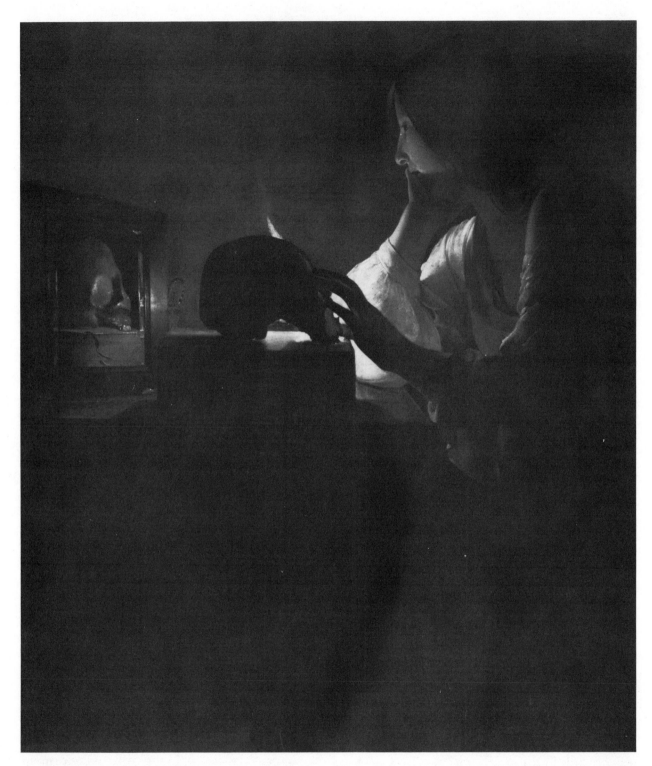

FIGURE 54: Georges de La Tour, *The Repentant Magdalen*, c. 1640, oil on canvas, 44½″ x 36½″ (1.130 x 0.927), courtesy of the National Gallery of Art, Washington, D. C., Ailsa Mellon Bruce Fund.

The supernatural quality of light in Georges de La Tour's painting heightens the implied "Vanitas" subject. We see Mary Magdalen contemplating a skull in front of a mirror. All the objects in the work are involved in the "Vanitas" play. The skull and the lit candle may symbolize the shortness of human life, and the mirror represents vanity and perhaps the vices of Mary Magdalen's past.[1]

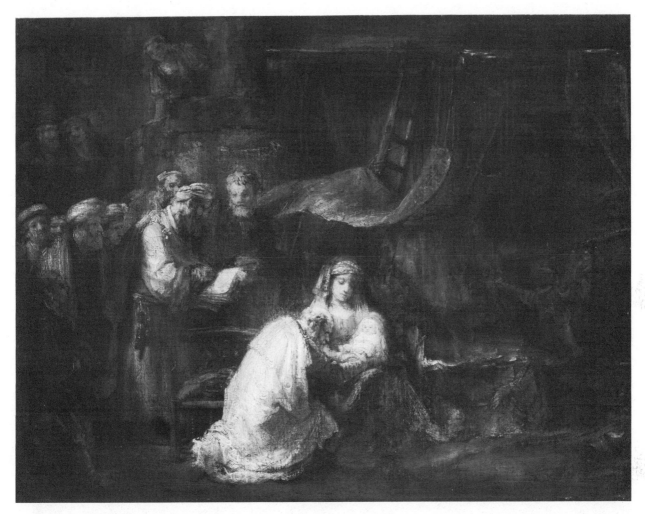

FIGURE 55: Rembrandt van Rijn, *The Circumcision*, oil on canvas, 22¼" x 29½" (0.565 x 0.750), courtesy of the National Gallery of Art, Washington, D. C., Widener Collection.

As a Protestant, Rembrandt was one of the rare artists of his time and origin who was interested in depicting biblical narratives. Usually, he chose narratives rather than "portraits" of God, which is not surprising, given his religious background.

they will disconnect from one another in the pictorial translation.

In preparation. *Materials:* canvas, oil paint in burnt umber, palette, wide bristle brush, jars of medium and thinner, rags or tissues. Canvas size: about twenty by twenty-four inches (don't paint too small or too big for now).

Prepare your canvas a few days before you wish to begin painting. It will take a couple of days for the paint to dry, and you should work on a dry surface. You might want to prepare several canvases at once with different-color primes (for the other painting methods).

1. Covering an entire canvas surface with a large brush can also be very messy. The paint tends to spray off the brush and onto nearby surfaces. I recommend that you cover any exposed walls or furniture.

2. Put a good amount of burnt umber (about three inches) on your palette, and thin it out just a bit with a little

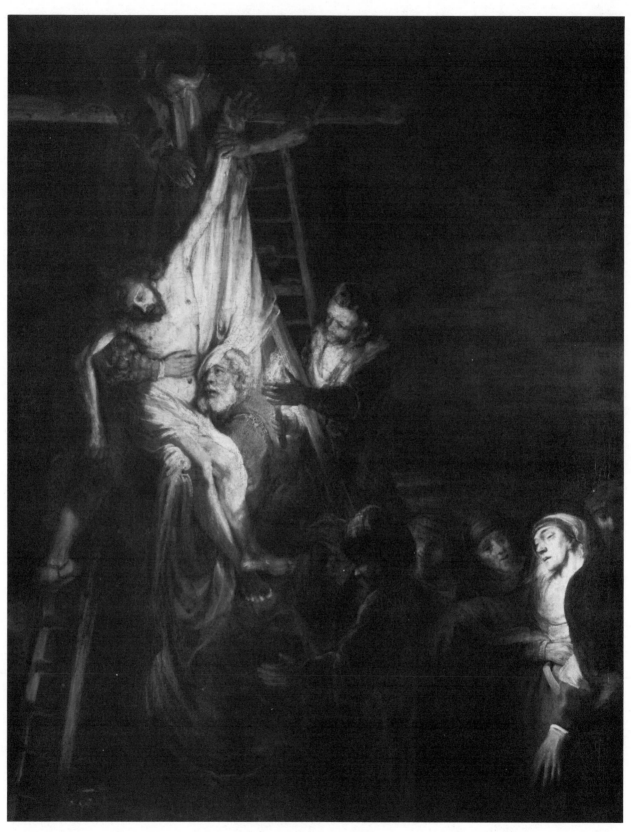

FIGURE 56: Rembrandt van Rijn, *The Descent From the Cross*, dated 165(1), oil on canvas, 56¼" x 43¾" (1.43 x 1.11), courtesy of the National Gallery of Art, Washington, D. C., Widener Collection.

thinner. You can use your brush or palette knife to do this.

3. Using a large bristle brush (one and a half or two inches), cover the entire canvas with burnt umber, using even strokes. The resulting colored surface should not be too thin or transparent, yet not completely opaque.

Preparatory Drawing

In preparation. *Materials:* white charcoal paper, soft vine charcoal, kneaded eraser, fixative. Cover the entire surface of the page with an even coat of charcoal.

Setup. You may use the same setup for the drawing as for the painting, or it might

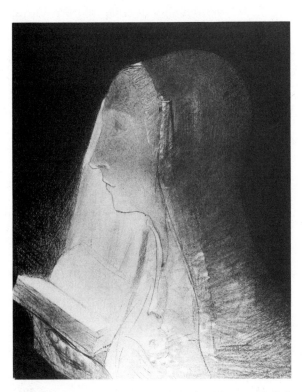

FIGURE 57: Odilon Redon, *Head of a Woman, Veiled,* courtesy of the National Gallery of Art, Washington, D. C., Rosenwald Collection.

The white of the page can take on the quality of light.

be interesting to draw from an old-master work by Caravaggio or Georges de La Tour.

Since you will paint on a canvas toned with a dark tone, burnt umber, cover the entire drawing surface with charcoal, to represent the dark canvas surface. Unlike the oil-painting procedure, you will erase areas of charcoal that represent the light. In the oil painting, paint light hues over the burnt-umber areas, where you see light.

1. Begin by making general judgments about the areas touched by light. Simply erase areas that are light.
2. You can easily make corrections by recovering areas with charcoal.
3. Once you have established the general areas of light and dark, go back into the drawing with the charcoal, accenting cast shadows and darker areas.
4. You can constantly go back and forth with the eraser, which is your tool representing light, and the charcoal, which represents the dark.
5. Spray the finished drawing with fixative.

Drawing on the Canvas. When the canvas surface is dry, you can draw either with charcoal or with paint. Some people feel more secure with pencil, but this tends to be hard on the canvas surface and restrictive.

If you choose to draw with charcoal, use vine (soft) charcoal in thin sticks. Charcoal is easily erased with a cloth or tissue. Before you begin to paint, "blow down" the charcoal on the surface by very simply blowing on the canvas, so that only a bare, light drawing remains. Blow away the excess so that it won't mix with the paint and dirty the colors.

This method of painting creates an extreme contrast of light and dark relation-

ships. All colors that fall in the shadows will remain the color of the canvas: burnt umber. The main point to remember is that the burnt-umber priming on the canvas is acting as the shadowed areas. Primarily, you will paint the areas of color you see in the light, that is, the sides of the objects illuminated by the light source and the areas of transition between the light and dark. For example, if you paint a blue vase, you would paint the bright blue you see illuminated by the light source and would leave the part of the blue vase in shadow the color of the canvas. You wouldn't paint the shadow side a dark blue. You could, however, give just an indication of the blue at the turning edge (this will be explained in detail in the following pages).

The Painting Process

First Session

1. After drawing on the canvas, begin by painting the colors you see in the lit areas.
 - Try to be as accurate as possible in reading the correct hue, value, and chroma of the colors you are painting.
 - If you paint a red vase, is it a cool red or a warm red? a red orange or a red violet? a light red or a bright red?
 - Remember that the direction of your brushstroke will affect the volume and form of the object. Move your brush in the direction of the turn of the volume.
 - Any mistakes can be corrected by going back into the painting with burnt umber.
2. As you paint you should always be rethinking the drawing and composi-

tion. Drawing and composing are ongoing processes.
 - Is the perspective correct in terms of the way we see?
 - Is the scale accurate? Are the sizes of all the objects correct in relation to one another? At which points do the different objects overlap or touch?
 - What is your point of view? Are you in the same position in relation to the setup as when you drew it on the canvas? Do you see the tops of the objects? into the openings of the objects? Be careful to paint what you actually see and not what you "know" to be there.
3. Always keep all the forms or objects in the painting at an equal level of development.
 - The first shot at chiaroscuro painting is a very rough stage. Don't try to do too much too quickly. This method depends upon building up a few layers of paint at different sittings, so the first layer can dry before we apply the next layer.
 - Don't try to render the forms on the first or even second sitting. Be patient and remember that oil painting takes time to develop, and all forms should develop at an equal rate.
 Painting develops as one unit rather than section by section or piece by piece. Don't even begin to worry about details now.

Second Session

1. Take a fresh look at the drawing and composition. Do you need to make any changes or adjustments? It is very easy to correct the drawing, utilizing the burnt umber. If you are having trouble

seeing your new or old drawing marks on the canvas, you can use a hue darker than the burnt umber, by mixing burnt umber with ultramarine blue and alizarin crimson.

2. Add a new layer to the colors that are in the lit areas.

3. Transitional colors: This method requires a color that acts as a middle area between the color in the light and the burnt umber. This area of transition can be subtle and add just enough to soften the shift between light and dark, or it can be a clearly seen third color. It is up to you.

 • The value of the transitional hue is most crucial to the creation of volume; it should be in between the value of the bright hue and the burnt umber. You may use an actual mixture of the two hues or a mixture from the limited palette.

 • Don't expect the transition to be smooth or easy at first attempt—it takes a few applications and quite a bit of manipulation.

 • Several types of brushes, both dry and wet, will be needed to create the volumes. Scumbling and wet into wet painting will aid in the transition.

Pointed Brush: Use this as your main drawing tool.

Small Bright: This brush can get into small places and should move in the direction of the form's volume. You can also use it for drawing and redrawing with burnt umber.

Medium Bright: This brush is used to apply large areas of color and move one color into another, wet into wet and scumbling. Sable brights are best for scumbling.

• Remember, this painting needs at least three sessions. Be patient; it is very difficult to work on an extremely wet painting.

Third Session

1. Now is the time to rethink all the marks you have made on the canvas surface.

 • Do you need to redraw? Look at the painting in a mirror. This will exaggerate any form that is out of drawing. Look at the painting from a distance, to get a new perspective.

 • Are the hues you applied accurate? Do they work?

 • Are your brushstrokes enhancing the volume or making forms appear flat?

2. Add another layer of the colors you see in the light.

3. Rethink the transitional area of color.

 • How much of the form is seen in the light?

 • How much of the form is seen in the dark?

 • How much of a role should the transitional color play?

 • Is the transitional mixture warm or cool? If the transitional color doesn't increase the volume of the forms, change it. It must add volume.

4. Do you see variations of hues in the areas of light or in the transitional color?

 • You may want to vary the hues slightly, maintaining the values so that you don't break the surface of the forms.

5. You may want to paint reflected light at the edge of the form in the dark.

 • Paint a dark value of the reflected hue at the turning edge of the form.

6. Cast shadows behind the edges of reflected light, using a mixture of burnt

umber, ultramarine blue, and alizarin
crimson. This will push the forms
forward in space and off the back wall.

• You may have to go back into the
original burnt umber to differentiate
between the shadow area and the
background color. This will entail
lightening the burnt umber that sur-
rounds the objects and shadows.

7. Make sure all edges are softened. Hard
edges tend to visually flatten surfaces.
Going back into the wet painted edges
with a dry brush may help to soften the
edges. It is also possible to soften edges
by mixing a slightly muted hue and
painting it on the contrasting edge of an
object.

PART II
PAINTING WITH THE NEGATIVE SPACE

Any good painting, drawing, or design
utilizes the concept of positive and nega-
tive space. Thoughtful artists are always
concerned with the way in which the pos-
itive elements (or drawn marks) interact
with the negative element (the so-called
background). Positive shapes can turn the
negative background into shapes as well.

When we view a painting, we do not
merely focus on the painted objects, but
we see the painting as a total unit. The
more we understand the interaction be-
tween the actual solid objects and figures
that we paint *and* the space or background
that surrounds them, the more dynamic
and meaningful our paintings will become
(*see* figure 58).

In the nineteenth century, when artists
began to paint from life, painting became at
times a rapid process. Old techniques, such
as underpainting and layered painting,

proved unsuitable for their new ideas and
rapid perceptual painting. They began do-
ing *premier-coupe* (one-shot) paintings and
developing new techniques to deal with
their newfound subjects and involvement
in perception. Édouard Manet, a nine-
teenth-century French painter who studied
with a master trained in traditional tech-
niques, broke with technical traditions and
innovated techniques. The style of the
painting with the negative space is essen-
tially derived from Manet's work (*see* figure
59).

Your interests might lie with depicting
multiple-figure biblical stories, but that does
not mean this style is not for you.
Multiple-figure composition of religious
narratives doesn't necessarily have to use
one particular style. Similarly, if your
interest is in symbolic still lifes, any style of
painting is open to you. This particular
painterly, wet-into-wet style can be applied
to any religious or spiritual subject.

Exercise 13: Premier-Coupe Painting

This method of painting allows us to
actually draw with the background space
and color! How? First, we prime the canvas
with a color. Second step is painting the
positive objects we see, without worrying
about their outlines or edges. The third step
is to use the same color we used to prime
the canvas to draw the edges of the objects
or figures that we painted.

Setup. This method is most easily learned
with the use of a floral still-life setup. You
may want to use flowers that hold symbolic
or personal meanings.

Place about two or three flowers with ferns
or greenery in a ceramic (light solid col-
ored) or glass vase on a tabletop. The

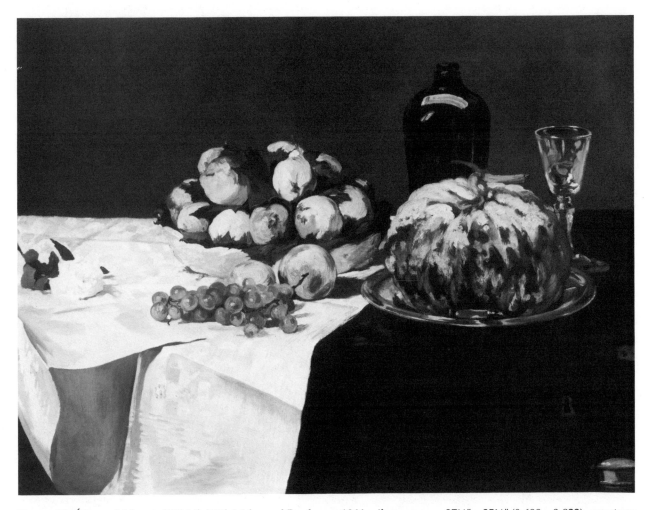

FIGURE 58: Édouard Manet, *Still Life With Melon and Peaches*, c. 1866, oil on canvas. 27⅛" x 35¼" (0.690 x 0.922), courtesy of the National Gallery of Art, Washington, D. C., gift of Eugene and Agnes Meyer.

Notice that the back wall takes on a distinct shape formed by the edges of the objects and back line of the table. The back wall, which is a dark color like burnt umber, can be used to describe and draw the edges of the positive forms (objects).

color of the table or background doesn't matter, because we will translate the back wall or background color and tabletop color to be the color of the primed canvas. It is a good idea to place one flower on the table, crossing in front of the vase. This will help establish the tilted plane of the tabletop. Light the floral arrangement from one side, with a tabletop lamp, wall unit, or natural window light.

Note that artificial flowers are fine for this purpose.

In preparation. *Materials:* canvas, oil paint in burnt umber, palette, wide bristle brush (about two inches wide), jars of medium and thinner, rags or tissues. Canvas size: about fourteen by sixteen inches.

Prepare your canvas a few days in advance; it should be dry to the touch before you begin to paint.

1. Squeeze about two inches of burnt umber on your palette and thin it with

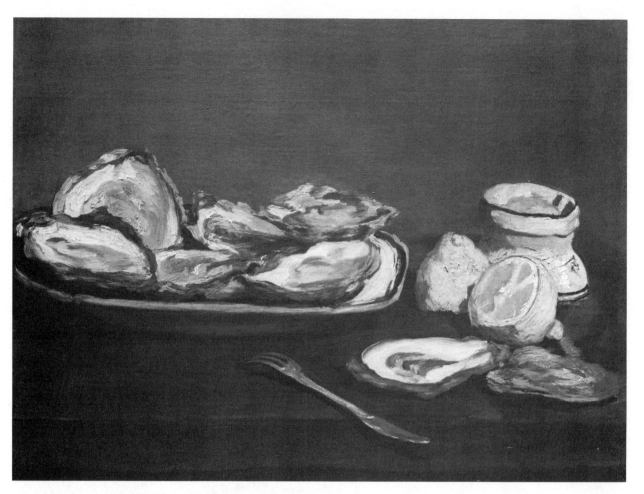

FIGURE 59: Édouard Manet, *Oysters,* oil on canvas, 15⅜″ x 18⅜″ (0.391 x 0.467), courtesy of the National Gallery of Art, Washington, D. C., gift of the Adele R. Levy Fund, Inc.

Visible brushstrokes that move in the direction of the forms they describe give volume to the objects. The turning edge of the table establishes the picture plane, and the fork moves in front of the picture plane into our space.

medium, using a palette knife or a brush wet with medium.

2. When applying a color prime to a canvas surface, the paint tends to spray off the brush. It is advisable to cover nearby surfaces and furniture.

3. Apply an even, thin transparent layer of the burnt umber to the canvas surface. To create an even surface of paint, try to use long strokes that begin at one end and move entirely across to the other end of the canvas.

4. Repeat. Your resulting canvas should have a transparent coating of burnt umber.

Drawing and composing on the canvas. You may want to use the erasure method of drawing to prepare for this painting.

In this technique of painting drawing on the canvas comes at a late stage in the painting process. Begin to paint by approximating the position of the objects and applying the appropriate colors, in terms of hue, value, and chroma, to the canvas with short brushstrokes. After you have painted your perceptions of all the colors in the setup, begin to draw into the colors with burnt umber. You are drawing the outline or contour edges that the objects create with the background. The burnt umber will serve

as outline, cast shadows, background color, tabletop color, and the cast shadow that divides the table from the background.

You have kept the original primed color of the canvas transparent so that you could increase the value and density (opacity) of the burnt umber during the painting process, in order to create cast shadows and outlines.

Use almost any color background, such as blue or red, for this painting method. A neutral tone, such as burnt umber or beige, would be best as a point of departure (*see* plate 11).

This method entails very little preliminary drawing on the canvas. A charcoal drawing on paper could be done as a study of light and shadow before painting.

The Painting Process

First Session

1. Do not draw with charcoal on the canvas. You can go directly to a simple drawing done with the brush.
 - If you are working from a vase of flowers, a green hue would be a good color to draw with.
 - Using a pointed brush, begin by drawing only about five lines that will indicate the position of the stems and the flower across the tabletop.
 - These lines will give you a sense of where everything will fall within the limits of the canvas. That is, by drawing a few lines, you should know where the flowers will be placed, where the vase will sit, how much of the tabletop will be visible, and where the back wall will meet the table.
2. Using your limited palette, including basic groups 1, 2, and 3, begin by mixing

small amounts of hues that you see within the flowers, vase, and greenery.
 - For example: If you are painting pink carnations, don't simplify the hues that are within that pink flower to read light pink and dark pink. Instead, look for the subtlest of variations within the overall tone and hue. You may see subtle values based on hues such as red violet, blue violet, alizarin crimson, the cadmium reds, and naples yellow. Are the hue mixtures you create warm or cool, light or dark? Try to be consistent; stay either cool in the light and warm in shadow, or vice versa.
 - When you see a particular hue and mix it, apply it only to the small area where you see it within the form.

 Perhaps you see it elsewhere in the setup? in the vase? another flower? in the stems? Place small strokes of the color wherever you see it.
 - Feel free to place hue variations wherever you see them. These small strokes of color can easily be changed or rethought.
 - The background color will be used to correct any incorrect edges of the forms. You simply mix the same color used to prime the canvas and correct the existing forms with that same background color.
3. Remember that you have lit the setup from one side so that the flow of light will be consistently from one direction, and the shadows will fall consistently in the same direction.
 - Once you have seen many small color variations, including the shift in hues within the flower; the shift from light on one side of the flower to shadow on the other side; the shift from light

to dark and cool and warm in the stems, greenery, and vase, you are ready to cast shadows behind the vase, tabletop, and flowers.

- The casting of shadows will push the forms forward in space and will heighten the sense of illusion.

Note, this is not a tight rendering method. This is, rather, a *painterly* loose, impressionistic method, based on visible brushstrokes and broken color.

- In order to cast a believable shadow behind the vase, use a darker, cooler hue than the background color. This shadow area should be extended to fall behind the tabletop on the same side as the cast shadow behind the vase.

- The tone to indicate the shadow that separates the tabletop from the back wall on the side where there is no shadow should be lighter than the tone on the other side. On the side receiving more light, this same tone can be used to cast shadows against the back wall cast from the flowers and stems. You can use this color within the floral arrangement to create depth and make drawing corrections.

4. The final step is the drawing!

- Using the original background color, come back into the forms you have set down with simple brushstrokes and redefine the edges. It is almost as if you were using the original color as scissors, cutting out the forms from the background. If you are painting this as a *premier coupe*, then this can be a *wet-into-wet* process, or you can wait a few days, until the colors dry, and then draw.

- Part of the drawing process entails the creation of shadow accents, using your darkest darks. Cool, dark mixtures of burnt umber, ultramarine blue, alizarin crimson, and phthalo green can be used to heighten the cast shadows. (The mixture of this dark hue should depend upon the form you are affecting and the background color.)

Not including the preparatory priming of the canvas, this entire method can be completed, from start to finish, in about two to three hours, depending on how quickly you work.

PART III
PAINTING WITH PLANES OF COLOR

Some of the most prominent French painters of the nineteenth century interpreted nature and all things perceived by the human eye as planes and strokes of color and light on the canvas. This method of slowly building three-dimensional images with planes of color on a two-dimensional surface gave painted images an inherently constructed colored glow. Paint and canvas seem to work together to create the things seen. Each and every stroke is put down on the canvas to remain and give life to the constructed images. The brushstrokes are not meant to be covered over by many other strokes. Every stroke adds to the three-dimensional mass of the objects and is not blended into other strokes of paint. Each stroke is thoughtful and meaningful to the entire picture surface (*see* figures 42, 43, and plate 12).

Exercise 14: Planes-of-Color Painting

Setup. A favorite subject of the painters who used this method is still life, including

flowers, fruit, and ceramic pieces. Set up any still objects you like, as long as the colors are not too dark. It is very difficult to read the hue changes within darkly colored objects or cloths when we first begin to paint. You may want to set up an arrangement that is symbolic, for example, objects that evoke particular meanings of hope or death (*see* chapter 8).

Be sure to arrange the objects in your still life so that they overlap one another. This will in some part insure compositional connections. If you choose to do a landscape or figure for this method, please take placement, scale, and gesture into compositional consideration. Light this setup from one side, while keeping an overhead room light on. This technique is best with a unidirectional light, but does not require the drama of the chiaroscuro lighting technique.

In preparation. *Materials:* canvas, oil paint in white and burnt umber, palette, wide bristle brush, jars of medium and thinner, rags or tissues. Canvas size: about twenty by twenty-four inches.

Prepare your canvas a few days before you wish to begin painting. It takes a few days for the surface to dry to the touch. You may want to prepare several canvases with this particular prime, because it is a very comfortable color upon which to work. You will mix white with burnt umber to create a kind of tan or beige color. This color is not as bright as the original white of the canvas, so you can better read the colors you set down. If you don't mind working on a white surface, then you do not need to prime the surface with a color for this technique.

1. Place a good amount of white on your palette and a small amount of burnt umber (about four parts white to one part burnt umber). Mix these paints together with your palette knife, to create an even, light tone of beige or tan. You may add a little bit of medium to this mixture, if you feel it is too thick or dry.

2. When applying an entire surface of paint with a large brush, it is a good idea to cover nearby walls and furniture in order to avoid spraying them with paint.

3. Using a large bristle brush, cover the entire canvas surface with this mixture. Be sure to create an evenly coated surface. The surface should be opaque, and the paint does not necessarily have to be thick to be opaque.

4. To create an even surface, try to use even, long strokes in a north-to-south direction, then apply the paint in an east-to-west direction.

Drawing and composing on the canvas. You may want to do preliminary drawings for the painting, but it is sometimes rewarding and challenging to draw directly from the setup, onto your canvas, if you have a good sense of where the composition will fall on your canvas surface. If you draw directly on the canvas, charcoal enables you to make corrections and adjustments without damaging the primed surface. If you use soft vine charcoal and draw lightly, you can easily erase your marks with a soft, dry chamois skin or damp cloth. Please note that the painted surface must be dry in order to do this cleanly, because charcoal will mix with wet paint and muddy the color.

Once you have finished, blow down the excess charcoal so that only a light drawing remains. You can then paint over this

temporary drawing with ultramarine blue paint and a pointed brush.

You may want to draw directly on the primed colored surface with ultramarine blue and a pointed brush, instead of drawing with charcoal. If so, you can erase unwanted brushstrokes in a couple of ways.

1. Using a paper towel, tissue, or rag dipped in thinner, wipe off the brush-stroke, then wipe dry with a clean rag.

2. If the brushstroke is thick (it really should be thinly drawn), first remove the excess paint by lightly scraping the stroke with a palette knife, then proceed with the above method.

3. You can "erase" the blue with a mixture of the original color of white and burnt umber. This will create a very wet surface. The paint will also begin to build up, depending upon how many adjustments you make, and will be a little duller (due to mixing with blue) than when you primed it. The benefit of this method is twofold:
 • You learn to draw with a brush, using the blue paint.
 • You have built up a kind of atmo-sphere with the limited colors.

The main point to remember about this technique is that you are building the mass of forms with planes or patches of color. *Do not blend!* Allow all the patches of color to remain, although you may certainly place one on top of another. The forms or objects in your composition will be a result of an accumulation of colored patches or planes.

The Painting Process

First Session

1. After drawing on the canvas with ultramarine blue, begin by painting patches of color on *all* the objects in the composition.
 • Try to be accurate as possible in the reading of the many hues within a form. Each form will be described by an accumulation of different colored patches or planes.
 • If you are painting an apple, the apple should reflect all its surrounding hues. Is there a lemon next to the apple? Do you see a reflection of yellow on the apple, from the lemon? from the cloth that the apple sits on?
 • Are the patches you apply cool or warm in the light? Try to be consistent about cool and warm areas. For exam-ple, if you decide that wherever light touches the forms those colors will be warm, then maintain that throughout.

2. Try to work all over the canvas. Do not linger on one object. Work on the entire canvas, maintaining an equal level of development on all forms.
 • Any unwanted colors can be corrected by going back into the painting with the original prime color (mixture of white and burnt umber).

3. The direction of your flat bristle brush will establish the direction of the plane on the surface of each form. Imagine that the brush is like a sculptor's chisel and that you are carving each plane into the surface of a form.

Second Session

1. Recheck your drawing. Reexperience your perception of the setup by going back and redrawing, reestablishing spa-tial relationships.
 • Continue to add patches of color.

- Notice which side of the form is receiving the most light. Are the lit sides cool or warm? Be consistent.

2. It is not necessary to cover every inch of canvas color. The color priming of the canvas can act as a color. Paul Cézanne allowed the white of the canvas to show and act with the applied patches of color.

3. This is a very process-oriented technique, based on visual perception. Enjoy the way in which you perceive color, light, and spatial relationships.
 - Have you noticed shifts in your vision?
 - Do things seem to be in motion?
 - Do you believe that the inherent movement in the way we see should be revealed or concealed in the painting process? This technique allows you to reveal your perception of shift and movement, whereas the technique of painting with light would allow us to conceal our movement.
 - Notice the volume that can be built without blending, by utilizing the building of patches of color.

PART IV
PAINTING WITH LIGHT

There are many ways of organizing elements on the canvas, and various compositional modes allow us to do so. We can tie all the pictorial elements together by emphasizing one major element: light. We can use light as the element of compositional unity, just as we can use line, brushstrokes, color, or shapes (*see* plate 13).

Even though we are utilizing light to act as a unifier of the entire surface, we are always conscious of the way the other pictorial elements—shapes, weights, color, size, scale, and placement—are part of the compositional makeup.

The seventeenth century brought about a great shift toward the use of light as a compositional unifier. Artists such as Vermeer, Rembrandt, Poussin, and Velázquez all set up clear and continuous light sources that moved across and touched each object or figure in the path of the light source. The light source was sometimes visually defined in the painting, but for the most part it was understood to be coming from some particular point outside of the pictorial illusion of the canvas.

In his painting *Holy Family on the Steps* (figure 60), Nicolas Poussin, a seventeenth-century French artist, establishes a flow of light from the left side. The light touches and illuminates the left side of forms in its path. If most of a form is not in the path of light, it will be painted in shadow. Notice that the male figure, Joseph, is almost entirely in shadow; only his foot is in the path of the light.

Poussin uses local color; for example, yellow drapery would be light yellow when touched by light and dark yellow when in shadow. The use of local color and the layered painting technique was the dominant color technique until the nineteenth century, when the use of broken color became popular. Local color allows the flow of light to dominate; the light flow is not overpowered by patches of broken color or brushstrokes.

Poussin's composition is rational, clear, and well structured. Not only does the flow of light unify the figures and the setting, but the gestures, size, scale, color, and arrangement of the forms act to unify the composition. The Madonna and Child are the main focal point of the painting. The gesture,

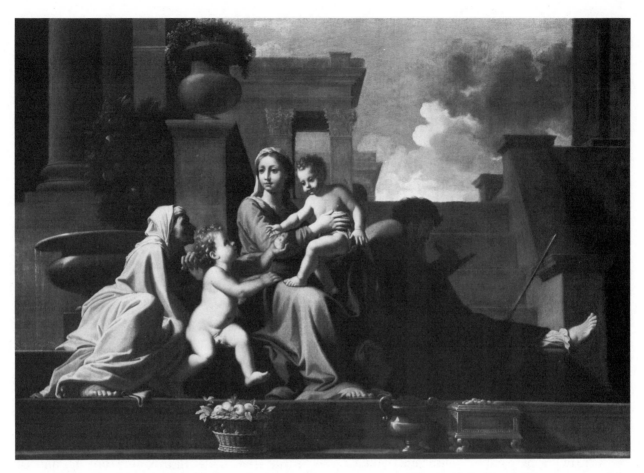

FIGURE 60: Nicolas Poussin, *Holy Family on the Steps*, 1648, oil on canvas, 27″ x 38½″ (0.686 x 0.978), courtesy of the National Gallery of Art, Washington, D. C., Samuel H. Kress Collection.

A logical light flow ties all the elements in a composition together.

position, and glance of the older woman lead us to the point of focus. The size and scale of the composition are rational, believable. We feel relatively close to the group because of their position on the steps. The illusion of space is heightened by the *trompe l'oeil* placement of the three still-life objects on the bottom step. These objects remind us that the steps are dimensional projections into space that are capable of supporting weight. The brightest hues in the work are on the two female figures in the foreground, which aid in the creation of depth and maintaining the focal point. We always assume that bright hues are closer to us in space than dull ones, due to atmospheric

perspective. The neutral grays and browns of the background architecture do not compete for our attention with the bright hues and contrasting values on the foreground female figures and children.

Why does Poussin utilize light as his major compositional element in this painting? His desire for rationality and structure go hand in hand with a clear and continuous flow of light. This clear structuring of a painting allows the viewers to grasp the painter's message.

Please note that this work is symbolic and allegorical, it compares the relative values of the intellectual and spiritual life. St.

Joseph with his compass and T-square is shown as a mathematical philosopher, symbolizing the human intellect; but he is placed in the shadow of Our Lady and her Son, who represent religion or the life of the spirit.[2]

In the same century as Poussin, Jan Vermeer, a Dutch painter, was also utilizing the flow of light as a major compositional mode. *Woman Holding a Balance* (figure 61) is a marvelous example of the way in which light can delicately touch, organize, and illuminate forms. The female figure, whose gesture is the focal point of the painting, is illuminated by the light coming from the window on the left. This illumination allows us to focus our attention on her and her gesture. Vermeer is a master of color. He can establish and maintain a tonal registry that yields a natural atmosphere. He, too, uses local color, but emphasizes the overall weight of the values, tones, of color rather than the chromatic differences. It is this overall tone that allows the illusion of volume to take place. By maintaining a middle range of value in the entire work, he creates shadows and high points of light, by using values that are either lighter or darker than the middle tone (*see* figure 62). You can clearly understand this concept when you do a preparatory drawing. You focus on the figure weighing gold, because of the light, but the emphasis on the interplay between vertical and horizontal movements, in the table, window, and painting, allows you to move your eyes around the entire space. Notice the painting on the back wall, which seems to be of the Last Judgment. Is Vermeer making an allegorical comparison between the weighing of gold on the scale held by the young woman and the weighing of souls in the painting? He most likely is

creating an allegory that further adds to the greatness of this work. The literal meaning of balance, whether it be the gold on the scales or the souls in the Last Judgment, is supported by the balance of forms in the composition. The distribution of weight and light, the vertical and horizontal movements, which repeat the edges of the container, and the rational space create a balanced painting.

Rembrandt van Rijn uses light not only as a compositional organizer but as an element of drama in the work *Joseph Accused by Potiphar's Wife* (figure 63). The light, which seems to be coming from the left, although it is not as clearly rational a flow as we find in Vermeer and Poussin, is a player in the narrative drama. The strongly illuminated figure of Potiphar's wife and the bed are obviously linked in the drama. The warm tone of this work is due to Rembrandt's use of burnt umber as the major color support for the painting. We are given little else to look at, beyond the figures and bed; this keeps our attention focused on the interpersonal drama. The linking of gestures, the arms, and glances act with the light to unify the composition.

The ability to paint the path of light, whether it be the miraculous light symbolizing spirituality, as in Jan van Eyck's *The Annunication* (plate 14), or the purity of natural light, as in Jan Vermeer's *Woman Holding a Balance*, is achievable and fascinating.

Since this is one of the most difficult methodologies, we will utilize a very controlled setup to begin to investigate the translation of visible paths of light onto the canvas. Once we have learned this method, we can use it to create great religious paintings.

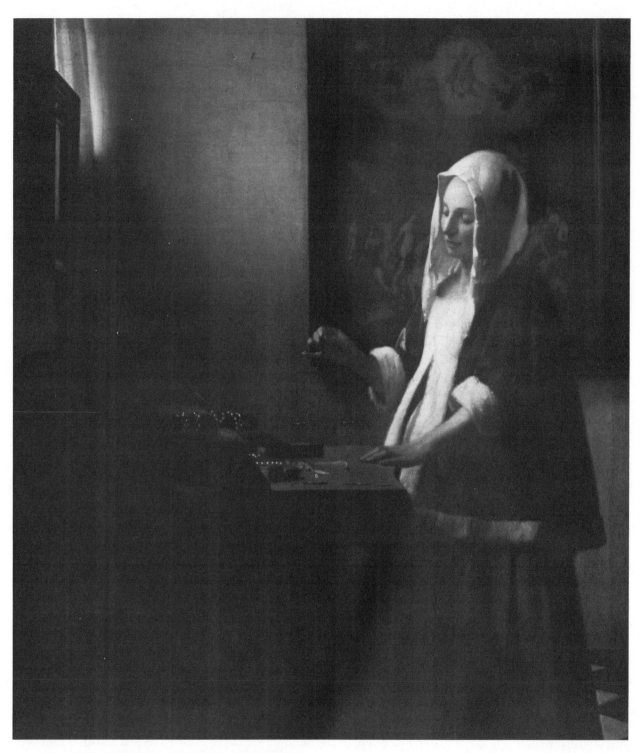

FIGURE 61: Jan Vermeer, *Woman Holding a Balance*, 1664, oil on canvas, 16¾″ x 15 (0.425 x 0.380), courtesy of the National Gallery of Art, Washington, D. C., Widener Collection.

With great naturalness, the light flows across and touches all forms in its path.

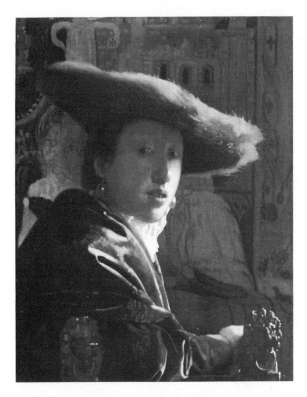

FIGURE 62: Jan Vermeer, *The Girl With a Red Hat*, c. 1660, oil on wood, 9⅛" x 7⅛" (0.23 x 0.18), courtesy of the National Gallery of Art, Washington, D. C., Andrew W. Mellon Collection.

In order for the white highlight on the pearl earring to work as such, all other values must be at least a step darker than white. If you squint at any Vermeer painting, you will notice he established a middle value of gray throughout the entire work. This middle tone allows him to create highlights with lighter values and shadows with darker values.

Exercise 15: Painting With Light

Setup. Arrange a still life on a tabletop, consisting of white boxes. Cover cereal boxes, shoe boxes, or any other various-sized boxes with white drawing paper or newsprint paper. Place them against a white or light-color wall and place a white cloth on the tabletop. Light the still life of boxes from *one side only*. A desk-top lamp, extended wall light, or window light would all do the job. The light must come directly from one side; the other side of the still life will be in shadow. This is necessary to maintain a logical, steady flow of light. The lighting of this setup is the same as in the technique of chiaroscuro, except that you can keep overhead lights on. The light to dark relationship on the forms need not have the contrast of the chiaroscuro setup. You merely want to be able to see clear planes of light and dark.

In preparation. *Materials:* canvas, oil paint in burnt umber and white, palette, wide bristle brush, jars of mixing medium and thinner, rags or tissues. Canvas size: about twenty by twenty-four inches.

Prepare your canvas a few days in advance so that the surface will be dry to the touch before you begin to draw and paint your images on it. You will prime the

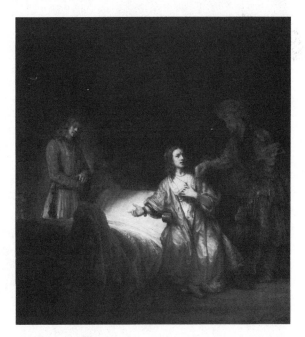

FIGURE 63: Rembrandt van Rijn, *Joseph Accused by Potiphar's Wife*, oil on canvas, 41⅝" x 38½" (1.06 x 0.98), courtesy of the National Gallery of Art, Washington, D. C., Andrew W. Mellon Collection.

The light acts to create the focal point of the narrative.

prepared canvas with a color mixture of burnt umber and white.

1. Put a good amount of white on your palette and add just a little burnt umber to it. Mix the two colors together with a palette knife to achieve a kind of beige or tan color.
2. Cover surrounding furniture, when priming a canvas with a large brush, in order to avoid spraying the furniture.
3. Using a large bristle brush, cover the entire canvas with the opaque color mixture, maintaining even strokes. The brushstrokes should not be very apparent.
4. The canvas surface should be evenly covered.

Preparatory Drawing

Materials: medium-tone paper for charcoal or chalk drawings, white and black chalk, charcoal or conté crayon, an H pencil or a piece of soft vine charcoal, and fixative.

Setup. You may use the same setup for your drawing as for your painting, or it might be rewarding to draw from an old-master painting that utilizes the type of light flow we are studying.

Since you will be painting on a toned canvas, you will draw on a toned paper. You may purchase paper for charcoal and chalk drawings in different colors, or you may color white paper yourself. Some artists purposely stain their paper with

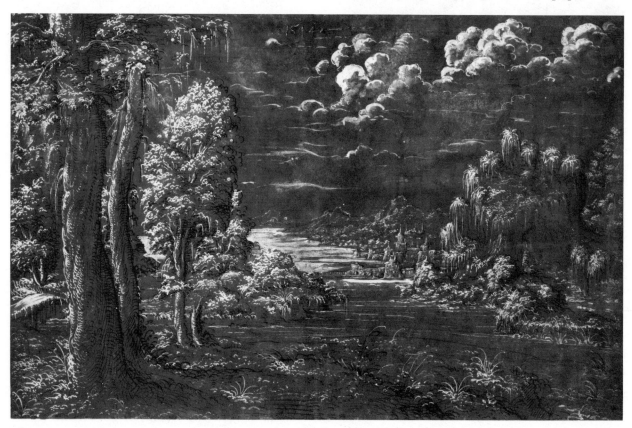

FIGURE 64: Anonymous, *Nuremberg River Landscape,* 1544, pen and black and white ink on red-brown prepared paper, courtesy of the National Gallery of Art, Washington, D. C., Ailsa Mellon Bruce Fund.

The tone of the paper is the middle value. The white chalk or crayon is the light, and the dark crayon or charcoal is the shadow.

coffee, yielding a light-brown paper. In order to keep the paper from curling, press it under books to keep it flat or tape its edges to a drawing board or table.

1. Begin by making judgments about placement: Where will the forms fall in relation to the edges of the page? You may want to use a viewfinder to aid in the choice of the composition. An H pencil or soft vine charcoal can be used at this point as lines to locate the positions of the forms. Some people feel more comfortable if they have linear guidelines before beginning to apply tones. These marks will eventually be covered by the planes of light and shadow.

2. If you are drawing from an old-master work, you may either use a grid to transfer the placement of forms or make the placement decisions by eye. Be sure to use an old-master painting, not a drawing. Using a painting forces you to translate the painting into the drawing medium; you will learn more from this experience than from working from a drawn image.

3. Using the white charcoal, conté crayon, or chalk, set down all the areas of light. The white will translate as the light.

4. The tone of the paper will be the transitional tone between the light and the cast shadow, which is the black. All the planes of forms that are in shadow will remain the tone of the paper.

5. The black tone will be used to create cast shadows or the darkest of any of the planes.

 Like Vermeer, we are using a medium tone as the tonal backbone of the drawing. This tone will hold the light and allow us to read the movement of the light as it touches one form and then the next. The black as the darkest darks will aid in the creation of volume by acting as cast shadow.

6. When you are finished, spray the drawing with fixative in a well-ventilated room or out-of-doors.

The Painting Process

You are painting the flow of light on a toned canvas. The tone of the canvas will act as the relative or general value of the planes of the boxes that are in shadow. Unlike the chiaroscuro painting method, you have an option in the rendering of the shadow planes. You may paint them in whatever hues you see, or if you wish, you may maintain the tone of the canvas for the majority of planes in the shadow areas as you did in the preparatory drawing. If a plane is extremely dark in value, paint it accordingly, in the same way as you used the black charcoal in the drawing.

Treat the hues you see as local colors, and do not vary them greatly within a given form or plane.

First Session

1. After drawing on the canvas, begin by painting the planes that are in the path of the light. They will be rendered as light hues.

 • Try to be as accurate as possible in reading the correct hue, value, and chroma of the colors you see in the setup. This is particularly challenging, since all the boxes are wrapped in "white" paper. But are the hues you see really just "white" or do they vary? Don't forget that the surrounding environment will affect the hues seen on the boxes.

- Try to be a discerning painter. Compare the hues on all the forms. Is one plane warmer than another? Is one cooler than another? Does one seem to have more of a red cast and one more of a violet cast?
- Remember that the direction of your brushstroke will affect the volume of forms. Move your brush in the direction of the turn of the volume.
- Any "mistakes" can be corrected by going back into the forms with the toned canvas color. "Mistakes" are part and parcel of the painting process. There are few, if any, perfect painters.

2. As always, it is important to rethink the drawing and composition as you paint. The processes of drawing and composing are ongoing ones.
 - Is the visual perspective correct in terms of point of view? Are you in the same position in relation to the setup as you were when you drew it on the canvas? Do you see the tops of all the boxes? Do you see the tops of some of the boxes? Remember to paint what you actually see, in terms of visual perception and foreshortening, and not what you know to exist.
 - Is the scale accurate? Are the sizes of all forms correct in relation to one another? At what points do the boxes overlap or touch?

3. Always keep the forms in the painting at an equal level of development.
 - The first session is a difficult one. You are really roughing out ideas. Don't try to do too much too quickly. There is a great temptation to want to give the picture a finished look right away. Resist it! Enjoy the slowness of this painting process. This method re-quires a building up of tones; the technique is layered painting.

Second Session

1. Take a fresh look at the drawing and composition. Do you need to make any changes or adjustments? Don't hesitate to correct poor drawings or compositions just because you want to finish. If you only want to finish, why paint in the first place?
2. Begin to paint the colors you see on the shadow planes. As you did in the painting of the planes receiving light, try to be accurate in reading the correct hues, values, and chromas.
3. Add a new layer of the colors that are on the planes receiving light.
4. Try to maintain an overall flow of light. Stand back from your painting; distance from it will enable you to read the light flow.

Third Session

1. Once again, take a fresh look at your work and make any necessary corrections.
2. Begin to paint the darkest areas, cast shadows, and planes that are very dark.
 - Should the darkest darks be cool or warm hues? How do they react to the colors that are already on the canvas?
3. Add a new layer of the colors that are on the shadow planes.
4. Paint any transitional colors that are needed to enhance the volume of forms.
5. Step back from your work and ask yourself the following questions:
 - Did I establish a clear and logical flow of light?

- Is the drawing accurate?
- Do the forms turn and have volume?
- Does each box have volume?
- Do the boxes relate to one another compositionally?
- Do the colors sit correctly in their spatial positions?

6. Remember that if you want to create white highlights, then none of the planes receiving light should be as light as white. All values must drop in order to create white highlights. For example, if you look at a painting by Jan Vermeer, you will notice all the values are darker than white, so that when he wants to throw a highlight on a pearl or glass, he can use a value as light as white.

7. Make sure all edges between planes are softened. Hard edges tend to visually flatten forms.

PART V
NARRATIVES (MULTIPLE-FIGURE COMPOSITION)

Paintings can be great storytellers, if the artist understands the painting medium and the audience is familiar with the story. Limiting? Yes, the limitations of this formula have, in part, been responsible for the disappearance of narrative painting in the late nineteenth and twentieth centuries. Of course, the modernist ideas of these times made narrative painting look quite obsolete, but even if painters wanted to deal with narratives, how much of the audience would have understood them? Countries had become and still are melting pots. Many people of different ethnic and religious backgrounds live in the same territory and are not all familiar with the same historical or religious stories.

In the Gothic, Renaissance, and baroque periods, when the Catholic Church had an enormous influence and patronized the arts, almost everyone knew the stories of the New Testament as well as related religious stories and writings. Religious people who could not read, particularly women and children, looked at paintings for biblical stories. A fifteenth-century monk is known to have said that paintings are the Bible of women and children. It was desirable for artists to paint narratives and allegories. People had similiar backgrounds and wanted to see their beliefs illustrated on church walls or on panels or canvas.

Although most contemporary artists are still involved with abstraction, conceptual art, performance art, and neoexpressionist art, there seems to be a resurgence of narrative and allegorical painting among some important contemporaries. These artists are disregarding the fact that most of us live in culturally mixed areas and are choosing rather esoteric subjects for their narratives and allegories. They draw upon personal stories, religious stories, and histories of foreign countries as well as their own. The logical question is, then, do our modern mixed audiences understand the new narrative and allegorical paintings? No, they don't.

Most people alive today, who are interested in looking at art in museums and galleries, have been reared on modernist works, that is, abstraction, conceptual art, performance art, earthworks. So they have a formalist approach to these new narratives and allegories. They look at them for the way in which the artist used color, shapes, light and shadow, in other words, the formal elements. We can bet, though, that underneath all that modernism, they want to know the story. Artists who do

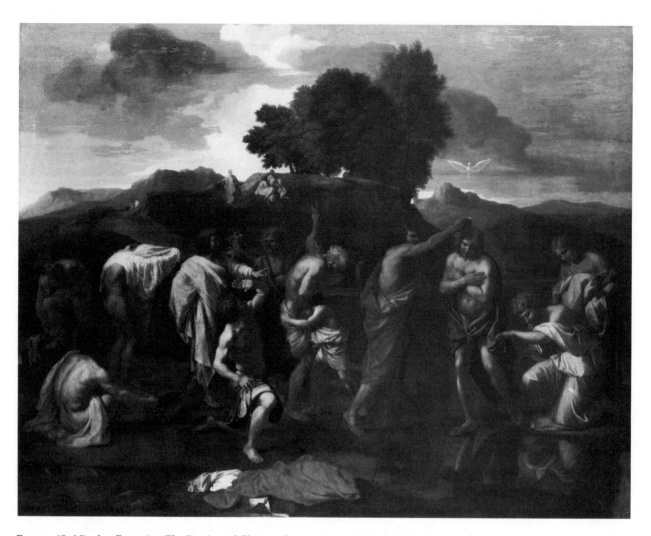

FIGURE 65: Nicolas Poussin, *The Baptism of Christ*, oil on canvas, 37⅝" x 47⅝" (0.955 x 1.210), courtesy of the National Gallery of Art, Washington, D. C., Samuel H. Kress Collection.

Once a theme is established, a mode should be considered. Is the theme sad, joyous, or severe? Poussin was very conscious of modal structures and the way in which they affected an audience as well as their appropriateness to particular subjects.

paint narratives or allegories see fit to release a written statement about their paintings that the audience can look to for explanations. This is perfectly valid, because the idea that art speaks for itself is a false one.

"Extrinsic" paintings, which use an outside source for their subject matter, are absolutely valid. Only in modern times have "intrinsic" works, works that use no outside source, for example, still life and landscape, become popular subjects (or

nonsubjects). Although fruits and flowers in a still life may be symbolic, they may be understood on a purely visual level by anyone without any knowledge of symbolism. Most still-life paintings done after the seventeenth century are not symbolic, and the average viewer doesn't expect them to be. Landscape is another intrinsic subject (figure 66). There are landscape painters who hold very particular beliefs and feelings about the specific location that they paint, but the viewer does not have to know

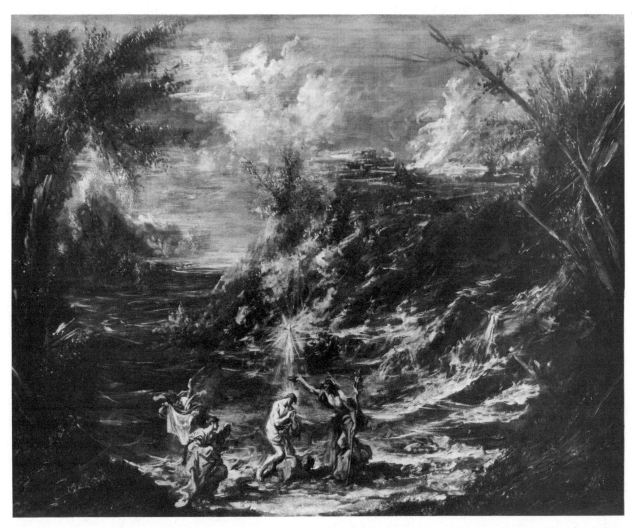

FIGURE 66: Alessandro Magnasco, *The Baptism of Christ*, c. 1740, oil on canvas, 46½" x 57¾" (1.17 x 1.47), courtesy of the National Gallery of Art, Washington, D. C., Samuel H. Kress Collection.

Magnasco set up a circular movement as an understructure to the entire scene.

the location of the work to receive the message. We would not need to know that a landscape was painted in Maine as opposed to Vermont to understand the imagery.

Of course, multiple-figure paintings do not have to be narratives or allegories. Figures can be used for purely aesthetic purposes; Michelangelo felt that the nude is the most expressive element in art. But most audiences would want to know the story behind the painting of figures. Antithetically, people do not question the meaning

behind still lifes or landscapes; they accept them at face value.

Exercise 16: Multiple-Figure Paintings

Setup. Nicolas Poussin is known to have used small clay figures set up on a boxlike stage, which he used as references in drawing and painting his multiple-figure compositions. Other artists use live models, one or more models taking the various poses in the narrative. Some artists invent

their compositions from their knowledge of the figure and composition; some use photographs as source material; others look to old-master works for inspiration. It is possible to draw the model in separate poses and then combine the poses into a multiple-figure composition. Having an idea of the composition, before hiring a model, enables you to clearly direct the model into the desired poses.

How to use source material: clay figures. Inexpensive modeling clay or plasteline is fine to mold small clay figures. These figures may be extremely rough, giving you the appropriate gesture rather than any detailed information. They also provide a vehicle for reading light and shadow. Simply place them on top of a sturdy cardboard box and light them from only one side with a desk or wall lamp. This will provide light and shadow on the figures as well as cast shadows on the ground plane. Move them around on the top of the box to make compositional decisions.

Ready-made wooden or plastic figures with movable limbs and torsos are available in most art-supply stores. They are made expressly for replacing live figures. Clay figures are probably a better tool, because they are much less expensive and much more flexible (and fun).

In preparation. *Materials:* canvas, oil paint in burnt umber and white, palette, wide bristle brush (about two inches wide), jars of mixing medium and thinner, rags or tissues. Canvas size: about twenty-four by thirty inches.

Prepare your canvas a few days in advance so that the surface will be dry to the touch before you begin to draw and paint on it. You will prime the prepared canvas with a color mixture of burnt umber and white.

A toned canvas allows you to judge colors more accurately. You do not want to fight the glare and brightness of the white priming on the canvas. The toned color is, of course, a darker value than white, which also allows you to more accurately judge the color values. The extremely light value of white makes other colors seem darker than they might really be.

1. Put a good amount of white on your palette and add just a little burnt umber to it (four parts white, one part burnt umber). Mix the two colors together with a palette knife to achieve a kind of beige or tan color.
2. Cover surrounding furniture when priming a canvas with a large brush, in order to avoid spraying the furniture.
3. Using a large bristle brush, cover the entire canvas with the opaque color mixture, maintaining even strokes. The brushstrokes should not be very apparent.
4. The canvas should be evenly covered.

Preparatory drawing. Since narrative or allegorical painting is usually invented, as opposed to painted from life, it is a good idea to have a few drawings as reference. One should emphasize compositional ideas, that is, the rhythms and structure of the composition, so that its structure is ever-present in your mind (*see* figure 67). Another drawing should utilize either light and shadow or line as a compositional unifier. (*See* method on painting with light, part IV, for second drawing.) You might want to have several drawings of each figure in more detail as a source of reference.

FIGURE 67: Jacob Jordaens, *The Martyrdom of Saint Sebastian*, c. 1617, pen and brown ink with brown wash, courtesy of the National Gallery of Art, Washington, D. C., Ailsa Mellon Bruce Foundation.

Preliminary drawings can be an essential step in this painting method.

How to compose a multiple-figure composition from your head. The most logical way to begin is to establish a theme, a subject, and then determine what type of feeling or mood your theme expresses. Themes can be broken into five categories or modes: sorrowful, loving, severe, joyous, or austere. Each warrants its own compositional mode.

This is where a knowledge of design comes into play. For example, we know that vertical lines and horizontal lines in a regular rectangular container convey a feeling of stability or calm, because they are static movements. However, place those lines in a circular container, a tondo, and they become severe. If you wanted to communicate a joyous mode, it might be inappropriate to use a horizontal extension as your choice of container. This container is best suited to austere or sorrowful themes. Its extreme horizontal nature gives forth a sense of slow, meditated movement.

Make visual decisions about all modal theories. Study old-master paintings. Notice their compositional modes for particular themes. Once you have established your theme and understand the type of container and movements that will best convey your subject, begin by drawing *five major movements* (lines) on your page that will be the basic structure of your composition. You can invent these lines or derive them from looking at your clay figures or even at an old-master painting.

1. Draw five major movements or lines that react to your container.
2. Turn these lines into figures, props, architecture, or environmental surroundings.
3. Go back and stress the original five major movements.
4. On separate sheets of paper, draw individual studies of each figure.
5. Decide whether you want to use light and shadow or line as your compositional binder. Your choice should, in some part, be determined by your theme and the feelings you want to communicate. For example, a linear style communicates a sense of tangibility; it relates to our sense of touch. Light and shadow appeal to our sense of vision, as though we were touching forms with our eyes.
6. Use light and shadow or line to unify the composition (*see* parts IV and VI).
7. At this point, you may want to do a color study for the painting. Oil sketches on heavy drawing paper are wonderful for working out color ideas.

Cut colored paper is another way of testing color ideas. (I used to create color abstractions as a way of giving myself a color guide.) Or you may simply want to forge ahead and work out your color ideas on canvas. Remember that your color, as well as your composition and major movements, will convey feelings.

The Painting Process

We are painting conceptually, from our minds, when we paint multiple-figure narratives, unless we can afford to have models in front of us. Painting invented imagery hardly ever looks as "real" or natural as perceptual painting. In fact, it can look rather cartoonlike. So do not despair—old masters who could paint realistic images from their minds studied figure drawing and painting for many years. For this purpose, it is a good idea to paint both from life and from your mind, so that one method feeds the other. Perceptual painting can help us build a vocabulary of visual images and teach us about the way light patterns itself.

First Session

1. Draw your composition on the canvas with charcoal or paint, either by gridding up your drawing or by eyeballing it onto the canvas.
 - If you are painting with light and shadow, first establish general planes of light and dark hues. If you are painting linearly, establish linear movements in color that act to visually (not literally) connect the figures and other imagery.

Second Session

1. Choose a painting method.
 - You can use the method of painting with small planes of color (part III), which will give the painting a modern, painterly appearance. These patches of color can be very close in tone so that you are building toward a natural, unified surface. Or they can be varied, bright, and apparent, moving toward an artificial look.
 - You can use any of the methods in this text for conceptual figure painting. Your choice should depend upon the kind of look you want to achieve. Study the examples of old masters who used the particular painting method to determine whether it is the look you wish to achieve.

 Chiaroscuro method = dramatic, volumetric, realistic

 Negative-space method = sketchy, less volumetric, natural, painterly

 Color-planes method = painterly, volumetric, less natural

 Light-flow method = volumetric, natural

 Linear method = artificial, less volumetric

 It is especially important with this painting method to rethink the drawing and composition as you paint. The processes of drawing and composing are ongoing ones.
 - Are your figures' gestures readable? Do they communicate?
 - Are your figures in correct proportions? Or do you want them to be purposely out of proportion?
 - Are your figures in an accurate scale to one another, to the setting, and to the props?

• Is your drawing out of perceptual perspective?

Looking at your painting through a mirror reflection can aid in pointing out flaws in the drawing and perspective.

PART VI
LINEAR STYLE: HOW TO UNIFY A PAINTING WITH LINE

There are many ways of organizing elements on the canvas. This technique will use the formal element of line. *Linear* rhythms establish compositional unity; this style was used by the artists of the Gothic and Renaissance eras. It usually goes hand in hand with detail and clarity of forms.

Even though we compose pictures in terms of shapes, weights, color, size, scale, and placement, we can still use one major element to act as the unifier of the entire surface. Painters unify the entire surface by tying all elements together through the use of a consistent flow of light across the canvas or the use of line as outline, edge, or contour.

The baroque era brought about a great shift to the use of a light flow as a compositional unifier. Before that time, during the Gothic and Renaissance periods of art, line was used almost exclusively (*see* plate 14). Artists such as Jan van Eyck, Andrea Mantegna, Carlo Crivelli, Sandro Botticelli, and Raphael set up clear and continuous linear rhythms within their compositional structures, which moved around, outlining and touching each object or figure in their path.

Line was sometimes visibly drawn at outlines and edges, clearly defining the limits of forms in the painting. In essence, line could act to hold and suspend forms in a kind of artificial timelessness that was possible in painted images. We understand the line to act as a modifier of the visual illusion, holding it up for our delectation.

The ability to use line as a rhythmical unifier is difficult. We have to believe in the idea that all forms or objects in a composition have some organic connection to one another. We should be able to feel the connections as we draw or paint the composition. A great deal can be learned by drawing from old masters who created linear paintings. Not only do we improve our coordination and extend our visual vocabularies when we draw from them, we also get the unique chance to empirically examine how they tied the composition together, to feel their compositional rhythm.

Exercise 17: Linear Painting

Place a piece of tracing paper over a linear old-master painting of any religious theme. On the paper, draw only the major linear movements and connections. Analyze the types of movements and connections within the composition and style and the overall structural idea or mode of composition. Is the composition based on repeating curves, vertical and horizontal movements, diagonal counterpoints? Does the artist emphasize edge, contour, or outline? (*See* figure 68.)

Choose several more old-master works with different themes. Choose a sad, joyful, pious, and a violent theme. Trace the movements in all of these on tracing paper. When you finish drawing them, compare their compositional and linear structures. Do you notice the differences? Did you feel their structures and linear rhythms?

Since this is one of the most difficult

FIGURE 68: Georges Rouault, *Christ and the Doctor*, c. 1935, oil on canvas, 3⅜″ x 4¼″ (0.087 x 0.108), courtesy of the National Gallery of Art, Washington, D. C., Ailsa Mellon Bruce Collection.

Line is used as outline in this modern work. Rouault was one of the few moderns dealing with religious themes in his time. The dark lines he often used to outline his forms not only unified all of them in the composition, but acted to intensify the colors they surrounded.

methodologies, we will utilize a very controlled setup to begin to investigate the translation of visible paths of line onto the canvas.

Setup. Arrange a still life on a tabletop. Light it from one side *only*, keeping an overhead light on in the room. A desktop lamp, extended wall light, or window light will be fine. The light must come directly from one side. The pieces in the still life should be colorful, including reds, oranges, greens, or blues. The wall or cloth behind the still life and on the tabletop should be light in tone. Add additional drapery on top of the tabletop, if you like, as part of the still-life arrangement. Try to overlap objects and drapery so that there is some compositional connection. If objects do not overlap, they will disconnect from one another in the pictorial translation.

In preparation. *Materials:* canvas, oil paint in white and burnt umber, palette, wide bristle brush, jars of medium and thinner, rags or tissues. Canvas size: about twenty by twenty-four inches (don't paint too small or too big for now).

Prepare your canvas a few days before you wish to begin painting. It will take a couple of days for the paint to dry, and you should work on a dry surface. You might want to prepare several canvases at once with different-color primes.

1. Put a good amount of white and a little burnt umber on your palette (four parts white and one part burnt umber) and mix it with your palette knife.
2. Covering an entire canvas surface with a large brush can be very messy. The paint tends to spray off the brush and onto nearby surfaces. It is recommended that you cover any exposed walls or furniture.
3. Using a large bristle brush (one and a half or two inches wide), cover the entire canvas with the mixed paint, maintaining even strokes.

 The resulting colored surface should not be too thin or transparent, yet not completely opaque.

Draw and compose on the canvas. When the canvas surface is dry, you can draw either with charcoal or with paint. Some people feel more secure with pencil, but this tends to be hard on the canvas surface and restrictive.

If you choose to draw with charcoal, use vine (soft) charcoal in thin sticks. Charcoal is easily erased with a cloth or tissue. Before you begin to paint, "blow down" the charcoal on the surface by very simply blowing on the canvas so that ony a bare,

FIGURE 69: Lorenzo Lotto, *Martyrdom of Saint Alexander of Bergamo,* early 1520s, pen and brown ink squared for transfer in black chalk, 10⅝″ x 7¾″ (27.1 x 19.6), courtesy of the National Gallery of Art, Washington, D. C., Ailsa Mellon Bruce Fund.

The transfer lines of the grid let us know this is a preliminary drawing for a painting.

light drawing remains. Blow away the excess so that it won't mix with the paint and dirty the colors.

You can either draw directly on the canvas, without doing a preliminary study, or begin with a preliminary drawing.

Preliminary drawing. *Materials:* white drawing paper, pencil, kneaded eraser.

You may use the same setup for your drawing, or it might be beneficial to draw from a linear old-master painting. Good artists to choose would be Andrea Mantegna, Sandro Botticelli, or Carlo Crivelli. Any early Italian or northern Renaissance artist will do.

1. Begin by lightly drawing the major compositional rhythms in the setup. Can you locate three or four major movements that dominate the composition?

2. Once you have established the major compositional rhythms, begin to draw one form, then draw its relationships to the forms around it. Never complete one form before you establish its relationship, the way it overlaps other forms, and its position in space.

3. Go back into the drawing and emphasize the cast shadows by stressing the lines behind the forms casting the shadows. Hatched lines should serve as shadow area rather than using a flat tone. After all, you are stressing line in this technique.

4. Go over the entire drawing by reinforcing the outlines of forms.

The main point to remember is that all the forms are connected or unified by their linear outline. You will paint the areas of color you see in the light and in the shadow, but the light and shadow are subordinate to the linear connections. Diffused light is the best type of lighting situation.

For example, if you are painting a blue vase, you would paint the bright blue you see illuminated by the light source and would paint the part of the blue vase in shadow a duller, slightly darker color. You wouldn't want to set up strong contrasts of light and shadow.

The Painting Process

First Session

1. After drawing on the canvas, begin by painting the linear rhythms you see in the composition.

FIGURE 70: Pieter Brueghel, *Landscape With the Penitence of Saint Jerome*, 1553, pen and brown ink, 9⅛" x 13¼" (23.3 x 33.6), courtesy of the National Gallery of Art, Washington, D. C., Ailsa Mellon Bruce Fund.

- Set down the colors you see in the light on all the forms. You apply the color in the form of planes, with a flat brush, or as line, with a pointed brush.
- Try to be as accurate as possible in reading the correct hue, value, and chroma of the colors you are painting.
- If you are painting a red vase, is it a cool red or a warm red? a red orange or a red violet? a light red or a bright red?
- Remember that the direction of your brushstroke will affect the volume and form of the object. Move your brush in the direction of the turn of the volume.

- Any mistakes can be corrected by going back into the painting with the color of the prime.
2. Remember that as you paint you should always be rethinking the drawing and composition. The drawing and composing process is an ongoing one. Rethink the linear connections, edges, and rhythms.
 - Is the perspective correct in terms of the way we see?
 - Is the scale accurate? Are the sizes of all the objects correct in relation to one another? Remember that all things are seen in relation to one another. Do the different objects overlap or touch?
 - What is your point of view? Are you in

the same position in relation to the setup as when you drew it on the canvas? Do you see the tops of the objects? into the openings of the objects? Be careful to paint what you actually see and not what you "know" to be there.

3. Always keep all the forms or objects in the painting at an equal level of development.

- The first shot at a painting is a very rough stage. Don't try to do too much too quickly. This method depends upon building up a few layers of paint at different sessions, so one layer can dry before you apply the next layer of paint.
- Don't try to render the forms on the first or even second session. Be patient and remember that oil painting takes time to develop, and all forms should develop at an equal rate. Painting develops as one unit rather than section by section or piece by piece.

Second Session

1. Take a fresh look at the drawing and composition. Do you need to make any changes or adjustments? It is very easy to redraw, using the ultramarine-blue, alizarin-crimson, and burnt-umber combination.
2. Apply the colors you see in the shadow areas to all the forms.
3. Add a new layer of the colors that are in the lit areas.
4. Transitional colors: This method requires a color that acts as a transition between the color in the light and the color in the shadow. This area can be subtle and just enough to soften the

shift, or it can be a clearly seen third color. It is up to you.

- The value of the transitional hue is most crucial to the creation of volume. It should be in between the value of the color in the light and the shadow color—an actual mixture of the two hues or a mixture from the limited palette.
- Don't expect the transition to be smooth or easy at first attempt—it takes a few applications and quite a bit of wet into wet manipulation.
- Several types of brushes, both dry and wet, will be needed to create the volumes.

 Pointed brush: Use this as your main drawing tool.

 Small Bright: This brush can get into small places and should be moved in the direction of the form's volume. It can also be used for drawing and redrawing with burnt umber.

 Medium Bright: Apply large areas of color and move one color into another with this brush.
- Once again, remember that this painting needs at least three sessions. Be patient. It is very difficult to work on an extremely wet painting.

Third Session

1. It is now time to rethink all the marks you have made on the canvas surface.

- Do you need to redraw? Look at the painting through a mirror. This will exaggerate any form that is out of drawing. Look at the painting from a distance, a new perspective.
- Are the hues you applied accurate? Do they work?
- Are your brushstrokes enhancing the

volume or making forms appear flat? You may want to allow hatched lines, painted with a pointed brush, to turn the forms moving in the direction of the volume.

2. Add another layer of the colors you see in the light and shadow.

3. Rethink the transitional area of color.

 • How much of the form is seen in the light?

 • How much of the form is seen in the dark?

 • What role should the transitional color play?

 • Is the transitional mixture warm or cool?

 If the transitional color doesn't increase the volume of the forms, change it. It must add volume.

 • Do you see hue variations in the transitional color?

 • You may want to vary the hues slightly, maintaining the values so that you don't break the surface of the forms.

4. Cast shadows behind the shadowed edges of the forms, using a mixture of burnt umber, ultramarine blue, and alizarin crimson and a pointed brush. This will push the forms forward in space and off the back wall, enhancing the volume and linear movement. *Allow the lines of your brushstrokes to show.*

5. Make sure all edges are outlined. The linear rhythm is the visual unifier in this technique.

PART VII
ABSTRACTION

We've all heard people make disparaging comments about modern abstract art. They say, "My two-year-old child could do that!"

or, "It doesn't take any talent to do that!" Are they all missing the point? Do abstract works have meaning? Could they hold religious meaning for us?

Yes, most people do miss the point of abstraction. Yes, most abstract works *do* have particular meaning. Yes, we can paint meaningful abstract religious paintings.

What is the point of abstraction, or nonrepresentational painting? It is the same as that of representational painting, minus the literal reference to real things in the real world. Both representational and nonrepresentational works use the formal elements of art: line, shape, light, shadow, color, form, mass, texture, and composition. We know that structured formal elements can communicate meaning. These elements do need the literal reference to real things that we can recognize. For example, if we agree that diagonal lines drawn in counterpoint to one another within a rectangular container communicate a feeling of violence, do we need to turn the diagonal lines into figures in order to communicate? The answer depends upon our audience. No, we don't have to turn the diagonal lines into figures, if our audience is sensitive to the formal elements in art. Yes, we have to turn them into figures, if our audience is literal and needs to identify the counterpointing movements as violent body gestures. Which of the two possible images is easier to understand, the counterpointing diagonal lines or the lines turned into counterpointing figures? It's a kind of catch-22! Abstraction *should* be more universal, democratic if you will, since it relies solely on the essential ingredients of the medium. Everyone should feel some primordial response to colors, shapes, and lines. Once we add a literal story, we have narrowed our potential audience.

Ironically, once we eliminate the human or real element, the general audience seems to feel less about the art. Paintings with identifiable images seem to provide a warm comfort and humanizing quality for most general audiences. The other obstacle that general audiences have to overcome when viewing abstraction is the loss of painting as a craft. Most people still believe that art is a craft-oriented rather than a thought-oriented medium. So when modern artists dispensed with rendering (which is the craft) and relied solely on the structuring of the formal elements, people felt these modern artists lacked "talent." The audience defined *talent* as "the ability to render, to depict images." Once paintings were devoid of rendering images, the talent was gone. The main point in question, therefore, is: Is art the rendering of images or the structuring of compositions? Any good artist, abstract or representational, would have to say that the main point to good painting is the structuring of compositions. Composition affects the viewer; the images add to the effect. Subject matter is truly communicated through the structuring of the formal elements.

We understand that feelings can be communicated by composing the formal elements. Besides the formal considerations, what of content? Can abstraction be symbolic? Is abstract painting any less meaningful than representational religious painting?

Art did not serve organized religion in the late nineteenth and twentieth centuries as it did in previous centuries. Church commissions were no longer the mainstay of artists' patronage. Instead artists painted for a general market and for themselves. The nineteenth century saw an intense interest in perceptual painting and the investigation

of the way we perceive the world as documented through painting. Art was created for art's sake. But some artists, of various faiths and origins, believed abstract art could communicate religious and spiritual meaning in a way that representational art never could. They were no longer bound by literal stories and images, but could explore the impact of form, shape, and color on the soul. Some were Protestants and Jews who had previously avoided religious iconoclasm and now had a whole arena open to them. Abstraction is a spiritual metaphor; it could be contemplated and used as an object of meditation, much in the way that orthodox icons and the lacework designs of illuminated manuscripts had been used in the past. Look at the work of artists like Kandinsky, Mondrian, Kupka, Pollock, Gottlieb, Still, Motherwell, Newman, Rothko, and Reinhardt, all of whose works have some spiritual base.[3]

Rather than giving you a specific procedure for abstract painting, I will set up a basic way to learn about compositional modes and direct you to the chapters on design, color, and composition. The artists' work in this chapter will give you ideas and possible directions to take.

Remember that color can be symbolic. Lines, shapes, textures, colors, and composition evoke feelings in the viewer.

Since the seventeenth century, artists and theoreticians have written about and investigated the idea that the particular movements of lines and compositions affect the viewer in different ways. Nicolas Poussin, in letters to his patrons about the paintings he created for them, refers to ideas about compositional modes. Poussin believed certain compositional structures were appropriate to certain themes. He would use a particular mode for a particular type of

FIGURE 71: Mark Tobey, *Above the Earth*, 1953, gouache, 39½" x 29¾", courtesy of the Art Institute of Chicago, gift of Mr. and Mrs. Sigmund Kunstadter.

If we transcend literal images, can we reach a greater truth? Do Tobey's cryptic forms evoke any primal responses in you?

subject, for example, severe subjects would have one type of mode and joyous subjects another. Where did Poussin get his ideas about modes? Perhaps from the writings of classical theoreticians who wrote about musical modes.

Exercise 18: Understanding Forms for Abstract Painting

Place a piece of tracing paper over an old-master painting of any religious theme. On the tracing paper, draw only the major compositional movements. Analyze the types of movements within the composition and the overall structural idea or mode of the composition. Is the composition based on repeating curves, vertical and horizontal movements, diagonal counterpoints? Choose several more old-master works with different themes. Choose a sad, joyful, pious, and a violent theme. Trace the movements in all of these on tracing paper. When you finish drawing them, compare their compositional structures. Do you notice the differences?

FIGURE 72: Robert Motherwell, *Reconciliation Elegy*, 1978, acrylic on canvas, 120″ x 364″ (3.048 x 9.242), courtesy of the National Gallery of Art, Washington, D C., gift of the Collectors Committee.

Could Motherwell's pure black and white, positive and negative, forms convey a symbolic message? Perhaps the juxtaposition of forms relates to the struggle of opposites, of the spirit and the flesh, of good and evil. As religious icons lost their meaning to modern audiences, paintings such as this became modern-day icons.

PART VIII
ICONS

The advantage of living and painting in the late twentieth century is that we can choose from an enormous range of methods, styles, and techniques. Is there a particular style that is in vogue now, you may ask? Yes. But if I mention the style, this book will be immediately dated. Why? Styles don't seem to last too long these days. The average style stays in vogue about three years; not very long, indeed, when we compare it to the styles of the Gothic and Renaissance periods. If we worry about what is in vogue and what is out of vogue, trying to second-guess the critics' taste, we might as well not paint. Painting, the choice of a method and style, should be as personal and as intuitively based a choice as your choice of life-style. Painting is a means of expressing your particular feelings about your religion or spirituality.

Some of us believe art is timeless. We can look at art from any period and appreciate its meaning. Of course, an art education helps us grasp the full meaning of a work of art. The idea that art is timeless leads to the idea that a style is timeless. Styles of painting should not be subject to current fashion tastes; they are vehicles for expressing a philosophy about religion, life, and the way we perceive life. If we choose to paint icons, we purposely ally ourselves with history, with the historical religious meaning and significance of such an image.

Icon literally means "an image." It has come to mean a religious or holy painting of one or more biblical figures, executed in a particular method. Before the fifteenth century, most icon painters used *egg tempera* on wood panels. Egg tempera is made from pigment and egg yolk. This medium is durable and yellows less than oil painting. However, because egg tempera is a transparent medium, it involves a painstaking procedure of applying individual brushstrokes and layered painting. Today we can

FIGURE 73: Marion C. Honors, C. S. J., *The Tree of Life Flowers*, 1980, acrylic paint, ink, graphite, 20″ x 15″, courtesy of the artist, Latham, N. Y.

Icons need not be traditional to take on meaning and spirit.

create icon, images in egg tempera,[4] oils, or acrylics (*see* plate 15 and figures 31, 73).

Traditional icons are painted on wooden panels. Panels are a rigid support conducive to individual brushstrokes and transparent layers. Solid wood panels, made of mahogany, poplar, or oak, are good choices. Plywood or veneer panels may prove more durable, including five-ply maple, walnut, mahogany, or birch. Fiberboards or Masonite may be used as well. You can glue canvas to Masonite. Most wood panels need a glue sizing, which is a process that fills the pores of the wood, thereby reducing its absorbency. A ground, such as white lead in oil or gesso (a chalk and glue mixture) must be applied, sometimes in layers, to the wood panel.

In preparation. *Materials:* Wood panel (any size), gesso or oil ground, glue sizing, sandpaper, wide bristle brush (about two inches wide), water, rags or paper towels.

1. If you intend to paint in oils, it is advisable to choose an oil-based ground. You can buy a ready-made ground or make you own.[5]
 * Sand the surface of the wood panel.
 * If the surface is not very absorbent, you may not need to apply a glue sizing. If it is absorbent, a sizing is necessary.[6]
 * Apply the ground in thin opaque layers. Allow each layer to dry before you apply the next one.
2. When the ground is entirely dry, draw your picture on the panel, using either vine charcoal or a soft pencil.
3. Gold leaf was, at times, used for entire backgrounds of paintings or for details, such as stars or halos. If you wish to include gold leaf in your icon, follow this procedure or invest in a good text on recipes and procedures for panel painting. *Materials:* Sheets of gold leaf—which come in books, with tissue paper separating each sheet—about a three-inch square, a can of oil gold size.
 * Cover the area that is to receive the gold leaf with oil gold size.
 * Lay the panel flat on a tabletop or floor.
 * Open the book of gold sheets and apply the gold directly to the wet area. Avoid touching the gold leaf; try to use the tissue paper to press it to the wet area on the panel.
 * Allow the oil gold size to dry and set (about twenty-four to thirty-six hours).
 * When the size is dry, you can paint over the gold with oil paint.

The Painting Process

After drawing on your panel or canvas and preparing it with gold (which is optional), the next step is to create an underpainting, which should establish the light and dark relationships of the forms and composition. These need not be extreme light and dark relationships; you can use a diffused (*see* painting method VI) or chiaroscuro (*see* painting method I) lighting effect. Choose from three basic types of underpainting:

1. *Grisailles:* This is tonal underpainting that uses shades or values of neutral grays. You can mix them from a combination of white, naples yellow, ultramarine blue, alizarin crimson, and burnt umber. These tones can be applied in hatched strokes with a pointed brush or in flat tones with a bright brush.

2. *Sepia:* This tonal underpainting utilizes shades made from one hue, either burnt umber, sepia, or raw umber. In combination with white, these brown tones establish the light and dark relationships of all the forms.

3. *Skin tones:* Old-master painters, primarily those who used egg tempera, used two color layers to create the underlying skin tones of their figures. First they applied a layer of green in hatched lines with a pointed brush. When that layer was dry, they applied a second layer of pink (made from alizarin crimson and white) by hatching into and in between the green strokes. These colors, in layered combination, simulate the underlying glow of skin tones. This combination is an underpainting, and transparent layers of color are applied over it. It can be used for any type of skin tones, with modifications given to the value of the green and pink hues.

Exercise 19: Painting an Icon

1. Choose a type of underpainting and begin to execute the painting in that technique.
2. Allow the underpainting to dry thoroughly.
3. The technique for applying the paint over an underpainting is called glazing. Glazes should have an oily consistency. Oil paints can be thinned down to a glazing quality, using either additional linseed oil or beeswax (don't thin with a solvent alone).
 - Apply colors in thin, transparent coats. The dried layer should look like a colored piece of film. Allow each layer to dry before the next transparent layer is applied. Use a pointed brush if you want to use a linear style or a bright brush if you want to use a natural flow of light. (*See* painting methods IV and VI.) Any of the painting methods in this chapter can be used; however, the linear style is traditional.
 - Glazes can be used over opaque paints and impasto areas.
 - You may want to build areas of the painted surface, for example, the architectural structures, details (stars, crowns, jewels), or furniture within the imagery, with impasto applications.
 - To create impasto with a brush, use a lot of paint on the brush and apply it thickly to the surface. Use little or no solvent in the thick paint. You may allow your brushstrokes to show or create textures in the paint. Impasto

can be built up, using smaller dabs of paint with a brush, or an entire area can be covered with thick paint, using a palette knife.

• Once you have applied thick paint to an area, you can scratch into it, while it is still wet, with a stick or the opposite end of your brush, to create incised marks or designs.

• Carefully varnish the finished work.

8 Themes of Religious Art

What does God look like? For centuries, artists have created images of God. Whether the artist chooses a particular narrative from the Bible or depicts God in a portraitlike image, we are presented with a great deal of poetic license. Images of God were created and are created to affect an audience, to stimulate the spirits of the viewers. Rather than being reportorial, these images invoke responses in us just because they have been interpreted by an artistic mind, through the powerful medium of painting.

Images of God

The deposition is mentioned in all four Gospels, and the descriptions are brief and fairly similar. However, artists have not strictly interpreted the biblical descriptions of this event. They were probably influenced by other factors, including apocryphal texts. Since the ninth century, artists have taken poetic license with this subject.

In fact, it is difficult at times to tell whether a painting depicts the deposition, lamentation, or pietà. The lamentation is the scene that occurs just following the deposition. Christ's body is usually depicted lying down, with a group of mourners around him. The pietà usually depicts the Virgin Mary mourning over the body of Christ. These subjects are some of the most popular in all of religious art, but curiously they are not referred to in the Gospels. They seem to be images that were created by artists or their patrons to evoke emotional responses in the viewers.

Rogier van der Weyden's *Deposition*, painted in the fifteenth century, is one of the most powerful religious images ever created (figure 74). Its composition, style, color, texture, size, scale, and rendering are the reasons for its power. The container is an odd shape, which follows the top half of the cross. The cross extends up into the extended vertical part of the container, but

FIGURE 74: Rogier van der Weyden, *Deposition*, courtesy of the Prado Museum, Madrid.

it also acts to press down and point to the figure grouping. The figures are friezelike, forming a tight frontal grouping in the shallow foreground. The space that they occupy is extremely shallow, almost coffin-like or nichelike. (Notice the ironwork in the upper corners, which defines the picture plane.) This shallow space forces us to focus on the figures and the subject. Van der Weyden does not provide a visual escape. We have no release from the figures and their feelings and gestures. We are forced to encounter their loss, grief, and mourning.

The composition can be analyzed in the following way. The Virgin Mary's body echoes the position and gesture of Christ's body. Could this symbolize their intercon- nectedness, their spiritual bond? The entire group forms an oval unit around Christ, which embraces him with love and support; it symbolizes, in formal terms, a sharing of his pain. Its linear style and proximate vision intensify the feelings. We can exam- ine and scrutinize every detail, the tears on cheeks, the crown of thorns, the fabrics and brocades, and the facial expressions. The use of detail acts to increase the tensions; our eyes are constantly examining things. We are never given an opportunity to rest. All the figures are actively involved, either supporting Christ and the Virgin or re- sponding to the tragedy with gestural

reaction. Within the linear structure, prolonged continuous curves and echoing rhythms increase the intimacy and emotional tension of the grouping.

Botticelli's *Lamentation*, created in the fifteenth century, like van der Weyden's, is an intense depiction of a religious scene with high emotional content (figure 75). The arch of Christ's body is the main focus of the work. The female figures that hold and embrace his head and feet act to embellish the curving arch of his body. The group of standing figures on the viewer's left lean inward and also echo the curve of Christ's form. Although Botticelli gives us slightly more background than Rogier van der Weyden, we still have little to examine save the grouping of figures. The stone crypt

behind them seems to react to the emotional strains of the figures, as if it too, in form, were mourning the loss of Christ. Once again we are presented with a shallow space, a linear style, proximate vision (though not as detailed as Van der Weyden's work), and a major compositional structure. The predominant downward curves of the figures' gestures suggest, in formal language (mode), the sadness of this subject.

The modern work *Lamentation* or *Descent From the Cross* (figure 76) was painted by William H. Johnson in New York. Johnson was born in South Carolina, but studied abroad. His style reflects a modern vision. Flat shapes, patterns, and the denial of perspective are all contributors to the modern look of his work. Our eyes are engaged

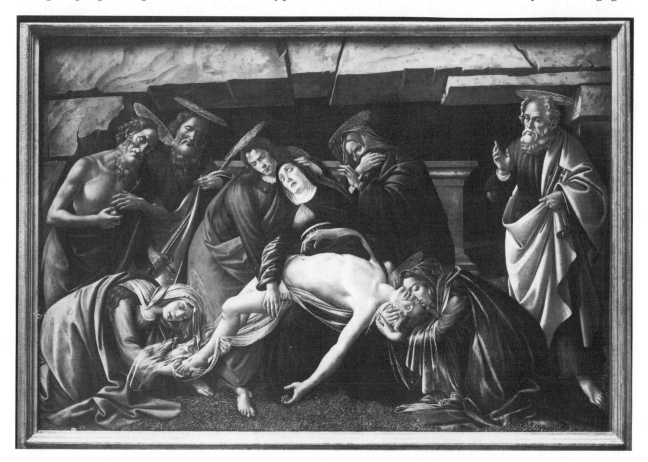

FIGURE 75: Sandro Botticelli, *Lamentation*, courtesy of the Staatsgemaldesammlung, Munich.

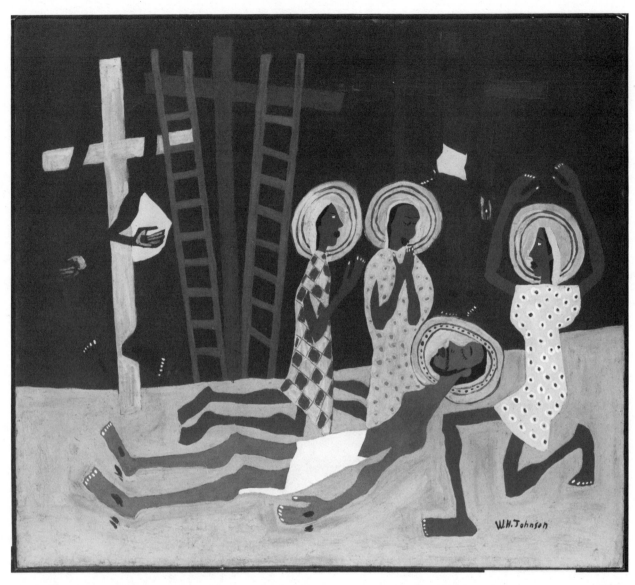

FIGURE 76: William H. Johnson, *Lamentation* or *Descent From the Cross*, c. 1939, oil on fiberboard, 74.0 x 84.6 cm., courtesy of the National Museum of American Art, Smithsonian Institution, Washington, D. C., gift of the Harmon Foundation.

by the interaction of the positive and negative shapes. All the shapes activate the energies of the container. Johnson, a black American, creates a personal and provocative image of God.

Ivan Albright's work *And God Created Man in His Own Image* (figure 77) provides a plethora of textures. The image is overwhelmed by textures, enveloped by them. The scale of the figure is large and fills the

container, almost becoming a kind of icon.

Matthias Grünewald's painting *The Small Crucifixion* (figure 78) also provides us with texture. We see a barren, rocky landscape, torn fabrics, a wooden cross, and the horrible surface of Christ's skin. Why does Grünewald depict Christ in this way? There was a terrible skin disease in Isenheim during this time period, and this altarpiece was commissioned for a monastery there

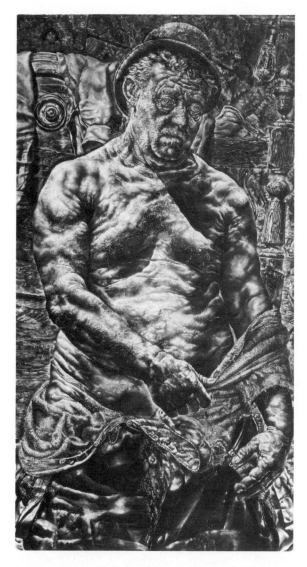

FIGURE 77: Ivan Albright, *And God Created Man in His Own Image*, 1930–31, oil on canvas, 48" x 26", courtesy of the Art Institute of Chicago, Chicago, Illinois, Gift of the Artist.

that acted as a hospital for people with the disease. Could Grünewald have been saying that if Christ could suffer this pain, so can you, the victim of the disease? Could the painting have a part in giving them hope for a miraculous cure?

The arms of Christ are elongated, his fingers and feet contorted with pain, and the wooden arms of the cross bend with the weight of his body. His head hangs as though his neck were broken, the texture of

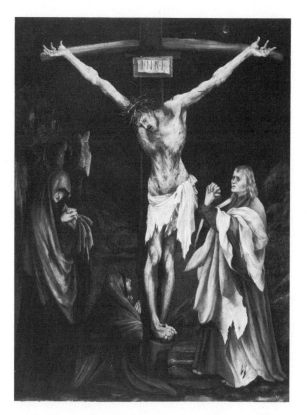

FIGURE 78: Matthias Grünewald, *The Small Crucifixion*, c. 1510, oil on wood, 24¼" x 18⅛" (0.616 x 0.460), courtesy of the National Gallery of Art, Washington, D. C., Samuel H. Kress Collection.

the crown of thorns contrasting with his hair and skin. His waist is emaciated and his rib cage is expanded. The ripped loincloth is in sympathy with his pain. Praying beside him, the three figures create an inner frame. This is not the type of image we would see coming out of the Italian Renaissance; Christ is not beautiful and stoic. We see the pain, the tortured body.

Perhaps we can compare Graham Sutherland's *Crucifixion* (*see* plate 16) to Grünewald's depiction of Christ. Here we have two religious paintings that are four centuries apart, yet the message is the same. Grünewald's depiction of Christ was probably directed at an audience suffering with great pain from a plague. In Sutherland's time, there were no such physical diseases, but there were plagues of another kind: the

tragedy of World War II and the concentration camps. Could this emotionally charged modern image of Christ help people deal with their family losses and suffering?

Depicting Stories

Saint Sebastian

The martyrdom of Saint Sebastian has been a very popular religious subject. Sebastian, a Roman praetorian guard during the third century, converted to Christianity. When his new faith was revealed to the Romans, he was sentenced to be shot to death with arrows for his beliefs. His executioners were told to avoid any vital organs, so that his suffering could be prolonged. He was left for dead by the Romans, but he miraculously survived. Nursed back to health by a woman named Irene, he went back to prove to the Roman emperor the power of his beliefs and plead for the toleration of Christians. He was then beaten to death by the Romans. Since Greek times, arrows have been associated with the cause of plagues; this idea was passed down to Christianity, and Saint Sebastian came to be the protector against the plague.

Let's look at two paintings of Saint Sebastian painted by Andrea Mantegna in the fifteenth century (figures 79, 80). Mantegna's earliest depiction, dated around 1470, shows Sebastian tied to a Roman marble pillar, surrounded by fragments of Roman antiquity, with a view that goes far back into space. Thanks to the artist's purposeful use of proximate vision, we can even see his assassins walking away from the scene of the attempted execution. Mantegna gives them an escape route. We, too, are given an escape route; we can

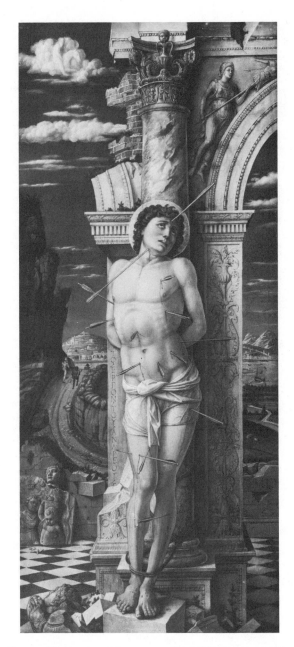

FIGURE 79: Andrea Mantegna, *Saint Sebastian*, c. 1470, 68 x 30 cm., courtesy of the Kunsthistorischen Museum, Vienna.

scrutinize the details in the clouds, fragments of sculpture, rocky cliffs, and the incised marble arch. Of course, the focal point is Saint Sebastian, depicted as young, strong, and stoic. Mantegna's personal passion for antiquity and skills in rendering are obvious in this work.

The later depiction, dated around 1490, is

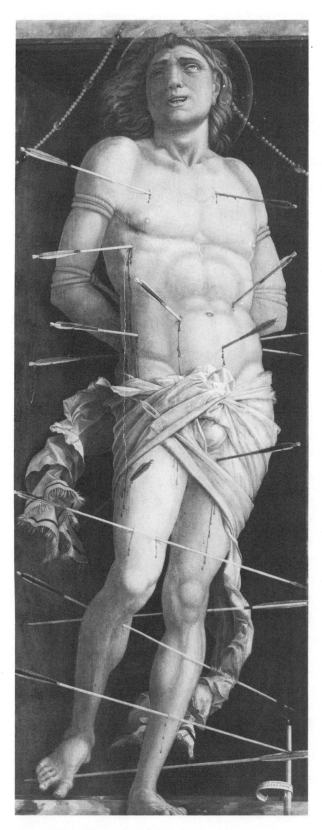

FIGURE 80: Andrea Mantegna, *Saint Sebastian*, c. 1490, 210 x 91 cm, courtesy of the Ca d'Oro, Venice.

very different indeed. We no longer have an escape route. There is no background, very much like the *Deposition* by van der Weyden (figure 74); the figure is in a coffinlike or nichelike space. We are forced to confront him in agony. The innumerable diagonally placed arrows are extremely dynamic elements set against the narrow rectangular container. The narrowness of the container seems to give the arrows more force, yielding greater pain. No longer stoic, Sebastian looks heavenward for help. Even his loincloth seems to scream with pain. Notice that Sebastian seems to be stepping out of the painted frame. If the painted frame established the picture plane, is Saint Sebastian stepping out into our space? How does that make you feel?

The popularity of Saint Sebastian as a subject for painters is a curious one. Could it be that patrons felt Saint Sebastian was the perfect prototype of endurance, of strong faith and will? Perhaps viewers felt that if Saint Sebastian could survive his martyrdom through his strong faith, then they, too, could survive through their own misfortunes and tragedies through a strong faith.

Tanzio da Varallo's *Saint Sebastian* (figure 81) is much more earthbound than are Mantegna's. Here we see Sebastian's wounds tended to; therefore we have a greater feeling of hope. The large-scale figures fill the container, and their forms, treated in a chiaroscuro style, dominate the space.

Images From the Old Testament

Daniel in the Lions' Den (figure 82), by Peter Paul Rubens, draws on a popular Old Testament story. Daniel, who was one of the four major prophets, was thrown into

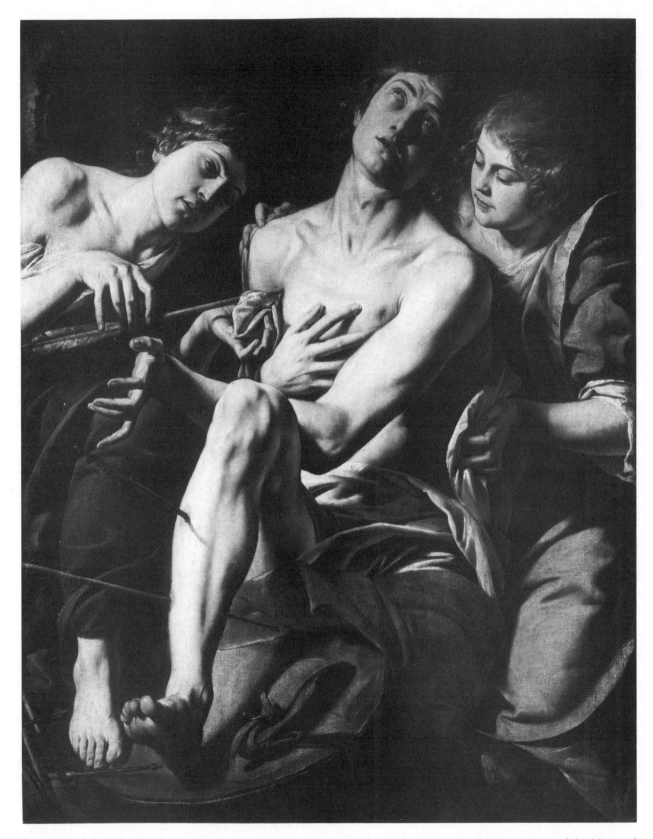

FIGURE 81: Tanzio da Varallo, *Saint Sebastian*, 1620/30, oil on canvas, 46½" x 37" (1.18 x 0.94), courtesy of the National Gallery of Art, Washington, D. C., Samuel H. Kress Collection.

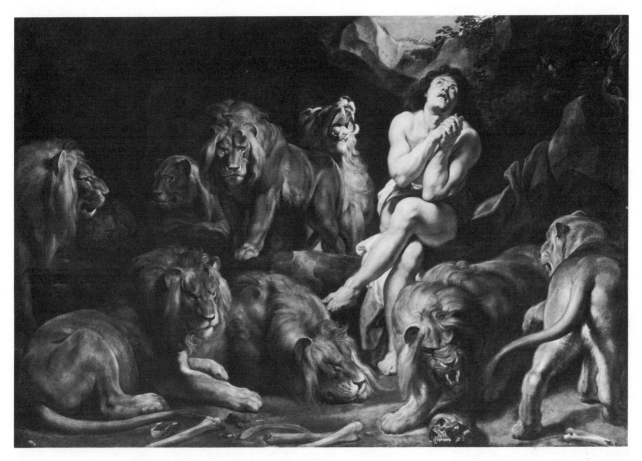

FIGURE 82: Peter Paul Rubens, *Daniel in the Lions' Den*, oil on canvas, 88¼" x 130⅛" (2.243 x 3.304), courtesy of the National Gallery of Art, Washington, D. C., Ailsa Mellon Bruce Fund.

the lion's den for disobeying a religious edict of the Persian king Darius. The prophet Habakkuk was told of Daniel's fate by an angel. The angel carried Habakkuk, bearing food for Daniel, to Daniel. Daniel saw this as a sign of God's belief in him and endured in the den for seven days (*Apocrypha*—Daniel, Bel, and the Snake 33–42). When the Persian king found Daniel alive, he was convinced of the power of the Jewish God. The Persian soldiers who had originally thrown Daniel to the lions were then thrown to the lions and immediately devoured.

Like Saint Sebastian, Daniel looks upward, to God, for help. He prays and believes his faith will save him. We see him surrounded by lions, some who seem satisfied, others who seem ferocious. The curving movements of the lions' bodies and the diagonal thrust of Daniel's pose all link together to create organic interconnections. The light on Daniel and his diagonal pose make him the focal point.

Henry Ossawa Tanner's *Daniel in the Lions' Den* (figure 83) is a much less earthy depiction than Ruben's. Daniel seems bathed in and protected by a kind of mystical light, which keeps the lions away from him. Not only does the "spotlight" effect give the light a mystical quality, but the apparent overall brushstrokes act as a mysterious veil.

Paolo Veronese's *The Finding of Moses* (figure 84) was painted in the sixteenth

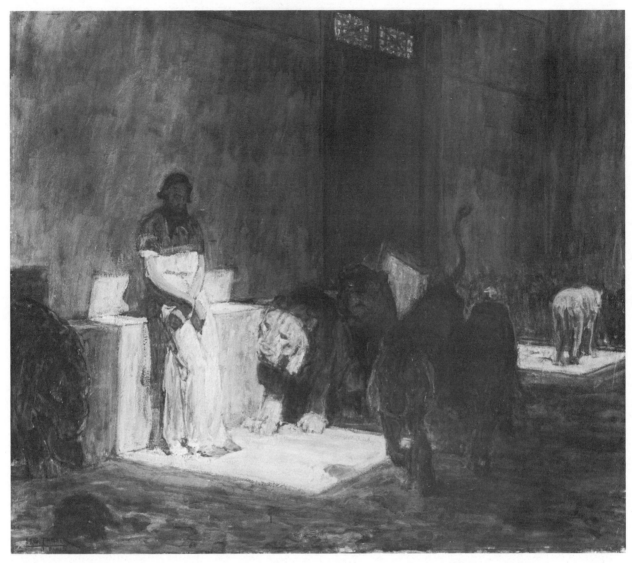

FIGURE 83: Henry Ossawa Tanner, *Daniel in the Lions' Den,* oil on paper on canvas, 41¼″ x 50″ (104.8 x 127.0 cm), courtesy of the Los Angeles County Museum of Art, Los Angeles, CA, Mr. and Mrs. William Preston Harrison Collection.

century. Veronese is considered one of the great High Renaissance artists who painted in the Venetian style, with an emphasis on color rather than line (the Florentines emphasized line). The story of the finding of Moses comes from the Old Testament (Exodus 2:1–10). When the Egyptian pharaoh ordered all male Hebrew infants put to death, Moses' mother set him adrift in a basket on the waters of the river. The pharaoh's daughter and her attendants found him on the river and recognized him

to be a Hebrew. Moses' sister watched from across the river and went to pharaoh's daughter, offering to find the child a nurse. Falling for this, pharaoh's daughter allowed his sister (though she did not say she was his sister) to take him. Moses was returned to his mother. This Old Testament subject is sometimes seen as a prefiguration of the flight into Egypt. Rather than setting this event in the days of old Egypt, Veronese chose to depict the women in the style of his contemporaries, with Venetian brocades

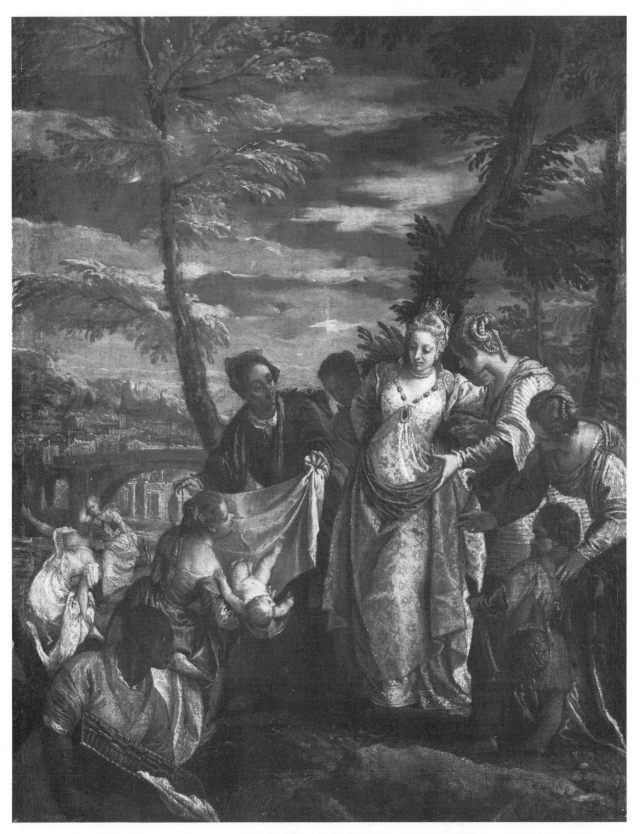

FIGURE 84: Paolo Veronese, *The Finding of Moses*, oil on canvas, 22¾″ x 17½″ (0.580 x 0.445), courtesy of the National Gallery of Art, Washington, D. C., Andrew Mellon Collection.

and costumes. The figure to the lower left, holding the empty basket, brings our eyes into the picture, then leads to the figure holding Moses, moving along the cloth to the figure of pharaoh's daughter. The V-shaped negative space between the trees also leads our eyes to pharaoh's daughter and the baby Moses. Notice the use of compositional curves, the curve in the cloth on pharaoh's daughter's dress, the curve of the cloth held behind Moses and the gestures of arms and torsos. This curving mode is a joyous one; a life has been spared, saved.

Still Life

Still life is a democratic subject: Everyone has access to it, and everyone understands it. If we looked at a painting of figures, and the figures were upside down, we would question it; but when we look at a still life, we don't question why a vase is overturned. This was not always the case. In seventeenth-century Dutch and Flemish painting, still-life objects held particular symbolic meanings. If a glass cup was broken, or if a fruit was half-eaten, there were reasons for these specific depictions. What happened to still-life symbolism? Why don't we understand its message anymore? Can we utilize it once again to create religious or spiritual paintings?

Still-life subjects became appealing to nineteenth-century artists who needed a perceptual subject that was relatively constant. Impressionist and postimpressionist artists like Manet, Renoir, Monet, and Cézanne painted still lifes, using fruit, bowls, flowers, vases, cloths, tableware, and various inanimate objects. Their interest in the still life as a subject was purely aesthetic, visual. For the most part, the objects did not hold symbolic meaning;

instead the still lifes were perceived as formal elements of color, light, shadow, form, and composition. Cubist artists used still lifes as vehicles for their formal philosophies about art. In the 1960s artists in the pop-art movement, such as Andy Warhol, used inanimate objects like the Campbell's soup can as popular recognizable images. These new "still life" artists gave their objects a new political and social meaning. In all cases, the still-life objects lost the symbolic meanings they held for artists in the seventeenth century. Today's average museum goer doesn't realize the potential and symbolic meanings in still lifes of seventeenth-century art.

Yes, we can use still-life subjects to create religious and spiritual paintings today. All avenues are open to us. If the average museum goer doesn't understand our message, then the atypical museum goer will. Someone who has studied the history of art will recognize symbolic imagery.

Most seventeenth-century still lifes that held symbolic meanings were known as "Vanitas" (see figure 85). They were meant to remind us of the transience of life, the inevitability of death, and the emptiness of material possessions (and inevitability of the Christian Passion and Resurrection). They stressed the falseness of human vanity and the fickleness of the human temperament. "Vanity of vanities . . . all is vanity" (Ecclesiastes 1:2). Most "Vanitas" paintings included one or more of the following objects: a candle or an hourglass (a symbol of time), a cup which was either broken or overturned (a symbol of emptiness), coins or jewels (symbols of material possessions that we leave behind), flowers (symbols of a short life), a skull (a symbol of death), a sword (a symbol that shows we have no defense against death).[1] The element of

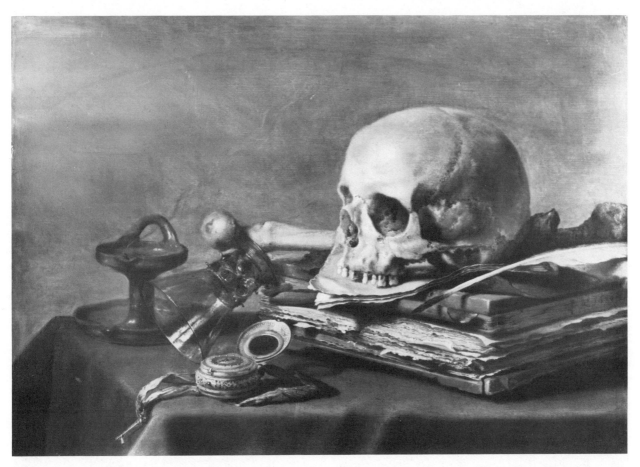

FIGURE 85: Pieter Claesz, *"Vanitas" Still Life*, 1630, courtesy of the Royal Picture Gallery, Mauritshuis, the Hague, the Netherlands.

time could be depicted through half-eaten fruit, spilled wine, smoke from a pipe, peeled fruit, spilled ink bottles. All these objects were proof of the passage of time; people had been there, affected things, and would surely leave this earth. Specific elements of Christianity could be introduced with a wine glass, bread, particular flowers, and instruments of the Passion; and specific elements of Judaism could be introduced with bitter herbs, a wine glass, prayer shawl, or religious objects. The moral symbolism is metaphorical (*see* figure 86).

Selected Symbols: Flowers, Fruit, and Still-Life Objects[2]

Almond: This is a sign of divine approval, referring to the Old Testament story of the miraculous blossoming of Aaron's rod. When related to the Virgin, it signifies purity and sweetness. The mandorla (*mandorla* means "almond" in Italian) is the name given the oval halo that encloses the body of Mary and Christ.

Apple: When held by Adam and Eve (in the Fall), the apple symbolizes sin, disobedience, and indulgence in earthly desires and sensual pleasures. When held by the Christ child or the Virgin Mary, the apple represents Christ as Savior.

Book: It symbolizes wisdom. In Christian art, a book symbolizes the Bible.

Bread: Generally bread symbolizes sustenance and God's providence in the Old Testament. When related to Christianity, it represents the staff of life, the body of

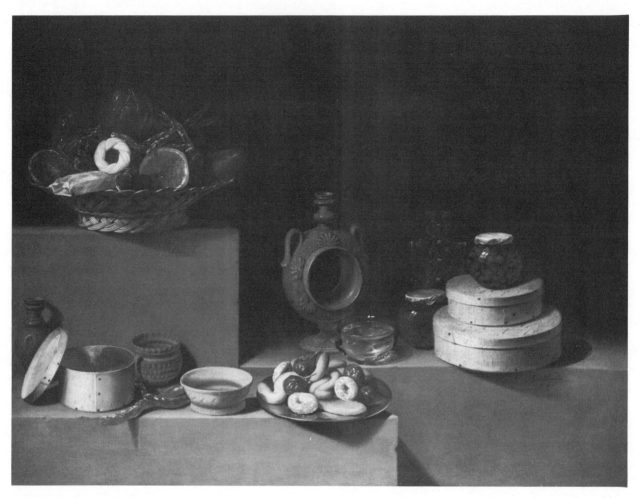

FIGURE 86: Juan van der Hamen y Leon, *Still Life*, 1627, oil on canvas, 33⅛" x 44⅜" (0.842 x 1.128), courtesy of the National Gallery of Art, Washington, D. C., Samuel H. Kress Collection.

Christ (and his sacrifice), and the Eucharist.

Candle: Candles play parts in many religious ceremonies. A lit candle symbolizes the light of faith and individual life. In Jewish art, the seven-branched candleholder, called a menorah, represents the Temple of Jerusalem. In Christian art it can represent Christ as the light of the world. In "Vanitas" still lifes, it represents the transience of human life.

Carnation or *pink:* This flower is a symbol of love and marriage, and is said to have originally sprung up from the tears shed by Mary on her way to Calvary. When red, it can be a symbol of fidelity and marriage, seen in wedding portraits. The pink can also be a symbol of Christ or the Virgin.

Caterpillar and *butterfly:* Either one may represent the life cycle, resurrection, or eternal life.

Chalice: A traditional cup used in the Eucharist, it holds consecrated wine and hence the blood of Christ. When depicted with bread in a still life, it can be a symbol of Christian faith.

Cherry: This is the fruit of paradise and a general symbol of sweetness and good character, because of its sweet taste.

Clover: The clover leaf symbolizes both good and evil. A four-leafed clover is good luck and a five-leafed clover is evil. A three-leafed clover represents the Trinity.

Coins or *jewels:* Such items represent the

secular world. In a "Vanitas" still life, they may represent the material possessions we leave behind when we die.

Cornucopia: The horn of plenty, this symbolizes fruitfulness, plenty, and hospitality.

Cup or *goblet:* In the Old Testament, a cup discovered in a sack of corn relates to Joseph, son of Jacob. In Christian art it symbolizes Christ's agony in the garden. In a "Vanitas" still life, an overturned or broken cup symbolizes emptiness and the mercurial nature of life.

Daisy: A flower that symbolizes simplicity and innocence, it is known as the "eye of God."

Dandelion: In the Old Testament, this represents a bitter herb (Exodus 12:8). In Christianity it is a symbol of the Passion and grief.

Egg: This represents purity, chastity, rebirth, and fertility, in a still life; in a "Vanitas" still life, a broken egg may symbolize the Resurrection.

Fig: Like the apple, the fig is sometimes seen related to the tree of knowledge of good and evil. It is also a symbol of lust, originating from Adam and Eve covering their nakedness with fig leaves. It can also symbolize fertility, because of its many seeds, or good works.

Fish: In the Old Testament, it is a symbol of the Archangel Raphael, and in Christian art it is an early symbol of Christ.

Glass: This is a symbol of the Virgin birth; a symbol of the Incarnation and purity in general.

Grapes: In Christian art, grapes refer to the Eucharist (the blood of Christ) and to the Passion.

Holly: In Christian art, it is a symbol of the Passion and a specific reference to the crown of thorns; holly's red berries relate to

Christ's blood and suffering. Generally, it signifies eternity.

Hourglass: This time keeper is a symbol of death and time; in a "Vanitas" still life it signifies the shortness and fleetingness of life.

Knife: In the Old Testament it relates to the story of the sacrifice of Isaac and is attributed to Abraham. Generally a symbol of vengeance, death, sacrifice, and martyrdom.

Laurel: This plant symbolizes immortality; a laurel crown symbolizes triumph and victory.

Lemon: It is a symbol of fidelity in love.

Lily: Generally the lily is a symbol of purity. In Christian art, it is a symbol of the Virgin Mary, the Immaculate Conception, and virgin saints.

Mask: Generally this is a symbol of deception.

Orange and *orange tree:* Symbols of chastity, generosity, and purity, like the apple and fig they are sometimes related to the tree of knowledge.

Peach: This has come to represent a charitable nature. It may signify salvation, in Christian art.

Peacock: Generally this bird is a symbol of vanity. In Christian art it may signify immortality and Christ's resurrection.

Pomegranate: It is a Christian symbol of the Resurrection and the unity of the church.

Rose: This flower is associated with Mary, who is called the "rose without thorns." Saint Ambrose's legend tells us the rose grew without thorns in the Garden of Eden before the Fall. After the Fall, it became an earthly plant, and the thorns appeared as a reminder of man's sins and fall from grace. A red rose symbolizes martyrdom. A white rose is a symbol of purity. A yellow rose is a

symbol of impossible perfection or papal benediction.

Strawberry: The strawberry symbolizes righteousness and good deeds.

Sword: In "Vanitas" paintings, it is a reminder that we have no defense against death. In other Christian art, it is a symbol for martyrs.

Violet: In Christian art, it is a symbol of humility.

Vine: This is a symbol of Judaism in the Old Testament. In Christian art, it symbolizes Christ and the church.

Landscape

Landscape, like still life, is accessible to all. We don't have to know the specific location of a painted landscape in order to appreciate its meaning. Whether an artist paints directly in front of a landscape or from recollection in a studio setting, landscapes can hold religious and spiritual meaning. The belief that God exists within nature and that nature is God's creation is reflected in many artists' works.

Landscape painting has been a great American tradition. America's pride in her natural unspoiled beauty, her mountains, rivers, and phenomenal land formations all prompted nineteenth-century American artists to paint America's true heritage: the land "from sea to shining sea" (figures 87, 88). For them, there was nothing more important or moral to contemplate than God's world, the land. There were moral values in an aesthetic experience, and moral benefits would be derived from contemplating landscape.[3]

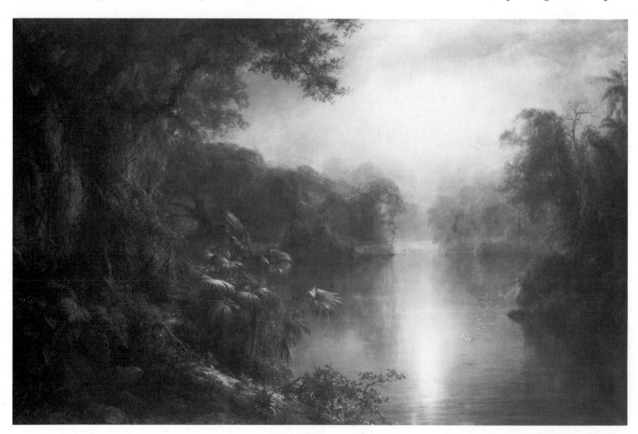

FIGURE 87: Frederic Edwin Church, *Morning in the Tropics,* 1877, oil on canvas, 54⅜" x 84⅛" (1.381 x 2.137), courtesy of the National Gallery of Art, Washington, D. C., gift of the Avalon Foundation.

The American artist Thomas Cole, in his painting of *The Notch of the White Mountains* (figure 88), revels in the spirituality of landscape. The belief in pantheism, the concept of God as one whole with the world, the universe, runs through American landscape painting. In this landscape painting the light can be thought of as a mystical light, even though it represents "real" light.

Pieter Brueghel the Elder, coming out of Protestant Holland, meshed man and landscape. He understood the deep interconnections between human beings and their earth (figure 89).

Social and Political Themes

Society and politics are everyone's affair. Can we ignore the state of the world,

hunger, loneliness, the homeless, and call ourselves religious or spiritual people? Some artists believe we can't. They find art a way of expressing their concern for the world's state of being and perhaps a way to convince others of a need for change.

One particular artist in the nineteenth century saw himself as a social commentator. Honoré Daumier created many cartoons, drawings, and paintings that pointed to the human predicament. His painting *The Beggars* (figure 90) does have spiritual significance. Perhaps it is not symbolic in the same way as a "Vanitas" painting or a specific event from the Bible, but it is nonetheless spiritual. Margaret Beaudette's works (*see* plate 2) define her concerns about the social and political world holding spiritual significance for her. Can it then hold

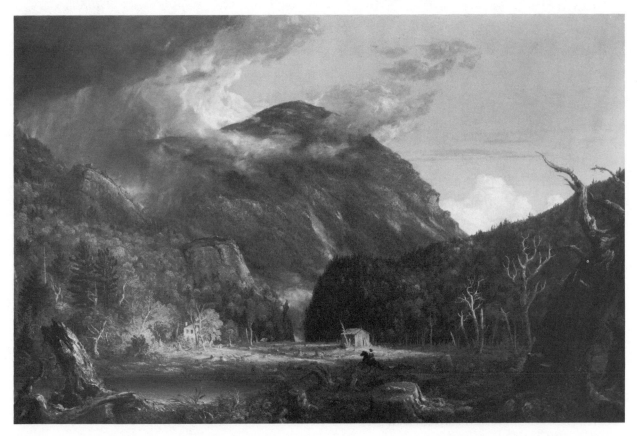

FIGURE 88: Thomas Cole, *The Notch of the White Mountains*, 1839, oil on canvas, 40" x 60½" (1.016 x 1.560), courtesy of the National Gallery of Art, Washington, D. C., Andrew W. Mellon Fund.

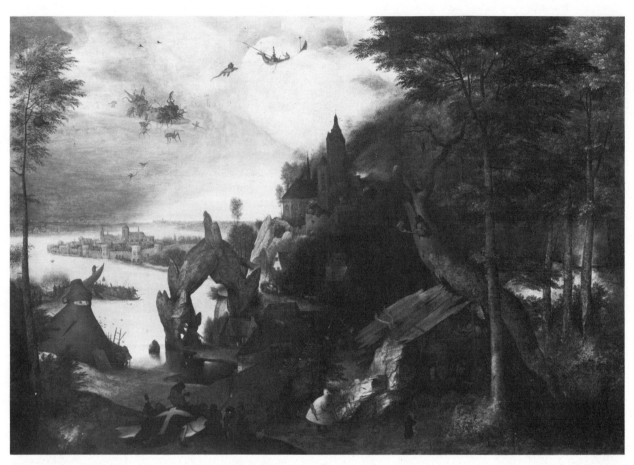

FIGURE 89: Pieter Brueghel the Elder, *The Temptation of Saint Anthony*, date probably between 1555 and 1558, oil on wood, 23″ x 33¾″ (0.584 x 0.857), courtesy of the National Gallery of Art, Washington, D. C., Samuel H. Kress Collection.

spirituality for its viewers? I would be compelled to say yes. Audrey Flack's *WWII* (plate 18) contrasts luxurious objects in vivid colors with a black-and-white image of people in concentration camps. It is difficult to look at this painting and not feel responsibility for the world's actions.

Questioning Reality

Some artists have contrasted the "real world" and "ideal world." To begin to deal with that subject is certainly a book in itself, but it must be said that artists in the very early twentieth century began to use art as a vehicle for questioning what is real. The church and royal governments were no longer major patrons of painting. Art no

longer had to serve established bodies of patrons. Artists could make art, paintings, and sculptures in order to express their beliefs, ideas, philosophies of life, heritage, visual perception, and their sensibilities. Why should the practice of philosophy be limited to writers and poets? Art turned in on itself and became a new branch of philosophy. Using paints and canvas, artists could create philosophical messages, quests into new and exciting realms. *Who am I? Where am I? How can I probe and prove my existence? Can I reach my subconscious mind, my unconscious mind? What is real? What is ideal? Where is God, in nature, in us? Can I communicate with God through art? Is the creation of art a religious experience?*

Josef Albers sets up an optical illusion for

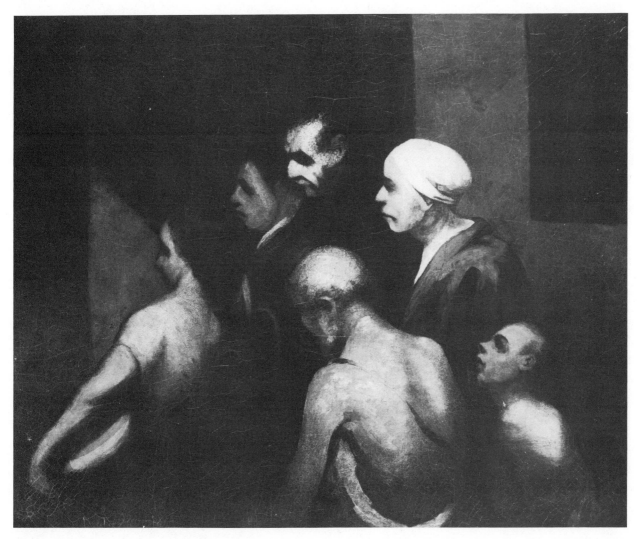

FIGURE 90: Honoré Daumier, *The Beggars*, c. 1845, oil on canvas, 23½″ x 29⅛″ (0.597 x 0.740), courtesy of the National Gallery of Art, Washington, D. C., Chester Dale Collection.

our perception in *Structural Constellation* (figure 91). Is our perception of the illusion of space real, or is the actual concrete concept of the flat surface of a canvas real?

Salvador Dali, a surrealist painter, made it his life's work to explore the various realms of reality through painting. *The Sacrament of the Last Supper* (figure 92) is no less a true religious image because it sets up problems of space and the believability of forms in space.

Camille Eskell, a modern Jewish artist, uses the theme of fear, in particular the nightmare, as a metaphor for the exorcism of demons or evil from the soul of the innocent. Like dreams, her works sit somewhere between reality and make-believe (figure 93).

When artists turned to still life and landscape as subjects with religious meaning, the move toward more universal subject matter with the potential for underlying meaning was inevitable. What subject matter is universal? The only true universal language in art is the formal elements: line, shape, light, shadow, color, texture, and composition. Any artist, in any country, has the potential to understand this language.

FIGURE 91: Josef Albers, *Structural Constellation*, courtesy of the Sidney Janis Gallery, New York City.

Although Eastern artists and Western artists do utilize the painting medium in slightly different ways, the formal elements are far more universal than paintings with specific symbols and references. So an abstract painting (only the formal elements) is far more accessible to all people than a specific religious scene.

It seems many artists feel that besides the formal elements of painting, some representational images are universal. Images of a mother and child, mourning, death, lights, passageways, embraces, and so on. In other words, interpersonal relationships, human situations, archetypes, and gestures are common to all people, regardless of their background. Loren MacIver's painting *Blue Votive Lights* (figure 94), which is part of a series, focuses on light. Lights and candles are part of many religious ceremonies. These rows of lights may bring the lights in churches to mind. But on a purely visual level, like an icon, they allow us to meditate.

Another artist's works are also icons. Dale Saltzman's prints (figure 95) are symbolic reminders, inspired by a raised religious consciousness.

Freedom in Religious Art

Whether you paint the "real world," an "ideal world," or remind others of faith

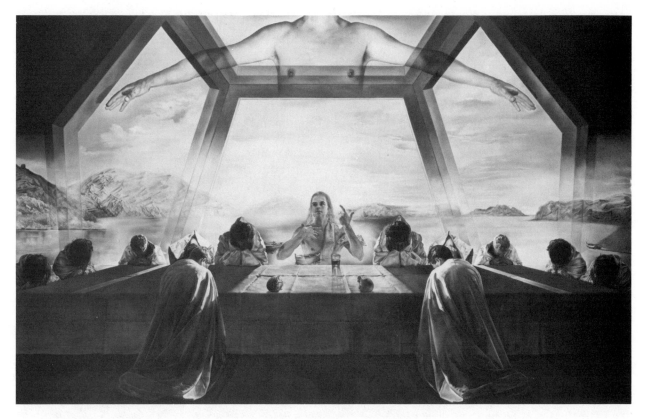

FIGURE 92: Salvador Dali, *The Sacrament of the Last Supper*, 1955, oil on canvas, 65⅝″ x 105⅛″ (1.667 x 2.670), courtesy of the National Gallery of Art, Washington, D. C., Chester Dale Collection.

through iconlike art, what you paint will reflect your outlook on the world, your philosophy of life, and the faith you hold. Trying to separate them from your art will not work, because even unconsciously you will show the ideas behind the construction of your paintings. Instead, use your faith as a conscious, integral part of your work, and you will discover a new freedom in art and belief.

Today, as never before in history, artists have a freedom to reflect their faith in any type of art they enjoy. Take advantage of this opportunity!

FIGURE 93: Camille Eskell, *The Blind Path*, 1984, black oil pastel, 38″ x 30″, courtesy of the First Street Gallery, New York City.

FIGURE 94: Loren MacIver, *Blue Votive Lights*, 1964, oil on canvas, 32" x 50", courtesy of the Pierre Matisse Gallery, New York City.

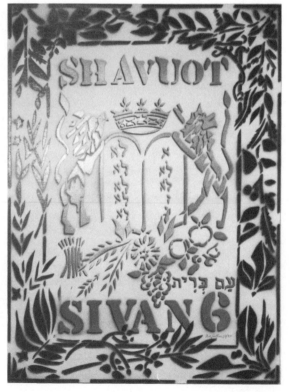

FIGURE 95: Dale A. Saltzman, *Shavuot*, 1984, print on paper, courtesy of the Temple of Israel of Northern Westchester.

Dale Saltzman's daughter, Naomi, was studying for her bat mitzvah, a Jewish ceremony marking a young woman's spiritual and moral growth; and Dale Saltzman became inspired. This work was created by the artist as a testament to the raising of his consciousness as a Jew through contact with his and his daughter's rabbi. It is part of a series, each of which represents a holiday; and reminds the faithful of the role and importance of the holiday's symbolic meaning.

Notes

Chapter 1

1. George Kubler, *The Shape of Time* (New Haven, Conn.: Yale University Press, 1974), 65.

2. Stella Pandell Russell, *Art in the World*, 2nd ed. (New York: Holt, Rinehart and Winston, 1975), 208.

3. Mia Cinotti, ed., *The National Gallery of Art of Washington and Its Paintings*, (New York: Arco Publishing Company, 1975), 50.

4. Betty Burroughs, ed., *Vasari's Lives of the Artists* (New York: Simon and Schuster, 1946), 219.

5. Meyer Schapiro, "Style," in *Anthropology Today*, ed. A. L. Kroeber, 4th ed. (Chicago, Ill: University of Chicago Press, 1957), 287.

6. This information is based on the comparative terms established by Heinrich Wölfflin, *Principles of Art History*, trans. M. D. Hottinger (New York: Dover Publications, 1950), 14, 15.

7. This information is based on the essay written by José Ortega y Gasset, "On Point of View in the Arts," *The Dehumanization of Art, and Other Essays on Art, Culture, and Literature* (Princeton, N. J.: Princeton University Press, 1972), 105–130. First appeared in *Partisan Review* 16 (1949) no. 8.

8. Ibid., 127.

Chapter 3

1. Robin Landa, *An Introduction to Design* (Englewood Cliffs, N. J.: Prentice-Hall, 1983), 18–23.

2. "Gesture," *Funk and Wagnall's International Dictionary of the English Language*, (New York: Publisher's Guild Press, 1978), 531.

Chapter 4

1. In my text *An Introduction to Design*, (Englewood Cliffs, N. J.: Prentice-Hall, 1983), I discuss all aspects of two-dimensional design and color as they relate to the media of painting and drawing and the printed page. The chapter on translation of space discusses several important issues in relation to drawing. Any preliminary drawing for a religious painting should take the principles in that chapter into consideration.

Chapter 5

1. These definitions are based on information from the following texts: Henry Turner Bailey and Ethel Pool, *Symbolism for Artists, Creative and Appreciative* (Worcester, Mass.: Davis Press, 1925); George Ferguson, *Signs and Symbols in Christian Art* (New York: Oxford University Press, 1954); James Hall, *Dictionary of Subjects and Symbols in Art* (New York: Harper and Row, Icon Editions, 1974); Erwin Panofsky, *Studies in Iconology* (New York: Harper and Row, Icon Editions 1972); Gertrud Schiller, *Iconography of Christian Art*, vols. 1 and 2 (Greenwich, Conn.: New York Graphic Society, 1971); Gertrude Grace Sill, *A Handbook of Symbols in Christian Art* (New York: Collier/Macmillan, 1975).

Chapter 6

1. If you are interested in making your own varnish or learning more about materials, texts such as Ralph Mayer, *The Painter's Craft* (New York: Penguin Books, 1979); Ralph Mayer, *Artist's Handbook of Materials and Techniques*, 4th rev. ed. (New York: Viking Press, 1981); and Bernard Chaet, *An Artist's Notebook* (New York: Holt,

Rinehart & Winston, 1979) are good sources of information.

Chapter 7

1. Barbara Rose, "Art as Icon," *Vogue* (December, 1979), 229.

2. John Walker, *National Gallery of Art, Washington* (New York: Harry N. Abrams, 1975), 316.

3. Barbara Rose, "Art as Icon," 308.

4. For more information on painting in egg tempera, *see* Bernard Chaet, *An Artist's Notebook* (New York: Holt, Rinehart and Winston, 1979) or Ralph Mayer, *The Painter's Craft* (New York: Penguin Books, 1979).

5. *See* above Chaet and Mayer texts for ground recipes.

6. *See* Chaet and Mayer texts for sizing recipes.

Chapter 8

1. James Hall, *A Dictionary of Subjects and Symbols in Art* (New York: Harper and Row, Icon Editions, 1979), 271.

2. Definitions in this section are based in part on the following sources: Henry Turner Bailey and Ethel Pool, *Symbolism for Artists* (Worcester, Mass.: Davis Press, 1925); Satia and Robert Bernen, *Myth and Religion in European Painting, 1270–1700* (New York: George Braziller, 1973); Howard Daniel, *Encyclopedia of Themes and Subjects in Painting* (New York: Harry N. Abrams, 1971); George Ferguson, *Signs and Symbols in Christian Art* (New York: Oxford University Press, 1954); James Hall, *Dictionary of Subjects and Symbols in Art* (New York: Harper and Row, Icon Editions, 1979); Erwin Panofsky, *Studies in Iconology* (New York: Harper and Row, Icon Editions, 1972); Gertrud Schiller, *Iconography of Christian Art*, vols. 1 and 2 (Boston, Mass.: Little Brown and Company, 1971); Gertrude Grace Sill, *A Handbook of Symbols in Christian Art* (New York: Collier/Macmillan, 1975).

3. Barbara Novak, *American Painting of the Nineteenth Century* (New York: Praeger Publishers, 1974), 61, 62.

Bibliography

Bailey, Henry Turner, and Ethel Pool. *Symbolism for Artists, Creative and Appreciative*. Worcester, Mass.: Davis Press, 1925.

Bernen, Satia and Robert. *Myth and Religion in European Painting, 1270–1700*. New York: George Braziller, 1973.

Burroughs, Betty, ed. *Vasari's Lives of the Artists*. New York: Simon and Schuster, 1946.

Chaet, Bernard. *An Artist's Notebook*. New York: Holt, Rinehart and Winston, 1979.

Cinotti, Mia, ed. *The National Gallery of Art of Washington and Its Paintings*. New York: Arco Publishing Company, 1975.

Daniel, Howard. *Encyclopedia of Themes and Subjects in Painting*. New York: Harry N. Abrams, 1971.

Ferguson, George. *Signs and Symbols in Christian Art*. New York: Oxford University Press, 1954.

Flack, Audrey. *On Painting*. New York: Harry N. Abrams, 1981.

Funk and Wagnalls International Dictionary of the English Language. New York: Publisher's Guild Press, 1978.

Getlein, Frank and Dorothy. *Christianity in Modern Art*. Milwaukee: Bruce Publishing Company, 1961.

Hall, James. *Dictionary of Subjects and Symbols in Art*. New York: Harper and Row, Icon Editions, 1974.

Kaniel, Michael. *The Art of World Religions: Judaism*. Poole: Blandford Press, 1979.

Kubler, George. *The Shape of Time*. New Haven, Conn.: Yale University Press, 1974.

Landa, Robin. *An Introduction to Design*. Englewood Cliffs, N. J.: Prentice-Hall, 1983.

Lewis, Samella. *Art: African American*. New York: Harcourt Brace Jovanovich, 1978.

Mayer, Ralph. *A Dictionary of Art Terms and Techniques*. New York: Thomas Y. Crowell Company, 1969.

Nemser, Cindy. *Art Talk*. New York: Charles Scribner and Sons, 1975.

Novack, Barbara. *American Painting in the Nineteenth Century*. New York: Praeger Publishers, 1974.

Ortega y Gasset, José, "On Point of View in the Arts." *The Dehumanization of Art and Other Essays on Art, Culture and Literature*. Princeton, N. J.: Princeton University Press, 1968. First appeared in *Partisan Review* 16, no. 8, (1949).

Panofsky, Erwin. *Studies in Iconology*. New York: Harper and Row, Icon Editions, 1972.

Rose, Barbara. "Art as Icon." *Vogue* (December, 1979).

Russell, Stella Pandell. *Art in the World*. 2nd ed. New York: Holt, Rinehart and Winston, 1984.

Schapiro, Meyer. "Style." *Anthropology Today*. 4th ed. Ed. A. L. Kroeber. Chicago, Ill. University of Chicago Press, 1957.

Schiller, Gertrud. *Iconography of Christian Art*. Vols. 1 and 2. Greenwich, Conn.: New York Graphic Society, 1971.

Selz, Peter. *Art in Our Times*. New York: Harcourt Brace Jovanovich, 1981.

Sill, Gertrude Grace. *A Handbook of Symbols in Christian Art*. New York: Collier/Macmillan, 1975.

Walker, John. *The National Gallery of Art, Washington*. New York: Harry N. Abrams, 1975.

Whittlesey, E. S. *Symbols and Legends in Western Art, a Museum Guide*. New York: Charles Scribner's Sons, 1972.

Wölffin, Heinrich. *Principles of Art History*. Trans. M. D. Hottinger. New York: Dover Publications, 1950.

Index